THE OUTDOOR PHOTOGRAPHER'S HANDBOOK

THE OUTDOOR PHOTOGRAPHER'S HANDBOOK

KENN OBERRECHT

Winchester Press

Library of Congress Cataloging in Publication Data

Oberrecht, Kenn.
 The outdoor photographer's handbook.

 Bibliography: p.
 1. Outdoor photography. I. Title.
TR659.5.023 778.7'1 79-10066
ISBN 0-87691-289-7

WINCHESTER is a Trademark of Olin Corporation
used by Winchester Press, Inc. under authority and
control of the Trademark Proprietor

Winchester Press
205 East 42nd Street
New York, N.Y. 10017

Printed in the United States of America

ACKNOWLEDGMENTS

It is impossible to acknowledge my debt to everyone who has had a hand in the production of this book. So to all those who have demonstrated an interest in this project, I wish to extend a very special thank you.

I wish to express gratitude to the individuals and companies who have provided willing assistance, information, photographs and other illustrations, and equipment for field testing. Without their able aid, this book could not have been completed.

I wish to particularly thank Kathy Sebree of the Vivitar Corporation for her help and her patience with me near deadline time; Tony Whitman of the Norman Camera Company for many years of fine service and some special help when I needed it; Mike Sullivan of the Eastman Kodak Company for graciously answering my requests and granting permission to use Kodak's terms and definitions in the Glossary; and Murray Burnham of Burnham Brothers, an outfit that makes some dandy calling tapes.

Portions of this book have appeared in *Petersen's Photographic*, *Points*, and *Popular Photography* magazines. My sincere thanks to the editors of these publications for permission to reproduce material here.

Finally, an overdue thanks is in order for all the fine folks at Winchester Press who have been not only expert business associates, but very good friends as well.

To my mentors and very dear friends
Professor Jimmy Bedford,
Professor Emeritus Charles Keim,
and
Professor Emeritus Minnie Wells.

CONTENTS

THE OUTDOOR PHOTOGRAPHER'S HANDBOOK

OUTDOOR PHOTOGRAPHY

Worldwide, photography is unexcelled as a hobby or recreational activity; since most photographic images are recorded outdoors, outdoor photography must be considered the most popular aspect of photography. Studies by the U.S. Fish and Wildlife Service show that the number of wildlife photographers in the United States increased dramatically from about 5 million in 1970 to nearly 15 million in 1975. The number is continuing to grow. And remember that wildlife photography is only one part of outdoor photography.

Depending upon the intensity and variety of your interests, outdoor photography is what you want to make of it. It can be a casual pastime, a serious hobby, a part-time job, or a full-time career. It can be a form of recreation or a means of scientific or technical investigation. You can approach it as an art, craft, or sport. You can specialize in landscapes or scenics, waterfowl, birds, small game, big game, insects, flora, water sports, or travel photography. Most of us are probably generalists of a sort, with a few favorite subjects that comprise our specialties.

Equipment and Techniques

The equipment and techniques of outdoor photography cannot be discussed separately, because one depends on the other. If we are to fully understand a camera, lens, filter, bellows, or any other piece of gear, we must know how to use it correctly and effectively. When we apply that knowledge in practice, we call it technique. And to master the techniques, we must have the equipment.

A vast array of equipment and gadgets and numerous films and formats are available today. The basic tool of the outdoor photographer is the single-lens reflex (SLR) camera—specifically, the 35mm SLR.

There are photographers who use everything from simple fixed-focus, nonadjustable cameras to bulky, cumbersome view cameras, but the 35mm SLR is the tool most often selected for outdoor photography. We will briefly discuss other types of cameras and film formats, but emphasis will be placed on the 35mm SLR, its accessories, and the techniques of 35mm photography. In each chapter we will be equally concerned with equipment and techniques.

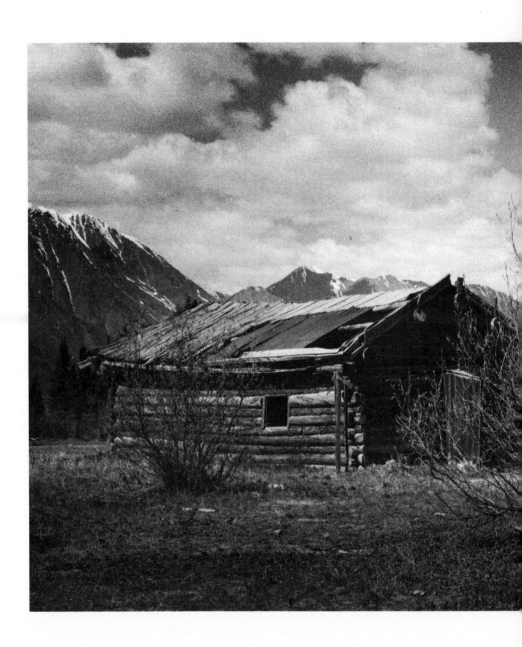

Familiarity Breeds Competence

No matter what kind of equipment you use, the secret of successful picture taking is total familiarity with gear and film. Through practice, you must reduce camera handling and control to reflex responses. When you first use a piece of equipment, you must think and use judgment, concentrate on technique, and consciously make necessary adjustments. As you gain proficiency, you will find that you think less about such matters and act more quickly, as if by instinct. The camera will begin to function as an extension of your brain, eyes, and arms. That is when you can channel your thinking toward visual expression. Your mind will be freed of its mechanical and technical burdens, allowing for more creative considerations. You will be able to

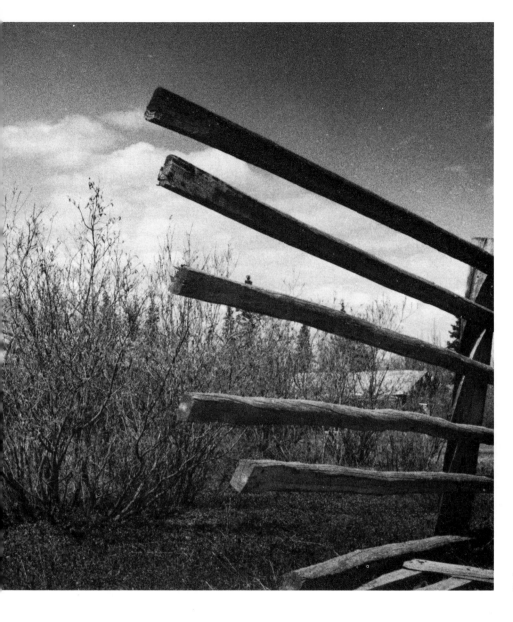

An old fence can help frame a deserted cabin . . .

concentrate on photographic communication and strive toward pictorial impact.

It is equally important that you learn all you can about the film you use. At first you will want to experiment and investigate. Try a variety of films, color and black and white. Ultimately, settle on a few films that will handle all the photographic situations you are likely to encounter, because the more you use a film the more you learn about it. You will know its abilities and limitations, its attributes and idiosyncrasies.

Searching for Subjects

When I began attending a magazine article-writing course some years ago, I wondered how anyone could find enough sub-

*. . . or from a different angle,
the fence becomes the
subject . . .*

jects to write about for a lifetime. By the end of the course, I was
wondering how I could live long enough to write about all the
subjects I was discovering. The subjects were there all the time, of
course. I had simply learned how to recognize them.

It's the same with outdoor photography. The subjects are limit-
less; all you have to do is learn to recognize them. In the begin-
ning, subjects seem elusive, but it is we who elude them by not
seeing them as potential photographs.

Some subjects are obvious and relatively easy to record on film,
but others require thoughtful searching. Our interests lead us to
many subjects; one common failure of beginning photographers
is to see a subject in only one way and be satisfied to snap a
picture of it that way. The competent photographer examines his
subjects from every angle. He exploits favorable lighting condi-
tions. He searches out framing details, interesting foreground,
and complementary background. While improving on one subject
he will find others.

An old abandoned log cabin may be an interesting subject, but
standing alone and unadorned, it makes a rather bleak picture. If
the sky is cooperative it can add some excitement to the photo. If
the surrounding scenery is pleasant, the cabin can become part

. . . closer inspection of the cabin may lead you to a good subject.

of a scenic photograph. An old wooden fence may provide good foreground or framing. From a different angle that excludes the cabin, most of the sky, and other details, the fence itself may become the subject of another picture.

On closer inspection the cabin might furnish a dozen more subjects. You can pose a partner in a doorway or inside the cabin near a window for an interesting portrait. You can go inside and use the window to frame a landscape shot. Perhaps you'll find an old rusty hinge on a door with a small beam of sunlight playing across it, or a kerosene lantern hanging near the front door, or a wooden wagon wheel propped against the rear cabin wall. You'll never find these suitable subjects if you are satisfied to just snap a picture of the cabin and move on.

You must search for subjects. Just as practice with your equipment will improve your technical skills, practice in finding subjects will improve your ability to locate subjects. You will learn to see and interpret subjects photographically, and you will learn, as I have, that you can never run out of good outdoor subjects.

Pictures with a Purpose

A good outdoor photographer—one who has developed a photographic consciousness, has mastered his equipment, and has learned a variety of techniques—can make interesting, even stunning photographs of subjects that less able photographers will pass by as uninteresting. The good photographer sees subjects differently; he forces the viewer to see them as he does.

After finding and examining the subject the competent photographer will use everything available to him—framing, lighting, angle, and position—to focus the viewer's attention on the essence of the photograph. He will make his purpose clear. He will communicate.

There are two questions you should ask yourself about any potential photograph: What is my subject? What is my purpose? If you can answer these questions honestly to your satisfaction, you are well on your way to making a good photograph.

Perhaps this all sounds inanely simplistic, but it works; first, those two questions force you to think before you shoot; second, they lead to other questions, answers, and observations.

When you ask yourself what your subject is, you may discover two or three subjects in the picture area, which would make for a distracting photograph. Move in closer, change your angle of view, switch to another lens, or find some other way of eliminating the extra subjects, or at least toning them down to being subordinate details.

Your purpose may be to interpret the awesome power of the pounding surf, or the tranquility of a meadow brook; the destructive force of a raging storm, or the refreshing sparkle of raindrops on wildflowers; the harshness of the frozen north country, or the thrill of a cross-country ski tour; the ravages of a rampaging forest fire, or the comfort of a friendly campfire. Your purpose can be philosophical, artistic, scientific, or just reportorial. You may be trying to convey a message or only to present a picture that is pleasing to look at. It really doesn't matter what your purpose is, as long as it is clear to you.

Professional vs. Amateur

I want to get this professional/amateur distinction cleared up immediately. There are a few folks making or trying to make a living as outdoor photographers (or writer/photographers) who like to call themselves pros and equate the terms "professional" and "amateur" with good and bad work, respectively. I would enjoy gathering them together someday and showing them a selection of carefully chosen photographs and having them guess which were taken by professional photographers and which by amateurs. They would certainly fail dismally.

Recently I read a rather expensive book on outdoor photography in which the author continually talked about "professional" results, often offering examples from his own experience. Whenever he discussed botched-up photos or stupid practices, he referred to amateurs, even "rank" amateurs. My feeling was that he came off as a rank professional. After all, every stumblebum boxer who gets paid to have his brains beat to putty is a pro.

Generalities are dangerous. If we must distinguish between professional and amateur photographers in general, we can only state that the professional sells pictures and the amateur doesn't.

Let's not be concerned with status, but rather with technical excellence, knowledge of equipment and materials, intimacy with subjects, purpose of endeavor, quality of visual expression, and that ever elusive "pictorial impact." If you're a poor photographer, strive to become a good one; if you are already good, get better. None of us will ever attain perfection, though it is certainly an honorable goal.

BASIC EQUIPMENT AND TECHNIQUES

2

The world of photography is a world of gadgetry. There are two ways of viewing the vast arsenal of cameras, lenses, and accessories available to us today: we can praise them as tools that simplify a task or even make it possible, or we can curse them as mind-boggling nuisances that only complicate the craft and get in the way of creativity.

I have had both attitudes, depending on my mood or the dictates of the situation. If I am out for a day of landscape photography, for example, and am working out of a vehicle, I will tote along all sorts of equipment. On the other hand, while I'm fishing I don't like to be bothered with any more gadgetry than necessary, and on a backpacking trip, where space and weight limitations are severe, I go with a minimum of gear. It's a good idea for the equipment-laden photographer to get back to basics periodically as a matter of discipline and reeducation. There are times when I just get fed up with lugging a lot of equipment, and I head off for a day of photography with only one or two cameras, sometimes an extra lens, a few essential filters, and a pocketful of film.

In the final analysis there is only one piece of equipment that is essential to recording an image on film—the camera. A camera can be a shoe box with a pinhole in it, or it can be a computer-age piece of sophisticated equipment with electronic shutter and exposure system, digital readouts, light-emitting diodes, motorized film transport system, and a $3000 price tag. Of course, it takes something more than a pinhole camera for quality outdoor photography, and a $3000 camera is too rich for most of us. So we choose among the hundreds of cameras that fall between these extremes.

From time to time I am asked to recommend the best camera for outdoor photography. That's like being asked about the best shotgun for quail hunting or the best fly rod for trout fishing. Recommendations on suitable equipment can be made to the photographer from the seemingly endless possibilities, but the issues tend to be clouded by personal preferences, conflicting opinions, and the all-important cost factor.

My first recommendation is to get an adjustable camera, which narrows the field of selection somewhat by eliminating all the

fixed-focus box-type and pocket cameras that exist by the millions. They are fine for the casual snapshooter, but if you want to take good outdoor pictures consistently and be able to exercise control over your photography, you must have a camera you can control. You must be able to select from a range of shutter speeds and aperture settings, and must be able to focus the camera.

The simple nonadjustable cameras often touted as "good for beginners" are only worthwhile if you want to remain a beginner. You can't learn much from them, since they do little more than record average (mediocre) images on film.

My next recommendation, for reasons which will become obvious later, is for the 35mm format. My preference is based on personal experiences, but my views are shared by most of the serious outdoor photographers and photojournalists in the world. The 35mm has become the tool of the trade.

There are some excellent cameras available in larger formats that perform admirably for many outdoor photographers and offer some advantages. But the advantages of the 35mm camera greatly overshadow any minor disadvantages that exist.

Cameras

The three types of cameras most widely used by outdoor photographers are the viewfinder, the twin-lens reflex (TLR), and the single-lens reflex (SLR). A fourth type—the view camera—is used by a few outdoor photographers, but its size and bulk as well as the inconvenience and expense of working with sheet film make it impractical for most of us.

The most popular film formats for outdoor photography are 35mm (24mm x 36mm), 6cm x 4.5cm (2 1/4" x 1 3/4"), 6cm x 6cm (2 1/4" x 2 1/4"), and 6cm x 7cm (2 1/4" x 2 3/4").

Viewfinder

The viewfinder camera has a viewing system that is separate from the lens. This system, or viewfinder, usually is a simple arrangement of optics that enables the photographer to see approximately what the lens will include. But since the viewfinder is located above and usually to the left of the lens, close-up photography with a viewfinder camera is complicated by the problem of parallax error, which can cause a portion of the picture to be cut off, even though the subject is in full view in the viewfinder. Some of the better viewfinder cameras are parallax-corrected, but extreme close-ups can still pose problems.

The best viewfinder cameras are equipped with a coupled rangefinder focusing system comprised of movable mirrors or prisms that render a double (split) image in the viewfinder. When the images are aligned the lens is properly focused on the subject, and the subject's distance appears on the lens's distance scale.

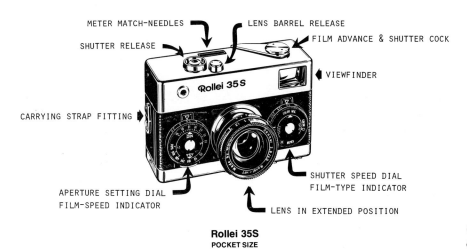

METER MATCH-NEEDLES — LENS BARREL RELEASE

SHUTTER RELEASE — FILM ADVANCE & SHUTTER COCK

VIEWFINDER

Rollei 35S

CARRYING STRAP FITTING

SHUTTER SPEED DIAL
FILM-TYPE INDICATOR

APERTURE SETTING DIAL
FILM-SPEED INDICATOR

LENS IN EXTENDED POSITION

Rollei 35S
POCKET SIZE

Compact 35mm viewfinder camera.

It is sometimes important to know the exact distance of your subject (as in flash photography), but the true value of the coupled rangefinder is that it is a simple, accurate focusing system. In low light the viewfinder camera is generally much easier to focus than other types of cameras, since the image in the viewfinder usually will be much brighter.

Viewfinder cameras, except for the most expensive ones (Leica, for example), are equipped with fixed, semiwide-angle lenses. The most popular focal length seems to be 40mm to 45 mm, which I agree is more versatile than the normal 50mm lens and offers better depth of field. On the other hand, the fixed lens is limiting. There is no limit to the number of subjects and situations that can be effectively photographed with a 40mm lens, but there are some types of subjects and settings that will require either wider or longer lenses.

For the beginning photographer, especially if he is unsure about how much he will get involved, the viewfinder can be a good first camera, provided that it is fully adjustable and, preferably, equipped with a coupled rangefinder. When the photographer decides to advance into a system of compatible interchangeable lenses and camera bodies, the viewfinder can be used for backup. A number of top-quality viewfinder cameras are manufactured by such companies as Canon, Konica, Minolta, Olympus, and Ricoh.

Another category of viewfinder cameras is the compact 35s, which will usually fit comfortably in a pocket or take up little space in a tackle box, backpack, or musette bag. Many compact 35s are equipped with electronic exposure systems and zone focusing; prices are around $100.

Some compact 35s make no provisions for manual override of the automatic features; this keeps the photographer from controlling picture taking, and thus they are not good learning tools. Furthermore, a zone-focusing lens is only a small step up from a fixed-focus lens: the photographer cannot choose among the infinite settings of a full-focusing lens, but has several

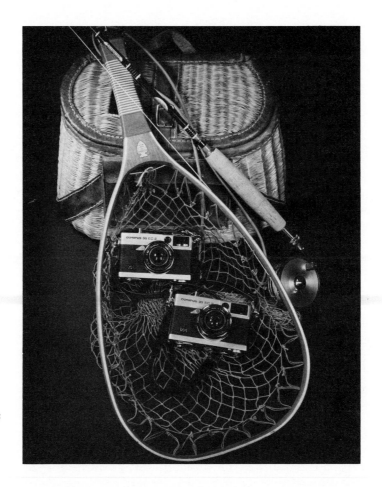

The author's choice among lightweight fishing cameras is a pair of Olympus compact 35mm viewfinder cameras.

(usually four) click settings or detents with corresponding symbols appearing in the viewfinder—a man's head, a man's torso from the waist up, a group of three people, and mountains, denoting respective distances of about 1m, 1.5m, 3m, and infinity. Because of the depth of field offered by the semiwide-angle lens, if the lens is set for the best zone it will overcome minor errors in distance estimation. The problem with zone focusing is that if you must grab the camera to capture a fleeting moment, it is too easy to forget to focus the lens, since there is no out-of-focus or split image in the viewfinder to serve as a reminder. Too often I have taken a head-and-shoulders shot of an outdoor partner only to leave the lens set for 1.5m when exposing the next frame for a more distant subject.

Now for the good news. The compact 35 is so small and lightweight, it can be carried along on "light-load" trips. Low cost permits us to own a compact as an auxiliary to more expensive, sophisticated equipment. Also, the compact camera can be taken along when an expensive camera would be left behind for fear of damage, as on a rainy-day fishing jaunt, a whitewater canoe trip, or a hunting or backpacking trek into rugged high country. The compact 35mm viewfinder can mean the difference between re-

turning home with a photographic account of an outing or no photos at all.

Most compacts are optically and mechanically sound instruments that will take a lot of punishment. My wife and I have been using a pair of Olympus compacts for nearly five years, and neither has ever malfunctioned. During that time we have added thousands of transparencies and negatives to our files because we had those cameras along.

Another tiny viewfinder I have had experience with, which we might call a subcompact, is the superb Rollei 35 S. About as big as a pack of king-size cigarettes, it will fit into a shirt pocket. It does not feature a coupled rangefinder, but the 40mm lens will focus fully from 1 m to infinity—you must estimate the distances. It has a built-in match-needle light meter, adjustable shutter speeds from B to 1/500 second, and aperture settings from f/2.8 to f/22—features important to any serious photographer.

Twin-Lens Reflex (TLR)

The twin-lens reflex camera used to be a favorite among photo-journalists, and it has had a faithful following among outdoor photographers for many years. But with the many advances in 35mm equipment and film, the ranks of TLR users today are dwindling.

In a twin-lens reflex camera the top lens provides an image for the photographer to compose and focus, while the bottom lens records the image on film. Behind the top lens is a stationary mirror that reflects the image onto a ground-glass screen above it; the photographer views the screen from above, looking down on a camera that is normally held at waist level. Most TLRs are equipped with small magnifiers that can be positioned above the ground-glass screen for critical focusing at eye level; but the waist-level finder is a distinct advantage when photographing subjects from a low angle, where the eye-level viewfinders of most 35mm cameras are impractical. The TLR can be set on the ground for ground-level shots, and can be held upside down, above the head, at arm's length to shoot over crowds, for example, during sporting events.

The image on the ground-glass screen is reversed left to right, which is a bit difficult to get used to at first, but with practice becomes only a minor nuisance. Eye-level prism finders are available for Rolleiflex and Mamiya TLRs that correct this problem.

Like the viewfinder camera, the TLR suffers from parallax problems in close-ups, although the more expensive models are parallax-corrected to some degree. There are other ways of compensating for parallax errors in these cameras. To correct the problem optically, there are close-up lens sets that feature a prism in the top lens that enables the photographer to position the

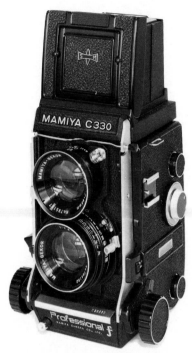

The Mamiya C330 is the most versatile of today's TLR cameras.

camera correctly for photographing with the bottom lens and a close-up attachment. For mechanical correction there are devices, such as the Mamiya Paramender, which are attached to the bottom of the camera (in the tripod socket) and mounted atop a tripod. When the camera has been focused close-up, the Paramender is used to move the camera upward precisely to the position for the lower lens to photograph the subject with no loss in picture area.

Although some TLRs have been made for smaller film formats, the standard is 120 or 220 roll film, producing negatives and transparencies in 6cm x 6cm (2 1/4" x 2 1/4") format. Some photographers find the larger format an advantage, but frankly, the quality 35mm film available today makes that a rather flimsy argument for the TLR. Also, there is a wider variety of film available in 35mm than in 120 and 220. Since you get only 12 exposures with 120 (24 with 220), your per-frame film cost will be higher with the larger format, and you will have to reload more frequently. When fast action is called for, frequent reloading is not only a nuisance, but can cause you to miss some great shots.

Lenses are noninterchangeable on most TLR cameras, which is a distinct drawback for outdoor photographers. The Mamiya C330 camera is probably the most versatile of the TLRs made today. It features a system of seven interchangeable lenses, from a wide-angle 55mm f/4.5 (normal for this format is 80mm) to a 250mm f/6.3 telephoto, and has a built-in bellows for close-up work, interchangeable focusing screens, and three prism finders.

The best TLRs are far from cheap. List prices range from more than $500 for the Mamiya C330 with an 80mm lens to about $1000 for a new Rolleiflex 2.8F.

If you're starting out in outdoor photography, or if you would like to experiment with a twin-lens reflex, consider shopping for a used camera. There are plenty of good, serviceable TLRs on the shelves of camera shops, especially in the larger cities. Or invest in one of the less expensive cameras, such as the Yashica Mat-124B. I owned one for several years and was most pleased with the results it gave me, its characteristic limitations notwithstanding.

Single-Lens Reflex (SLR)

In a single-lens reflex camera, light reflected from the subject enters the camera's lens and is reflected upward by a movable mirror positioned at a 45° angle behind the rear element of the lens. The inverted image appears on a ground-glass viewing screen directly above the mirror, but before it reaches the photographer's eye the image is bounced off two sides of a five-sided prism so that it appears right side up in the viewfinder.

The major inadequacies for outdoor photography of the other cameras already discussed are nonexistent in the single-lens re-

flex camera. Since the subject is viewed through the same lens that records the image on film, there is no parallax error. The prism finder is integral to the design of most SLRs, so there is no need for an auxiliary attachment to correct the inverted image on the ground-glass screen. And the range of interchangeable lenses—from superwide-angle to supertelephoto—that can be fitted to the SLR will cover any photographic situation. SLRs can even be attached to microscopes and telescopes for extreme close-up and long-distance photography.

The SLR camera is the basic tool of the serious outdoor photographer, on which a system of compatible equipment and accessories can be built. It is important to keep this in mind when comparing the SLR to other camera types, because the system photographer is the versatile photographer, the complete photographer. If your hobby or profession were golf, you would not try to make do with one club; rather, you would have a set of clubs designed to handle a wide variety of situations. It is the same with outdoor photography. If you confine yourself to one camera with a fixed lens, you will be able to take photographs—even good photographs—but only the ones possible with that particular camera and lens.

The 35mm SLR is not perfect, and it does have its faults, which critics are quick to point out. But sometimes the criticism seems mighty one-sided and picky. For example, the critics say the SLR is heavier and bulkier than the viewfinder camera. We have already discussed the limitations of most viewfinder cameras. Now let's look at the best viewfinders: they are optically and mechanically superb cameras, and since their lenses are interchangeable, and there is a variety of accessory items available for them, they are true system cameras.

But remember, they are viewfinders, and the viewing frame is accurate for only a narrow range of lenses, usually from medium wide-angle to short telephoto. So what happens when you put a 21mm wide-angle lens on the camera? To see what you're going to get, you will have to fit the camera with an expensive auxiliary wide-angle eyepiece. And what about shooting with a long telephoto, such as a 400mm? Now you will have to fit your camera with a reflex finder which will make it every bit as bulky as the largest 35mm SLR. Furthermore, this is a costly accessory to add to an already expensive system.

And don't forget that SLRs are getting smaller and lighter each year. The premise for the argument just seems to dissolve like a lump of sugar in a hot cup of camp coffee.

Another criticism of the SLR is that it is noisy. When the mirror behind the lens moves up and out of the way as the shutter opens, and flops down again as the shutter closes, there is some sound. Furthermore, the focal-plane shutters of most SLR cameras make

more noise than the leaf shutters found in viewfinder and TLR cameras. But so what?

Those who find SLRs too noisy usually refer vaguely to problems encountered while taking candid photographs of people or when trying to photograph animals without spooking them. If you want really candid photographs of people enjoying the outdoors, you will need something longer than a normal lens—anything from about 90mm to 200 mm with a 35mm camera—because if you have to get your picture with a normal or wide-angle lens, it isn't likely to be very candid. Photographing from a distance with a telephoto lens will reduce the chances of shutter-release noises interfering with your work. And even if the person does hear your camera, the image will have already been recorded.

Similarly, with animal photography, if you can get in close enough to photograph your subject with a normal or wide-angle lens, you are going to be close enough for it to hear *any* camera click. At that range the animal already knows you're there, and chances are, it doesn't give a furry or feathery damn. If you are photographing from a blind or a remote position, the noise may cause the animal to spook, but, again, that will be after the fact.

I have used SLR cameras for wildlife photography for years, and as often as not the click of the camera has been an advantage. Once in Mount McKinley National Park I was stalking a small herd of bull caribou that I had been observing with binoculars for two days on the open tundra. I had moved up a gully and was completely concealed from them. When I belly-crawled up the side of the draw for a look, I saw a magnificent bull with antlers like rocking chairs grazing on a direct path toward me. I had plenty of time to position myself, make necessary camera adjustments, and wait for my shot. The caribou continued moving toward me, with his head down, feeding on mosses and lichens. The low tundra growth was just tall enough to obscure the animal's face. Finally he got so near that I feared he would move within the minimum focusing distance of my 200mm lens. So I fired off one frame and cocked my camera for the next shot. When he heard the click he lifted his head and looked right at me, his handsome face and incredible antlers filling the frame. The second click captured the moment.

Another SLR problem associated with the movable mirror is that when the shutter release is depressed and the mirror lifts up and out of the way so the image can be recorded, the photographer's view of his subject is temporarily blacked out. I never recognized this as a problem—it's so insignificant—until some photographic writer brought it to my attention, and since then I have seen the complaint registered time and again, as a matter of duty to the readers, I suppose. The complaint is as baffling to me as it was the first time I read it.

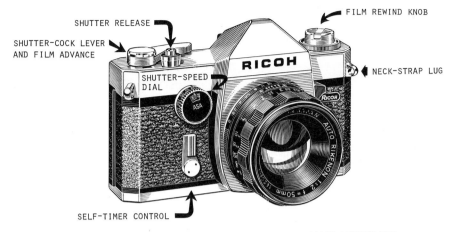

SHUTTER RELEASE

SHUTTER-COCK LEVER
AND FILM ADVANCE

FILM REWIND KNOB

RICOH

SHUTTER-SPEED
DIAL

NECK-STRAP LUG

SELF-TIMER CONTROL

RICOH SINGLEX TLS
SINGLE-LENS REFLEX

35mm SLR camera.

As outdoor photographers we shoot with fairly fast shutter speeds much of the time, so the blackout at speeds of 1/60 second and faster will be nearly imperceptible. At slower shutter speeds, with the camera mounted on a tripod, we are usually photographing slow-moving or stationary objects, so any change in the subject area during the blackout will be inconsequential or nonexistent. Let's face it, by the time you put your finger on the shutter release you should have already positioned yourself properly, composed your picture in the viewfinder, focused, and selected an appropriate shutter speed and the right aperture setting. All that remains is to pick the precise moment to press the button. That mirror won't move until you press the shutter release, and then you are already committed to the view in the frame of your viewfinder. Blackout is subsequent. It's beyond me how it can possibly interfere with picture taking.

Now it's time to do a bit of conceding. Since you look through and photograph with the same lens in a single-lens reflex camera, focusing can be difficult if you have had to attach a dense filter to the lens. A simple solution would seem to be to focus before placing the filter on the lens, but placement of any optical attachment (even clear glass) on the lens can cause a minor shift in focus. One way to correct this is to focus with a clear glass or less dense filter attached, and then substitute the proper filter, but the filter used for focusing purposes should be of equal thickness. It's simpler, though, to just focus with no filter and use the smallest possible aperture to compensate for any focus shift.

Other focusing problems may be encountered with some types of viewing screens when using extreme wide-angle or long telephoto lenses. These difficulties are easily remedied in SLR cameras that feature interchangeable viewing screens. In SLRs with permanent viewing screens, partial or total blackout of the center focusing spot can occur. When that happens, just use any area outside the center spot to focus the image.

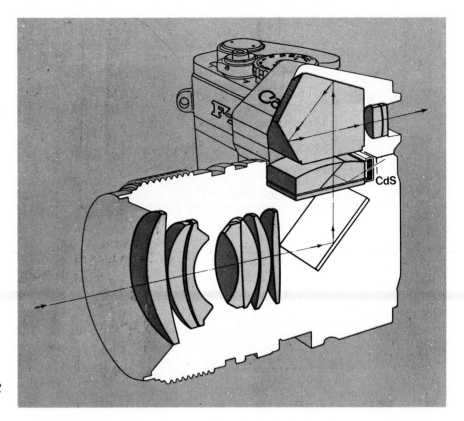

This cutaway diagram of a Canon F-1 camera illustrates the path of light through a typical 35mm SLR camera.

In low light levels, the viewfinder camera, with its brighter image, is easier to focus than the SLR, but this is a minor deficiency in the SLR that most of us can live with, taking its advantages into consideration.

There are so many excellent 35mm SLR systems available today—including Nikon, Canon, Minolta, Olympus, and Pentax—that it would be pointless to recommend one. Any is suitable for all aspects of outdoor photography.

The most popular and abundant SLRs are made for use with 35mm film, but there are other system cameras designed for larger formats, which have found favor among some outdoor photographers. The Swedish-made Hasselblad, distributed in the U.S. by Braun North America, is perhaps the best-known medium-format SLR. The Hasselblad system is extensive indeed, featuring three camera designs, 14 lenses ranging from a 30mm fisheye to a 500mm telephoto, interchangeable focusing screens, more than a half-dozen viewfinder options, and a host of accessories to handle virtually any photographic task.

Compared to 35mm SLR systems, Hasselblads are heavier, bulkier, and far more expensive. Optically and mechanically, they are among the finest cameras in the world. When compared with the best of the 35mm systems, the cost of a Hasselblad system is competitive, especially in view of Hasselblad's best feature—interchangeable film magazines.

There are several advantages to a system that employs inter-

changeable film magazines. First, there is no faster way to reload a camera, so they're great for fast-action photography. Also Hasselblad offers, in addition to the standard magazine which provides twelve 6cm x 6cm exposures per roll of 120 film, four other magazines, including one that uses cassettes of 70mm film and produces seventy 6cm x 6cm exposures per cassette. Most important is that the availability of interchangeable magazines means you don't have to own more than one camera body, which not only reduces the cost of the system but appreciably diminishes equipment bulk and weight.

Bell & Howell-Mamiya offers two SLR cameras designed for medium-format film. The Mamiya 645 is a compact machine that provides negatives and transparencies in 6cm x 4.5cm with 120 roll film. The RB67 is a 6cm x 7cm camera that features interchangeable film backs, one of which is motorized. Both cameras are system machines, for which a variety of lenses and accessories are available.

Bronica cameras and lenses—marketed in the U.S. by Ehrenreich Photo-Optical Industries—are medium-format SLR systems available in 6cm x 4.5cm and 6cm x 6cm.

Understanding Shutter and Diaphragm

Two of the most important controls on a camera are the shutter and diaphragm, which is why I recommend only cameras that provide for adjustment of these controls. Both are managers of light: the shutter dictates the duration of exposure, and the diaphragm determines the amount of light that reaches the film. Together, they allow us to make accurate exposures in virtually any light.

Shutter

There are two types of shutters in the cameras we have discussed. Viewfinder and twin-lens reflex cameras employ leaf shutters, built into the lenses, which consist of several overlapping blades which, when tripped, open from the center and close again to properly expose the film. With this type of shutter, the maximum speed attainable is 1/500 second.

Most single-lens reflex cameras employ focal-plane shutters. Rather than being built into the lens, the focal-plane shutter is inside the camera body, in front of the film. The shutter usually consists of two overlapping curtains with an adjustable slit between them. When the shutter is tripped, the curtains move from side to side (or vertically in some cameras), with light passing through the slit reaching the film and essentially "painting" an image as the curtains travel. The slower the shutter speed, the wider the slit, and vice versa. With such a shutter, speeds up to 1/2000 second are possible. One minor fault of the focal-plane

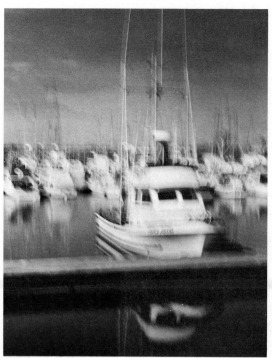 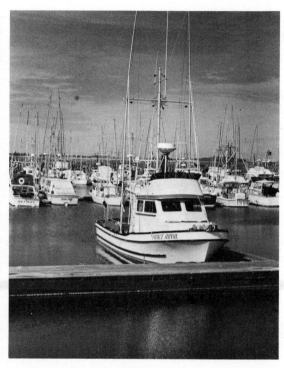

Left: *Taken with a hand-held 35mm camera with a 50mm lens and 1/30-second shutter speed, this photo exhibits excessive camera motion.* Right: *The same subject shot at 1/250 second appears decidedly sharper.*

shutter is that high-speed subjects photographed as they move parallel to the film plane can come out slightly elongated. This distortion is more pronounced in formats larger than 35mm, which is probably one reason why Hasselblad uses leaf shutters in their lenses instead of focal-plane shutters in their cameras.

The shutter is also responsible for the motion in any photograph. Slow shutter speeds can be used to indicate motion; fast speeds can give the impression of stopped action. The kind of motion you don't want, though, is unplanned or inadvertent motion.

If you are shooting with a hand-held camera and using a shutter speed that is too slow, camera motion will destroy the picture. Even with your camera mounted on a tripod or other stabilizing device, a fast-moving subject can be unintentionally blurred if your shutter speed is too slow.

The general rule to remember to avoid unwanted camera motion with a hand-held camera is to convert the focal length of the lens to the nearest shutter speed and use that as the *minimum*. The minimum speed for a 50mm lens is 1/60 second; for a 105mm lens, 1/125 second; for 200mm and 400mm lenses, 1/250 and 1/500 second, respectively.

There are times when the rule must be broken, but if you must drop below the recommended minimum speed, try to brace the camera and hold it as steady as possible. Then shoot at least a dozen frames, if time permits, and hope that one of them turns out sharp.

I try to shoot at 1/125 second or faster when I'm hand-holding a camera with a normal 50mm or any wide-angle lens. When I'm

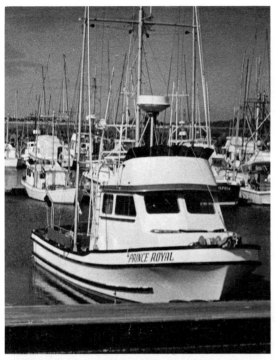

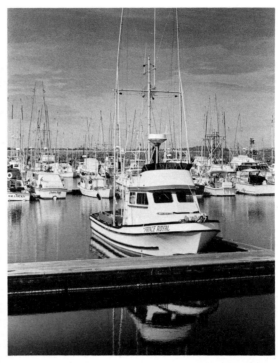

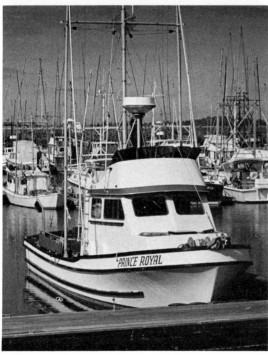

Left: *Great enlargement of the 1/250-second exposure, however, shows some evidence of camera motion. Notice fuzzy edges of "Prince Royal." Right: The same subject shot at 1/1000 second is truly sharp and crisp.*

Bottom: *Sharpness at 1/1000 second is even retained when greatly enlarged.*

using a telephoto I go for all the speed I can get, and I try to shoot at twice the recommended minimum speed, at least. For example, I prefer to shoot at 1/500 second with a hand-held 200mm lens and 1/1000 second with a 400mm lens.

You may want to depict motion in a picture by deliberately blurring either subject or the background. If you want the back-

ground sharp and the subject blurred, mount the camera on a tripod and shoot at a relatively slow shutter speed—1/30 or 1/15 second or slower (you'll have to experiment). If you want the subject fairly sharp and the background blurred, try shooting at 1/30 or 1/15 second and moving the camera (panning) with the subject. It is possible to pan a tripod-mounted camera, but I'm more comfortable panning a hand-held camera. It is important when panning to move the camera in an even, fluid motion, just fast enough to keep up with the subject.

The secret to good motion photographs is to use a slow enough shutter speed to emphasize the motion—to sufficiently blur the subject or background. When a subject or background is only slightly blurred, it looks accidental.

To truly stop a subject in motion, even with the fastest shutter speed, is theoretically impossible, but we can give the impression of stopped action. The most difficult action to stop is parallel to the film plane; the fastest speed possible should be used. Subjects moving at an angle to the film plane are a bit easier to stop, and those moving directly toward or away from the lens are easiest.

Several years ago I was photographing a boat race and had my camera set up on a tripod for the finish. I had the shot framed with blooming lilac trees and wanted to use a small aperture for maximum depth of field. I wanted the winning boat to be sharp in the picture, so that the boat's name, sponsor's flag, and crew would be recognizable. I figured I could get by with a shutter speed of 1/250 second to stop the action of the first-place boat as it crossed the finish line.

Wrong. Next day, when I came out of my darkroom with the 8″ x 10″ print of my 50-mph subject, the boat was blurred—not enough to make it a good depiction of motion, but just enough to make it appear an accident. Some weeks later I was having coffee with the winner of that race, who is an engineer, and I told him of my dismay over the blurring of the photo. He promptly took out a pad and pencil, did a bit of calculating, and said, "From the time the shutter opened until the time it closed again (a mere 250th of a second, mind you) my boat traveled two inches. Obviously enough to blur the shot."

Stop-action photography is a relative matter. The action may appear to be stopped in a small print or a slide in a viewer, but if the picture is blown up or projected, movement may be noticeable. Since most of us are satisfied with what appears to be stopped action, the reality of movement is of little consequence, provided that the shutter speed is adequate to create the illusion.

A simple formula is much handier than trying to make mathematical computations, and that's what my boat-racing friend came up with while we sipped our coffee. Take the speed, or estimated speed, of your subject and multiply it by 10. Convert

that number to the nearest shutter speed, and your subject will travel about 1 inch while the shutter is open. Each time you increase the speed of the shutter by one click, you will cut the distance traveled by your subject in half. Conversely with every click that decreases the shutter speed, the distance traveled will be doubled.

For example, I could have multiplied the speed of the boat by 10, set my shutter at 1/500 second, and known that my subject would travel 1 inch as my shutter snapped open and closed again. By going to 1/1000 second, my subject would move only 1/2 inch, which, in an 8″ x 10″ print, looks stopped.

Of course, if you are using a telephoto lens your subject will be magnified, as will the subject's motion. With a wide-angle lens and reduction of subject size, motion becomes less noticeable.

Diaphragm

Inside an adjustable lens is a set of thin, overlapping blades with a symmetrical opening that is centered on the optical axis. This component, the diaphragm, can be adjusted to increase or decrease the size of the center opening. The opening in the diaphragm is called the aperture, and the size of the opening is expressed in f/numbers or f/stops—the larger the number, the smaller the aperture.

In a typical scale of aperture settings or f/stops—f/1.4, f/2, f/2.8, f/4, f/5.6, f/8, f/11, and f/16—a setting of f/1.4 provides the largest opening, and f/16 the smallest.

By closing the aperture (or stopping down the lens, as we say) we reduce the amount of light reaching the film during exposure. By opening the aperture (no, we don't say "stopping up"; drains do that) we increase the amount of light admitted to the film.

Sounds simple, doesn't it? Well, it is, yet it is one of the greatest sources of confusion for the beginning photographer. The shutter/aperture relationship even baffles some experienced photographers.

The Important Shutter/Aperture Relationship

Several summers ago I was in the busy little Cascade resort town of Bend, Oregon, to teach an upper-division and graduate level course in outdoor photography at the community college. The course was recommended for experienced photographers, but did not require previous formal training.

To determine the proficiency of my students, most of whom were schoolteachers, I gave them a quiz at the start of the first class. Although most of them had some photographic experience and several had even completed college-level photography courses, only 2 of the 17 starting students correctly answered

APERTURE								

◄ To *increase* amount of light reaching the film and *decrease* depth of field

APERTURE	f/1.4	f/2	f/2.8	f/4	f/5.6	f/8	f/11	f/16

To *decrease* amount of light reaching the film and *increase* depth of field ►

◄ To *increase* duration of exposure and subject/camera motion

SHUTTER	B	1	2	4	8	15	30	60	125	250	500	1000

To *decrease* duration of exposure and subject/camera motion ►

The aperture and shutter are managers of light: the aperture controls the amount of light reaching the film, and the shutter controls the duration of exposure.

questions on the shutter/aperture relationship. In courses I have taught since, it was the same story.

I must tell my readers what I tell my students: If you don't understand the shutter/aperture relationship, you cannot function as a competent outdoor photographer, because under the veil of simplicity lies the most important aspect of controlling the adjustable camera and using it effectively and creatively.

First, shutter speeds are separated by a factor of 2. A setting of 1/250 second is twice as fast as 1/125 and half as fast as 1/500. The 1/250-second setting allows the film to be exposed for twice as long as the 1/500 setting and half as long as the 1/125 setting.

Aperture settings are correspondingly related. (Remember, the larger the f/number, the smaller the opening or aperture.) A setting of f/8 admits twice as much light as a setting of f/11, or half as much as a setting of f/5.6.

At any level of illumination, the film must receive a certain amount of light for a certain length of time to get a correct exposure. If the amount of light (function of the aperture) is changed, the duration (function of the shutter) must also be changed to compensate for the difference in exposure.

We determine the required exposure by measuring the level of illumination with a light meter, which gives us a shutter speed and aperture setting for the picture. But the recommended settings are only starting points. We can change the shutter or aperture to suit our purposes, but when we change one we must change the other in the opposite way. If the amount is increased, the duration must be decreased, and vice versa. It's as simple as that.

Let's say your light meter tells you that at a shutter speed of 1/125 second you should use an aperture setting of f/5.6. Now, if you want to shoot at 1/250 second, you will be cutting the exposure time in half. To compensate, you double the amount of light by opening the diaphragm to the next aperture setting, f/4. If you want to shoot at 1/500, you will set the aperture at f/2.8. At 1/1000 second you will use f/2.

Beginning with the same reading of 1/125 second at f/5.6, if you want to shoot with a smaller aperture, you will compensate

APERTURE	$f/1.4$	$f/2$	$f/2.8$	$f/4$	$f/5.6$	$f/8$	$f/11$	$f/16$
				⬆	↑			

SHUTTER	B	1	2	4	8	15	30	60	125	250	500	1000
									↑	⬆		

↑ Small arrows denote original settings according to meter reading.

⬆ Bold arrows denote adjusted settings that will render identical exposure.

Given initial settings of f/5.6 at 1/125 second, if shutter speed is changed to 1/250 second, aperture must be opened to f/4 for identical exposure.

APERTURE	$f/1.4$	$f/2$	$f/2.8$	$f/4$	$f/5.6$	$f/8$	$f/11$	$f/16$
		⬆			↑			

SHUTTER	B	1	2	4	8	15	30	60	125	250	500	1000
									↑			⬆

↑ Small arrows denote original settings according to meter reading.

⬆ Bold arrows denote adjusted settings that will render identical exposure.

If, with the same initial settings, you wished to shoot at 1/1000 second—to stop the action of a fast-moving subject, for example—you would have to open the aperture to f/2. A shutter speed of 1/1000 second is eight times as fast as 1/125 second; an aperture of f/2 allows eight times as much light as a setting of f/5.6.

APERTURE	$f/1.4$	$f/2$	$f/2.8$	$f/4$	$f/5.6$	$f/8$	$f/11$	$f/16$
				↑				⬆

SHUTTER	B	1	2	4	8	15	30	60	125	250	500	1000
						⬆			↑			

↑ Small arrows denote original settings according to meter reading.

⬆ Bold arrows denote adjusted settings that will render identical exposure.

If, on the other hand, you wished to shoot at the smallest possible aperture for maximum depth of field (in this case f/16), you would have to slow your shutter speed to 1/15 second. The relationship is the same as at top. Here the aperture has been stopped down by three click settings; to compensate for the reduced amount of light, the shutter speed is reduced by three settings.

Basic Equipment and
Techniques

with a slower shutter speed. To use an aperture of f/16, for example, which will reduce the amount of light by three f/stops, you will have to increase the duration by three shutter speed settings, all the way down to 1/15 second.

The concept is not difficult, and when you master it you are well on your way to photographic control. A light-meter reading becomes a point from which you can launch into creative application, and it is the source of a wealth of photographic information.

In the above example, for instance, you know that 1/15 second is too slow for a hand-held camera, so you will either have to put your camera on a tripod or you will have to shoot with a faster shutter speed and correspondingly larger aperture. If you are using a 50mm lens and you want to use the smallest possible aperture, you're going to have to settle for f/8. Remember the earlier formula for hand-held photography, which states that the minimum shutter speed corresponds with the focal length of the lens, in this case 1/60 second. Settings of 1/60 second at f/8 provide an exposure identical to 1/15 second at f/16, or the original meter reading of 1/125 second at f/5.6.

Understanding Depth of Field

Depth of field is another source of confusion for beginning photographers, and from the looks of some of the photographs that appear in magazines, books, and photo exhibits, there are some experienced photographers who would do well to brush up on it.

Depth of field is the range of acceptable focus in a photograph. When you focus critically on one subject, there are other objects in front of or behind the point of critical focus that will be in acceptable focus. The acceptable range extends farther behind the subject than in front of it. If the range is short, the depth of field is said to be shallow. A photograph exhibiting maximum depth of field, on the other hand, is in acceptable focus from near foreground to infinity.

Although depth of field depends on camera-to-subject distance and lens focal length, the primary control for most pictures is the diaphragm aperture size. The smaller the aperture, the greater the depth of field.

So what's the value of all this? In two words: *selective focus*. The way you wish to interpret a subject or scene is up to you, and its basis is in how you present the subject to the viewer. Selective focus is one important way to direct the viewer's attention to the focal point of interest of the photograph.

In a portrait of an outdoor companion, for example, you will want to draw attention to the person portrayed. If the background is something distracting—tree branches, foliage, or boat docks—you can throw it out of focus by using the widest aper-

ture. The critical focus will be on the eyes (the most important feature on man or beast) and the rest of the face will be in acceptable focus. The background will dissolve into a nondescript, formless backdrop that only enhances the portrait.

You may wish to retain at least a suggestion of form in the background or foreground of some photographs. In framing a half-dozen wildflowers you can draw the viewer's attention to two or three that are in acceptable focus (and at least one in critical focus), while blurring the others so that they are not necessarily identifiable but are still suggestive. This rendition can give an impression of depth to an otherwise flat photograph. You will want to experiment with midrange apertures of f/5.6 and f/8, keeping in mind that the closer your camera is to the subject, the shallower the depth of field will be.

In a scenic photograph or panoramic landscape where there are many subordinate details, contours, rhythms, textures, patterns, and nuances that should remain sharp, as well as important foreground and framing elements that would be distracting if out of focus, you will want to reach for all the depth of field you can grab, by using the smallest possible aperture.

Depth-of-Field Preview

Another advantage of today's SLR camera is the automatic diaphragm, open-metering lens, which enables us to focus, compose, take meter readings, and make necessary adjustments with the diaphragm wide open. Only when the shutter is snapped does the lens stop down to its proper aperture.

These cameras are equipped with a depth-of-field preview (usually a small button). It surprises me that some photographers rarely bother to use this feature when composing their pictures. I consider it one of the greatest assets the SLR has to offer, and I rarely take a picture without previewing the depth of field first.

When the preview button is pressed it stops the lens down to the aperture you have set, allowing you to see your subject as it will appear in the final photograph. Although at the smallest apertures the image in the viewfinder is dimmed considerably when the diaphragm is closed down, if you allow a few seconds for your eyes to adjust partly, you will be able to thoroughly examine all areas of the viewfinder frame to determine the suitability of the depth of field at the given aperture.

Beyond Infinity

You know now that to get maximum depth of field you must use the smallest aperture, but that's not all. It is possible to extend the range of acceptable focus with another feature found on all good, adjustable cameras—the depth-of-field scale. Like the depth-of-field preview, this often goes unused, even by experienced pho-

The author's 50mm f/1.4 Nikkor lens focused toward infinity.

tographers, perhaps because it seems a bit complicated and unnecessary. Believe me, it is quite simple and at times very necessary, especially when you want to achieve striking results with apparent total depth of field.

The depth-of-field scale is used along with the lens-focusing ring (focusing knob, on TLRs) and is located near it. The scale on some cameras or lenses is numerical, the numbers of the scale coinciding with the aperture settings. On others the scale may consist of color-coded lines etched into the lens barrel, the colors of the lines corresponding to the colors of the f/numbers on the aperture ring. On my 50mm Nikkor lens, for example, blue, yellow, pink, and green lines match the colored numbers on the aperture ring for f/16, f/11, f/8, and f/4, respectively.

The depth-of-field scale consists of two sets of numbers or markings, one extending right from the centered distance scale indicator, the other extending left, with the largest f/numbers (smallest apertures) farthest from the indicator.

The depth-of-field scale is a little difficult to write about, because some lens-focusing rings move clockwise toward infinity and others move counterclockwise. So it is impossible to orient all readers. The simplest way is to use my camera and its 50mm lens as the teaching tool and tell you that when this camera is held in shooting position, the focusing ring turns clockwise toward infinity. If your lens operates the same way, follow me. If not, just reverse my directions.

It is theoretically impossible to focus beyond infinity, but it is one way of looking at the lens capabilities that go to waste if you don't use the depth-of-field scale on your camera or lenses. To illustrate, if I am photographing a landscape with my 50mm lens

With aperture set at f/16 and the lens focused to photograph a subject at infinity, maximum depth of field can be attained by back-focusing the lens until the infinity symbol on the distance scale aligns with the f/16 mark left of center on the depth-of-field scale.

With the lens focused on a subject at 10 feet and aperture set at f/16, the depth-of-field scale indicates that everything from 6 1/2 to 29 feet will be in acceptable focus.

I, of course, want everything in the distance to be in focus, so I focus on infinity. At f/1.4 (my lens's largest aperture), the foreground and any peripheral objects within the field of view are out of acceptable focus for more than 30 feet out from the camera. To increase the depth of field, then, I stop the lens down to the smallest aperture possible. At f/16, with the lens focused on infinity, everything from 15 feet to infinity is in acceptable focus—quite an improvement over the f/1.4 setting.

But the depth-of-field capabilities of this lens are even greater—beyond infinity, so to speak. But since there are no subjects beyond infinity, I use the capabilities of the lens to

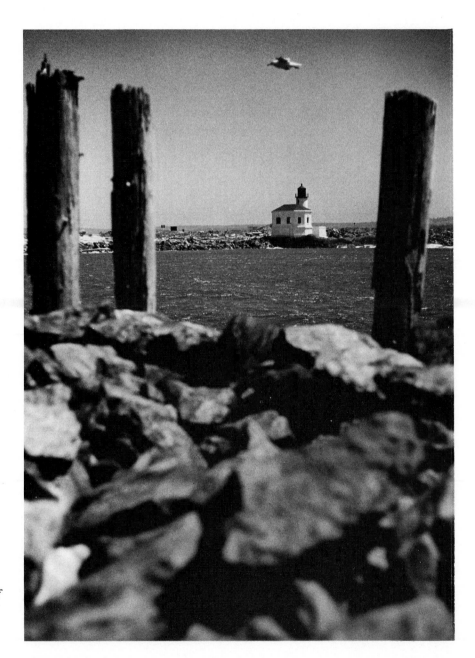

Taken with lens focused at infinity, aperture set at f/2. Because of shallow depth of field, about 75% of the subject area is out of acceptable focus.

improve foreground focus. From the infinity setting I back-focus to a point where the infinity symbol on the focusing ring aligns with the f/16 mark on the depth-of-field scale. Now, by finding the f/16 mark at the opposite end of the scale (remember, there are two sets of marks or numbers) and reading the distance scale above that mark, I find that I have everything from about 8 1/2 feet to infinity in acceptable focus.

You can use the depth-of-field scale when photographing nearer subjects to determine what the range of acceptable focus will be at various aperture settings, selecting the setting that best suits your needs.

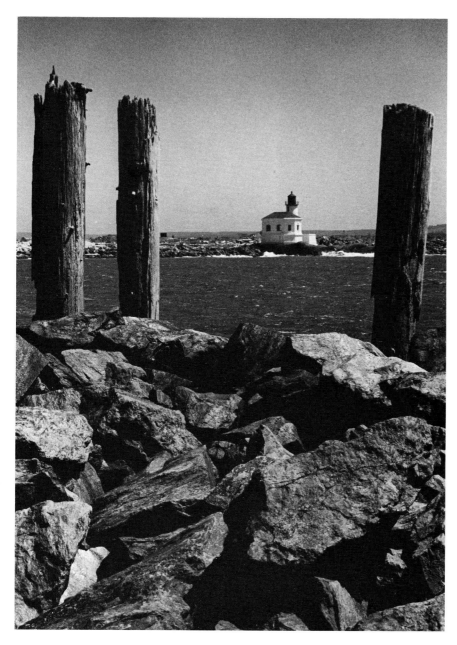

With aperture set at f/16, lens focused at infinity, then back-focused until infinity symbol aligns with f/16 mark on depth-of-field scale, almost total depth of field is achieved. Everything from foreground to infinity is in acceptable focus. (The only tricky part was keeping that sea gull in the same place for the second shot.)

If you use a lens like mine and are photographing a subject at 10 feet, by checking the "near" and "far" marks on the depth-of-field scale you will find that at f/4 the range of acceptable focus is from about 9 to 12 feet. At f/8 it would be 8 to 14 feet, at f/11, 7 to 16 feet, and at f/16, about 6 1/2 to 29 feet.

Only by using the depth-of-field scale along with the aperture settings can you attain the maximum depth-of-field capabilities of a lens.

Camera-to-Subject Distance

The effect of camera-to-subject distance on depth of field is

The view down the barrels of a wide-angle lens and a telephoto lens—each set at f/16—shows the differences in aperture. Lens on left is a Nikkor 28mm f/3.5; lens on right is a Nikkor 200mm f/4.

important in the composition of many outdoor photographs, especially if you don't have a variety of lenses of different focal lengths to rely on. A photograph can be ruined by too much or too little depth of field.

Outdoor portraits are often destroyed by too much separation between camera and subject. Subject size is reduced, relative to subordinate details, and depth of field is so great as to bring distracting background and foreground details into focus, resulting in overall confusion. The problem can often be solved by moving in closer. As you focus on the subject, the distracting background can be softened or put out of focus.

If you need more depth of field you can often get it by backing up a few feet. Landscape and scenic photos are sometimes ruined when the photographer fails to consider how close his camera is to dominant foreground or framing elements, resulting in large out-of-focus areas that distract the viewer. By moving the camera back, the foreground or framing can be brought into focus, often without changing the lens aperture.

Lens Focal Length

Focal length is the distance between the lens and the point behind the lens where the light rays are focused into an image. As focal length increases, so does the size of the image, but focal length also affects depth of field.

Since wide-angle lenses optically put you farther from the subject than a normal lens does, they give an impression of greater depth of field. Conversely, telephoto lenses draw you close to the subject and in the process compress the background, subject, and foreground, diminishing the depth of field. The range of acceptable focus for a wide-angle lens is greater than that of a normal lens; for a telephoto, the range is less than that of a normal lens.

There is another reason why depth of field decreases as the focal length increases. Remember, the smaller the aperture, the greater the depth of field, for any lens. For example, f/16 will give you greater depth of field than f/11 will. But f/16 in a wide-angle

lens will give you greater depth of field than f/16 in a normal or telephoto lens.

Any aperture setting in a telephoto lens requires a larger opening than the identical setting in a normal lens. In a normal lens the opening will be larger than in a wide-angle lens.

What f/stops do, mainly, is work with shutter speeds to give us consistent exposures, no matter what lens we are using. Any given f/stop in a lens will get the same amount of light to the film as the same f/stop in any other lens, regardless of focal length. But the longer the lens, the farther the light rays are spread, and the greater the diaphragm opening must be to keep image brightness consistent. So we find that f/16 in a 200mm lens, for example, is a much larger opening than f/16 in a 28mm lens. Since wider apertures provide shallower depth of field, the longer the lens is, the shallower its depth of field will be.

Lenses

Today's modern compound lenses are masterpieces of technology and computer design, intricate mechanisms of optical precision, with internal elements and special lens coatings that minimize or eliminate the problems caused by light passing through a transparent medium. The variety of top-quality lenses and their range of applications are sources of befuddlement for the photographer with limited experience.

We are bombarded with articles and advertising in photographic magazines that tell of all the nifty things that can be done with this lens or that. We need to read this material and to keep abreast of changing technology, but it can add to our confusion and make it tough to decide on the lens or group of lenses that will enable us to accomplish what we want to do. The problem is compounded for those who enjoy more than one aspect of outdoor photography. If I did nothing but close-up work, I would carry only one or two lenses and a few accessories. If I only enjoyed landscape photography, I could get by with two or three lenses. If my only interest were wildlife photography, I would want at least one good telephoto lens, and I wouldn't bother toting wide-angle lenses with me.

But all of these areas are of interest to me, and although I do take some trips where I specialize in one area, I am usually interested in and prepared for a variety of subjects and situations. Most of us are all-around photographers, capable of photographically interpreting whatever we encounter in the out-of-doors. How bewildering to face the truth that we are primarily beasts of burden, and only secondarily photographers!

Normal Lenses

A normal lens "sees" a subject in about the proportions the human eye would. The focal length of a normal lens depends on

AUTO RIKENON
EE LENSES
200mm F3.5
136mm F2.8
35mm F2.8
28mm F2.8

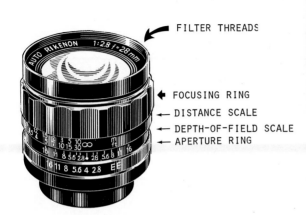

FILTER THREADS

FOCUSING RING
DISTANCE SCALE
DEPTH-OF-FIELD SCALE
APERTURE RING

Typical wide-angle and telephoto lenses for a 35mm SLR.

the size of the film the camera uses, and is determined by a diagonal measurement of the negative. A 35mm negative measures 43mm from corner to corner, and a 6cm x 6cm negative measures 85mm. So the 50mm lens is normal for 35mm cameras, and the 80mm is normal for most medium-format cameras.

Most of us start out with a 35mm camera and one lens that may be 40mm to 55mm in focal length, depending upon the type of camera. I find that I do little photography with my 50mm lens, and I do more with my 35mm lens than any other. I like the increased depth of field that this lens provides and the slightly wider field of view. My particular 35mm lens (a Nikkor f/2.8) will focus down to about 9 inches, which allows me to get a lot of close-up shots without special close-up attachments.

I'm not alone in using a 35mm lens as my normal lens. Many photojournalists choose it for similar reasons. When you consider that true normal for 35mm format would be a 43mm lens, the 35mm lens is about as close to being normal as a 50mm lens.

Wide-Angle Lenses

Since we usually consider the 50mm lens normal for 35mm photography, anything shorter can be considered a wide-angle lens. We often refer to focal lengths from 35mm to 40mm as slightly wide-angle, focal lengths shorter than 21mm as super-wide-angle, and everything between as wide-angle or medium-wide-angle.

Among the most popular wide-angle lenses for outdoor photography are the 35mm and 28mm, with 24mm and 21mm lenses following closely. Unless you do a lot of photography in tight confines or have a big bank account, I don't recommend super-wide-angle lenses. Most of them are heavy, bulky, expensive, and of very limited value.

As for the fisheye lenses that can give us as much as a 180° field of view, most outdoor photographers will find them worthless. The first fisheye shot ever taken was startling enough to be interesting, but fisheye shots possess an overwhelming similarity to one another, and seem hackneyed to me.

If you are going to use a 50mm lens as the normal lens on your 35mm SLR, and you only want to carry one wide-angle lens, my recommendation is the 28mm, an excellent lens for shooting in the cramped quarters of a boat or inside a tent. It is good for camp scenes and a variety of landscapes and waterscapes. It is also dandy for close-in action shots.

Since wide-angle lenses exhibit greater depth of field than longer lenses, many photographers consider them easier to focus. Acceptable focus is easier to attain: in the average scene shot with a wide-angle lens just about everything will be in acceptable focus. But wide-angle lenses are more difficult to *critically focus* than longer lenses are; often, wide-angle shots that exhibit good depth of field and overall acceptable focus will, on close examination, show no area that is totally sharp. It is easy to get into the bad habit of relying on the wide-angle lens's depth of field to compensate for sloppy focusing, and this is a habit that must be broken. So don't be fooled by the wide-angle lens. As with any other lens, we must take pains in focusing to assure that we get the sharpest possible pictures.

Telephoto Lenses

If bird or animal photography is important to you, a good telephoto lens is essential. Telephotos up to about 200mm (and even longer) can be used for candid outdoor portraits and stunning landscape photography. Additionally, macro telephotos are useful for maintaining a safe distance when photographing some subjects close-up (rattlesnakes come immediately to mind!).

If you are accustomed to watching wildlife with binoculars or spotting scopes rated according to magnification powers, you can translate the focal lengths of photographic lenses into magnification powers. If you consider the 50mm lens to be normal for 35mm photography, you call it a 1X lens. To determine the magnification power of a longer lens, divide 50 into the focal length: a 200mm lens is 4X; a 400mm lens, 8X; a 1000mm lens, 20X.

The most popular focal length for general wildlife photography is probably the 400mm. One reason is that you can get a good

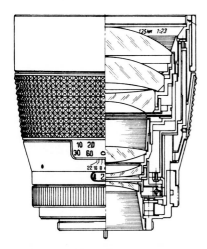

135mm f2.3 Automatic Telephoto lens

This cutaway view of a Vivitar Series 1 135mm telephoto shows the complex mechanical and optical design of a modern, automatic lens for 35mm photography.

400mm without taking out a second mortgage on the house. But a more important reason is that a 400mm lens is about the longest lens that can be hand-held with consistently good results. Anything longer will require a tripod for sharp pictures, and for most wildlife photography a tripod is a nuisance—sometimes necessary, but always a nuisance.

If you insist on owning one of the best 400mm lenses, count on spending $500 to $1000 or more. If your budget doesn't allow for such an expenditure, I suggest you examine the excellent lenses offered by Soligor, Tamron, and Vivitar, to name but three accessory lens manufacturers. Photographs taken with these lenses may not hold up in a critical comparison with those produced by the best lenses available, but chances are you will find them acceptable. And an acceptable photograph is better than no photo at all.

Even if you plan to eventually own a more expensive lens, it's a good idea to start out with a cheaper lens in order to gain experience with the longer focal length. You may find that what you need for your kind of photography is something longer or shorter. And it's best to learn such a lesson with a minimum cash outlay.

I have been working with a Vivitar 400mm f/5.6 MC lens, and I was pleasantly surprised with the results I got when I field-tested it. My first experience with Vivitar lenses was in the early 1970s when Vivitar quality was fair at best. Shortly after, Vivitar introduced the Series 1 family of lenses, and the name Vivitar came to be uttered with greater reverence by photographic writers. The Series 1 lenses have been recognized as some of the finest photographic optics available.

I was pleased to find that the rest of the Vivitar line had improved so much. Today's Vivitar lens is an optically and mechanically sound instrument, and I readily recommend the 400mm f/5.6 MC.

The serious outdoor photographer shopping for a good telephoto lens must not only consider expense and optimum focal length, but must also choose among a variety of brands. There are three types of long lenses available today: fluoride lenses, conventional all-glass refractive lenses, and catadioptric or mirror-reflex lenses.

The fluoride lenses are considered the sharpest because they can correct chromatic aberrations, which cause light of different colors to focus on different planes and can result in unsharp images, color shifts, or color fringing of bright objects. Modern compound lenses are designed to correct aberrations of the primary colors, but fluoride lenses will correct secondary colors too. They are a bit more complex than refractive lenses and are considerably more expensive. Furthermore, fluoride crystals are more fragile than conventional optical glass, so fluoride lenses

will not stand up to the rugged treatment that refractive and mirror lenses will take. Their chief advantage is their ability to provide superior images at wide-open apertures, which makes them ideal for low-light telephotography.

If you pick a conventional refractive telephoto, use fast film with it, not only to allow faster shutter speeds when hand-held, but to use smaller apertures which will correct the image sharpness problem. With a 400mm lens try to shoot with aperture settings of f/8 or smaller when possible. For sharp pictures with a 1000mm lens, f/11 is the widest aperture you should use.

Catadioptric lenses will reduce chromatic aberrations somewhat better than conventional refractive lenses, but this will be only barely detectable in most pictures. The basic advantages are in compact size, light weight, and lower cost.

A significant drawback of catadioptric lenses is the fixed aperture. Light must be controlled with shutter speed adjustment or neutral density filters. Since the objective end of a mirror lens is so large, filters must be placed at the rear of the lens, which is a cumbersome and awkward process.

Zoom and Variable-Focus Lenses

The concept of zoom lenses dates back to the late 19th century, but it wasn't until 1959 that a zoom lens for still photography was introduced. During the following decade, zoom and variable-focus lenses got the reputation of being optically inferior: images produced were poorer than those of fixed-focal-length lenses, especially at close ranges. Zoom-lens photos often exhibited peripheral distortions, hot spots, and ghost images due to excessive flare.

But the idea of one lens that would do the job of several was worth pursuing. Several lens manufacturers persisted and some exceptional lenses began to show up. Many of the inherent problems were corrected, so that by the mid-1970s zoom lenses were viable photographic instruments.

Fixed-focal-length lenses produce sharper images than zoom and variable-focal-length lenses will, but when top-quality lenses are compared the differences are often insignificant.

A true zoom lens is parfocal. Once the subject is brought into focus, it will remain in focus throughout the focal-length range of the lens. A lens which must be refocused as the focal length is changed should be called a variable-focal-length or variable-focus lens. The term "zoom," however, is used rather loosely these days to mean any lens with variable focal length. If the parfocal feature is important to you, make certain that the zoom lens you buy is a true zoom.

The most popular zoom lenses have focal-length ranges of 70mm to 210mm, or thereabouts. One such lens eliminates the

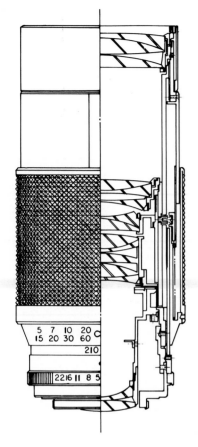

70-210mm f3.5 Automatic Zoom lens with Macro Focusing

The best modern zoom lenses are marvels of computer design and technology. This cutaway view of the Vivitar Series 1 70–210mm Macro-Focusing Zoom shows the arrangement of internal optical elements.

necessity of owning such popular lenses as the 90mm, 105mm, 135mm, and 200mm. With one lens you can handily do the job of four or more.

Another popular lens is the wide-angle-to-telephoto zoom with a focal-length range of 35mm to 105mm. Although such a lens is considerably heavier and bulkier than any fixed-focal-length lens in its range, it can replace the popular 35mm, 50mm, 90mm, and 105mm lenses. One lens does the job of four.

Many zoom lenses have a close-focusing capability, which increases the adaptability of an already versatile lens.

I have done much outdoor photography with zoom lenses, and I find them far more convenient than fixed-focal-length lenses. There are times when it is just about impossible to use anything but a zoom—for example, when photographing subjects that are constantly moving or when shooting fast action.

My personal favorite is the Vivitar Series 1 70mm–210mm Macro-Focusing Zoom, with which I can handle shooting situations from full-frame close-ups to telephoto shots of birds and animals. When shooting landscapes, outdoor portraits, action shots, or whatever, I can zoom to the focal length I want for ideal cropping. With this lens and one or two wide-angle lenses, I can traipse off into the boondocks and be prepared for most of the subjects I will encounter.

Despite improvements in zoom-lens design and flare-reducing lens coatings, flare is still more of a problem with a zoom lens than with conventional lenses, because of the increased number of elements in the zoom lens. Always use a lens shade when shooting with a zoom, and be especially careful when photographing backlighted subjects.

Teleconverters

If a zoom lens that can replace four or more fixed-focal-length lenses is nifty, then how about an optical device, smaller than a normal lens, that can double or even triple the power of a lens? In concept, it is a boon. But in practice there are pros and cons.

I have used several teleconverters, and until recently my comments were negative. These blasted gizmos rarely produced photographs worth keeping. I was using the simple, two-element teleconverters that other photographers had complained about. Of course, I had to find out for myself.

But it's only a matter of time before some manufacturer will come up with an improvement. In 1976 I read about the introduction of the seven-element Komura teleconverter; and not long after, I heard about Nikon's plans to introduce two new teleconverters of superior design.

Herbert Keppler, editorial director and publisher of *Modern Photography*, has kept his readers posted on teleconverter devel-

The Nikon TC-200—smaller than the average 50mm lens—is one of the new breed of teleconverters. It is an optically superior instrument capable of turning a 200mm lens into a 400mm lens.

opments in his column, "Keppler's SLR Notebook." His column in the February 1978 issue convinced me to give teleconverters another try.

The new breed of teleconverter is more expensive ($200 list price on the Nikon TC-200), but if a unit can turn a 200mm lens into a 400mm lens with a minimal decrease in image quality, it is worth the price.

On Keppler's recommendation I checked around and found a Nikon teleconverter at Norman Camera and ordered it. I'll tell you now that I don't plan to be without this item on any outing. A 400mm Nikkor lens would, in a very critical analysis, provide sharper photographs than my 200mm Nikkor with the 2X converter, but for my purposes, the results I'm getting are excellent.

There is a light loss with any teleconverter (two stops with a 2X converter), but there is another advantage of such units, other than the obvious reduction of bulk and weight. Adding a teleconverter to a lens does not change the lens's minimum focusing distance. So instead of being restricted to photographing subjects that are at least 18 feet away, as I would be with most 400mm lenses, I can focus on subjects a mere 6 feet away—a decided advantage in photographing small animals, birds, and waterfowl, and getting in close to large animals for head shots.

The Nikon TC-200 Teleconverter is designed for use with Nikkor AI (auto-indexing) lenses of 200mm or less in focal length. The model TC-300 is for lenses of 300mm and longer. Nikon originally announced the availability of two other teleconverters—the model TC-1 and model TC-2—designed for use with the older non-AI Nikkor lenses, but very few of these units were manufactured. So if you want to use a new Nikon teleconverter, you will have to use it with auto-indexing lenses, or you will have to have

your older non-AI lenses factory-converted to AI configuration. Write Nikon for information about factory conversion.

Now that the teleconverter barrier has been broken by Komura, Nikon, and Vivitar, other top-quality units are sure to follow. Avoid the cheaper, primitive teleconverters, but investigate the advantages of the high-quality teleconverters. I think they're well worth the money.

EQUIPMENT CARRIERS

3

It seems to me—and to others, from the comments I have heard and read—that with all the extraordinary tools, accessories, and attachments that have been made available to us in recent years, someone could design an adequate means of carrying them. I have owned a baker's dozen of equipment carriers, and I have found no one design that is universally useful, and have resigned myself to the fact that the average all-around outdoor photographer needs more than one type of equipment tote.

For working out of a vehicle where bulk and weight pose no problems, or in any other situation for which the photographer wants to be totally prepared, the largest equipment carrier is necessary to safely store a maximum amount of gear. Commercial travel often requires the photographer to take special measures in packing equipment. Day hiking and backpacking impose weight and volume restrictions on how much the photographer can carry afield. And fishing, boating, and canoeing call for maximum protection from potential water damage, shock, and excessive heat from sunlight.

Gadget Bags
The traditional gadget bags are probably the least useful for outdoor photographers. Most gadget bags, however they are designed, share a basic inefficiency. With the possible exception of the smallest models—those that can only accommodate a camera, an extra lens or two, and a few rolls of film—gadget bags breed clutter and disorganization. Their bulky dimensions make them poor choices for commercial travel, and they are not comfortable or practical for field use. They afford relatively little protection against the elements and are only minimally shockproof.

I have made these discoveries the hard and expensive way, so learn from my mistakes. Of the four bags I own, one has been turned into a fishing pouch, another has had all its partitions removed to create a large, single-compartment bag that I use for carrying extra film and equipment on extended trips; and the other two—the most expensive—are up for sale.

Custom-Fitted Hard Cases

Fitted hard cases are far better for the general outdoor photographer; the best are made by the Zero Halliburton Division of Berkey Marketing Companies.

Lightweight Halliburton cases are made of prestressed aluminum alloy and feature interlocking tongue-and-groove closures with gasket seals to keep out dust and moisture. The insides of these luggage-type cases are lined with a reliably dense, durable polyester foam.

Halliburton cases come in eight sizes to fit the requirements of most photographers, and a case can be customized to safely store equipment while keeping it readily accessible.

Inside the lower shell of the Halliburton case are two layers of foam. The upper layer can be cut to snugly and precisely fit the equipment you intend to carry. The cases come with complete directions, a template, and a cutting knife. Extra foam inserts are available so that you can use the same case for different gear arrangements. The foam in the top of each case is convoluted and on closure conforms to the contours of the equipment.

The Norman Camera Company carries the complete line of Halliburton cases and the System IV VersAdjustable cases, which are luggage-type cases with convoluted foam lid liners, with the storage areas featuring adjustable interior compartments and padded velveteen lining. Two sizes are available: Model C-2 (18″ x 13″ x 5 1/4″) and Model C-3 (18″ x 13″ x 7″).

Other luggage-type cases, made of aluminum or molded high-impact plastic, are available. Prices vary considerably, depending on quality and features offered, but with a bit of shopping you can find one that fits your needs and your budget.

To determine what size case you need, lay out all the equipment you plan to carry, arranging it efficiently and allowing at least 1 inch separation between major items such as camera bodies, lenses, and strobe. Measure the layout to determine the length and width you require. Measure the height of the tallest item (usually a camera) and add 2 inches to allow for the top and bottom layers of foam. This will give you the required height.

The advantages of the fitted hard cases include that when opened they display everything inside and that they keep each item isolated and in its proper place. They are ideal for working out of a vehicle and for commercial travel.

Another fitted hard case, smaller and of a different design, is the Vivitar Enduro case, which I have found useful for a variety of situations. It is just large enough to carry one 35mm SLR and two auxiliary lenses in the lower padded, partitioned portion. The foam-lined lid has spaces for four rolls of 35mm film in their plastic canisters.

This contoured case rides naturally at the waist. One strap is

SPECIFICATIONS FOR HALLIBURTON CASES:

CAT. NO.	FINISH	LENGTH*	WIDTH*	HEIGHT*	HEIGHT* UPPER SHELL	HEIGHT* LOWER SHELL	NET WT. POUNDS
☆ 121-100 121-200	Silver Black	12	9	5	2	3	4
121-101 121-201	Silver Black	16	9	7 3/4	2 1/2	5 1/4	6
☆ 121-102 121-202	Silver Black	18	13	4 1/2	2	2 1/2	6
☆ 121-103 121-203	Silver Black	18	13	6	2 1/2	3 1/2	6 1/2
☆ 121-105 121-205	Silver Black	21	13	6 1/2	2 3/4	3 3/4	7 3/4
121-106 121-206	Silver Black	21	17	7 1/2	3	4 1/2	11 1/2
121-110 121-210	Silver Black	26	18	9	4 1/4	4 3/4	15 1/2
121-111 121-211	Silver Black	24	18	7	3	4	12

* All dimensions are in inches. Length and width are outside dimensions.

☆ Fits under most airplane seats.

placed diagonally across the back and chest and another around the waist. The strap arrangement not only keeps the case comfortably in place, but eliminates the strain associated with conventional shoulder straps. The case can be positioned to ride at the side or can be pushed around to the back.

The Enduro case is ideal for the one-camera photographer. I have found that with two cameras (with lenses attached) draped around my neck and another inside the case, I can go afield with three camera bodies and five lenses. With filters, film, and accessories stuffed in jacket pockets, I'm ready for action.

The hard shell and foam lining of the Enduro case make it shockproof, and the efficient rain lip provides adequate rain protection. It is an excellent case for the fishing photographer.

To determine which Halliburton case best suits your needs, lay out all the gear you will be carrying in it and measure according to instructions in the text. Use the chart to find the case that will hold your equipment.

Photographer's Vest
Speaking of fishing, outdoor photographers have been using

Equipment Carriers

The Vivitar Enduro case allows for comfort and security of equipment.

fishing vests as equipment totes for years. The problem with vests designed for fishing is that the pockets are usually too small to accommodate cameras and large lenses. But the folks at Ultimate Experience have redesigned the fishing vest and have come up with something for the photographer. It features four pleated front pockets that are large enough for cameras, lenses, and major accessories. Elastic loops keep film in place, and a large rear pocket provides extra space for film, filters, rain suit, lunch, or what-have-you.

Cases for Hiking, Backpacking, Fishing, and Hunting

Ultimate Experience has also designed Shutterpack cases for the hiking and backpacking photographer, and manufactures Pic Pouches, which are padded lens cases that attach to the belt,

SPECIFICATIONS FOR SHUTTERPACK CASES AND PIC POUCHES:

	MATERIALS	POCKETS	TRIPOD. ATTCH.	FRAME	COLOR	DESIGNED FOR	PACK WEIGHT MEAS.	WEIGHT CAPACITY	COMMENTS AND FEATURES
WINDAGO	Water resistant 7.5 oz nylon pack cloth 1.9 ripstop ½ inch foam padding #5 zipper Cordlace and spring lock Padded shoulder straps	3 section filter pocket Exposed film pocket Unexposed film pocket 2 section miscellaneous 8½ x 11 notebook pocket Notepad pocket	Yes	Interior A shaped aluminum frame	Beige Royal blue	All 35mm 2¼ systems and most 4 x 5 units	28 oz 13 x 18 x 6	30 lbs	Locking waistbelt Double slide zipper Space for personal attire Padded dividers Access when tripod in place
ALBATROSS	Water resistant 7.5 oz. nylon pack cloth 1.9 ripstop ½ inch foam padding #5 zipper Padded shoulder straps 1 inch nylon webbing	3 section filter pocket 2 section film pocket Notepad pocket	Yes	Interior A shaped aluminum frame	Beige	All 35mm 2¼ systems and most 4 x 5 units	24 oz 13 x 18 x 6	30 lbs	Locking waistbelt Padded dividers Access when tripod intact Double slide zippers Space for personal items
SUNDAWN	Water resistant 7.5 oz. nylon pack cloth 1.9 ripstop ½ inch foam padding #5 zipper Padded shoulder straps 1 inch nylon webbing	Notepad pocket	None	None	Beige Royal blue	All 35mm 2¼ systems	14 oz 13 x 15 x 6	23 lbs	Locking waistbelt Adjustable shoulder straps Double slide zippers Padded dividers
SNOWBREEZE	Water resistant 7.5 oz. nylon pack cloth 1.9 oz. ripstop ½ inch foam padding 2 inch nylon webbing	None	None	None	Beige Royal blue	All 35mm systems	8 oz 5 x 15 x 6	15 lbs	Shaped to waist Padded dividers Double slide zippers Locking waistbelt
PIC POUCHES	Water resistant 7.5 oz. nylon pack cloth 1.9 oz. ripstop ½ inch foam padding Cordlace with spring lock Leather belt patch Zippered sides	None	None	None	Beige Royal blue	Lenses	2 oz- 6 oz 4" 6" 8½" 12½" 16"	one lens	Extra flap for weather protection Locking drawstring
PHOTOPACK INSERT	Water resistant 7.5 oz. nylon pack cloth 1.9 ripstop ½ inch foam padding 1 inch nylon webbing	None	None	None	Beige	All 35mm systems	6 oz 6 x 6 x 12		Fits in any size backpack, has handle for easy carrying and D-rings for shoulder strap.

WINDAGO

6" 7" 2" 6" 2" 2"
Depth 7" lower section

ALBATROSS

6" 7" 2" 6" 2" 2"
Depth 7" lower section

SUNDAWN

6" 7" 2" 6" 2" 2"
Depth 7" lower section

SNOWBREEZE

3" 5½" 5½" 2¾" 5½" 2¾"
Depth 5¾" down view

9½" 3½" 3" 6" 3"
Depth 11" top section

4" 5" 4" 6"
Depth 11" top section

3" 4" 3" 5½"
Depth 8" top section

PHOTOPACK INSERT

6" 6" 2" 6" 2" 2"
Depth 6" top section

These specifications will help you select the right Shutterpack case.

featuring drawstring closures with locks and made of the same water-resistant materials used in UE's backpacks.

The Shutterpack line has four models. The Snowbreeze fanny pack is ideal for the ski-touring photographer, day hiker, fisherman, or hunter. Although it weighs only 8 ounces, it has a 15-pound capacity and enough room for one camera, two auxiliary lenses, film, and accessories. It features a double-slide zipper with overlapping flap for protection against the elements.

The 14-ounce, 23-pound-capacity Sundawn is a day hiker's pack, padded and divided into compartments to protect and organize a variety of photographic gear. The pack has two sections that will accommodate two cameras, up to four lenses, film, filters, and other accessories. Other features include padded shoulder straps, waist belt, carrying loop, and notebook pocket.

The Albatross and Windago packs are the largest in the line, each with a carrying capacity of 30 pounds, and equipped with an interior aluminum frame for added support. The Albatross has two exterior side pockets for storing exposed and unexposed film, and the Windago has four such pockets for film and extra accessories. Like the other model packs, these are well padded and divided into compartments for carrying all the gear you may need in the field. Both packs have outside leather belt loops for attaching a tripod.

If you already own a good backpack, you can outfit it for photography with a Photopack Insert from Ultimate Experience. Like the Shutterpacks, the insert is padded and divided. It has a double-slide zipper closure and is water-repellent. It was designed to be carried in a backpack, but it has a nylon web carrying handle, as well as D rings to which a shoulder strap can be attached.

Equipment Totes for Water Sports

If you enjoy fishing, boating, or canoeing and like to have your photography equipment along when you go afloat, you have to be concerned about protecting your gear from rain, spray—even a possible dunking—and you need to shield your film and loaded cameras from bright sunlight.

In a reasonably stable boat, cases such as Halliburton cases provide immediate access to equipment while affording maximum protection. The Vivitar Enduro case is fairly watertight, and is suitable for many activities on the water. Or you can use a small ice chest to keep your gear out of the rain or insulated from the sun's heat.

For rough-water trips you will want to provide maximum protection for your equipment; the best carrier I have found for this purpose is the Sports Pouch from Sima Products. This unique case is made of heavy-gauge vinyl with inflatable air chambers that not only cushion and protect equipment but allow the pouch to float with as much as 10 pounds of gear inside.

A mountain parka with plenty of large pockets is excellent for toting a lot of gear afield or afloat.

The cleverly designed closure system provides triple protection. The inside is closed off by an interlocking waterproof seal at the top of a fold-down collar. The waterproof collar is folded over itself for added protection. Finally, the whole works zips shut with a heavy-duty nylon zipper.

The pouch is large enough to carry one camera, one or two extra lenses, several rolls of film, and a few accessories. If you want to have more gear along, use two or three of these pouches. You can also pack them with billfold, binoculars, first-aid kit, and other items that must be kept dry.

Sports Pouches are available in black or high-visibility yellow. I

recommend the yellow, not only because it is easier to locate if washed overboard, but because it will reflect much of the heat that the black pouch will absorb.

Other Means of Toting Gear

Clothing with plenty of pocket space is probably more important to the outdoor photographer than to any other outdoorsman. Since I got into outdoor photography I have made it a point to shop carefully when buying outdoor clothing. I look for jackets and parkas with many, adequate pockets. I like pockets at least large enough to hold a compact camera, a lens, or some other accessory, as well as extra film. For most of my activities I prefer a good windproof, water-repellent mountain parka with two big bellows-type pockets for carrying large items, and smaller pockets for notebooks, lens tissues, and the like.

Most hunting and fishing coats and jackets have enough large pockets and can serve the outdoor photographer well. Another good choice is an army field jacket.

Pocket flaps are a must for keeping expensive accessories from getting lost or damaged. The flaps should have positive fasteners. I prefer Velcro closures on all pocket flaps.

The inventive photographer can find many ways to carry equipment afield and afloat comfortably; a good place to start looking for ideas and materials is a military surplus store, where you will find containers that are usable as they are and others that can be customized to fit your needs.

Metal ammunition cases, for example, are excellent for moistureproof, dustproof storage of film and equipment. They can be foam-lined for added protection and painted white or silver to reflect sun rays.

Heavy-duty canvas musette bags and gas-mask pouches can serve as camera carriers, and the various pouches that attach to a canteen belt are also useful for carrying accessories.

If you want to make foam inserts for your improvised equipment carriers, you will find 1-inch and thicker high-density foam at a local upholstery shop. It can be trimmed to size with scissors and cut for custom fitting with an X-Acto knife (available at hobby or office supply stores).

CAMERA- STABILIZING DEVICES AND TECHNIQUES

There are several factors that affect image sharpness in any picture, including focus, depth of field, type and quality of lens, and filtration. One of the major causes of "fuzziograms" is camera motion. The steadier and more rigidly supported your camera is, the sharper your picture will be. For ideal sharpness every picture should be taken with a camera mounted on a sturdy tripod, but conditions aren't always ideal for the outdoor photographer, and toting a bulky tripod everywhere is impractical. When it is possible and practical, though, you should employ some sort of stabilizing device to steady your camera.

There are some basic camera-stabilizing habits that every photographer should develop to assure minimum camera motion. There are techniques that will help you steady your camera when no tripod or other camera-stabilizing device is available.

How to Hold a Camera

It may seem elementary to instruct you on how to hold a camera, but the simple truth is that few photographers handle their cameras properly for minimum camera motion. The problem is compounded by manufacturers' instruction manuals, books, magazines, and advertisements which show models holding cameras as one might grasp a teacup.

One of the first exercises in any photography course I teach is to have students take pictures of me as I sit on a corner of a desk. I have the students shoot with empty cameras—pictures aren't important for such an uninteresting subject—and while they shoot I am able to observe habits they have developed. I then set out to nurture the good habits and eliminate the bad ones. In the average class, about one in ten students will handle a camera correctly. Others will just snap away without regard to camera stability.

Some photographers will hold a 35mm SLR horizontally by grasping the left and right edges of the camera body with their left and right hands. From this position it is easy to reach the shutter release with the right (on most cameras) forefinger, but to reach the aperture and focusing rings the left hand must be moved, which leaves the camera gripped precariously along one small edge. Even after the left hand has returned to its position, the grip is unstable.

Left: *The correct way to hold a 35mm camera. Keep elbows tucked in close to the body and press the shutter release smoothly and steadily.* Right: *For a vertical shot, turn the camera on end and support the left edge of the camera body in the palm of your hand. You will have to elevate your right elbow for vertical shots, but keep your left elbow tucked into your body.*

The second method—an attempt to remedy the problem of reaching the focusing and aperture controls—is even more unstable. The photographer grips the right edge of the camera as above, and uses his left hand to hold the lens-focusing ring with thumb and forefinger. Then to make aperture adjustments he must temporarily release his left-hand grip. Furthermore, as he focuses with a wrist-pivoting motion, he may move the camera without being aware of it. The weight of the camera and lens is inadequately supported by holding the movable focusing ring; any body movement, repositioning of the camera, even the release of the shutter can cause excessive camera motion as well as movement of the focusing ring.

There is one correct way to hold a 35mm SLR for maximum support and minimum movement. Use the palm of your left hand as a platform for the camera, with your thumb and forefinger extended to the lens to control the focusing and aperture rings. Use the right hand to grip the right side of the camera body so that you can comfortably reach the shutter release with the right forefinger. With the camera supported by the left hand you can move the focusing ring and adjust the aperture settings without affecting the stability of the camera. The method works equally well for vertical pictures.

When using a long telephoto lens, modify the holding method by supporting the rear of the lens in the palm of your left hand, with your left elbow pulled in snugly to your chest.

If you are using a telephoto lens that is so long that you are unable to reach the focusing ring by employing this method, modify it slightly by supporting the lens barrel in the palm of your left hand at a point where you can comfortably reach the focusing ring.

You can further stabilize your camera by tucking your elbows in close to your body. When shooting a vertical picture it will be

Left: *A sitting position is one of the best ways to minimize body movements that can be transmitted to the camera.* (Photo by Pat Oberrecht)
Right: *When you can't get into a firm sitting position, drop down on one knee and support your upper left arm on the other knee.* (Photo by Pat Oberrecht)

necessary to elevate the right elbow slightly, but keep the left one tucked in tightly. When using a long telephoto lens you can increase your support of the lens by turning sideways to your subject and tucking your elbow into the side of your chest as you would to support a rifle for an offhand shot from a standing position.

Shutter release is as important to the photographer as trigger squeeze is to the target shooter. A sudden snap of the shutter will move the camera at the most critical moment. Use an even, steady press of the release button that will keep camera movement under control.

You must be conscious of your breathing too. As you inhale and exhale you move the entire upper torso—chest, shoulders, arms, and head—and this movement is transmitted to the camera. Take a breath before shooting, exhale slightly, hold your breath, and press the shutter release.

Increase the stability of your camera by minimizing body movement. Try to shoot from a sitting, kneeling, or prone position. If you must shoot from a standing position, find firm footing and spread your feet apart 20 to 24 inches, then turn your upper torso slightly to the left to face your subject. To change position, move your feet, not your upper torso.

If there is a stationary object nearby of the right height to support your camera, use it. Tree branches, fences, bridge railings, boulders, even the hood of a vehicle can be used. To keep from marring the finish of your camera or lens, put a rolled-up jacket or shirt between the camera and its resting place. Some photographers carry beanbags for this purpose. If you have no

The hood of a vehicle makes a good camera support. Use a rolled-up jacket or shirt as a resting pad. (Photo by Pat Oberrecht)

When shooting from a still vehicle, support your camera on a window and cushion it with a rolled-up jacket. (Photo by Pat Oberrecht)

padding available, cushion your camera in the palm of your hand and rest the back of your hand on the stationary object.

If you can't find something to rest your camera on, look for an immovable object—a tree trunk, building wall, or side of a cliff—to lean against. If you brace yourself against something solid you will reduce body movement that would otherwise be transmitted to the camera.

The camera's carrying strap will also serve to stabilize the camera. Use it as a shooter would use a sling to support his rifle. With the strap draped over the back of your neck, slip your left arm through it and bring the strap up into your armpit. Now bring your left hand over the strap and place it under the camera as you normally would. Some strap adjustment may be necessary, but with the strap tightly wrapped around your left arm and your camera snug against your face, camera motion will be markedly reduced.

Many photographers—particularly those who travel the back roads—encounter subjects that must be photographed from inside a vehicle. Birds and animals that have been accustomed to traffic will be unalarmed as long as you stay inside your vehicle, but may spook if you try to get out for a better shot. So before attempting to leave your vehicle to improve your vantage, fire off a few frames from inside the vehicle to assure that you will get something on film. But switch off the engine. Today's engines are deceptively quiet and smooth-running, but whether you notice it or not, they cause the vehicle to vibrate.

If you must shoot from a moving vehicle, support your camera as best you can in your hands. Do not rest it against any part of the vehicle, or engine vibrations, and swaying and bouncing of the vehicle will be transmitted to the camera. Your hands act, to some extent, as shock absorbers.

When shooting from a still vehicle, you can support your camera on a window raised or lowered to proper camera height. Cushion your camera or lens to prevent damage.

Tripods and Tripod Accessories

If you don't own a tripod, buy one. If you are just getting into outdoor photography, buy a camera and film first, of course. But don't purchase another accessory or gadget until you get a tripod. It's that important.

Having made that imperative recommendation, I can admit that I hate tripods, and I am constantly searching for new ways to avoid using them. The best tripods are bulky, cumbersome, and too heavy. All must be adjusted, readjusted, and fiddled with for every shot. If there is an afterlife, photographers' hell must be full of tripods.

A tripod is a necessary nuisance, and I never leave mine at home. For a session of animal or bird photography, I usually leave the tripod in my vehicle, because when I'm stalking wildlife I don't want to be clanging around the fields and woods with a noisy and troublesome piece of equipment. For animals and birds, I prefer a hand-held camera and fast film. And, of course, a tripod is useless in a watercraft. Whenever the action is fast, a tripod is a hindrance. In crowded conditions (sporting events, zoos, or at a

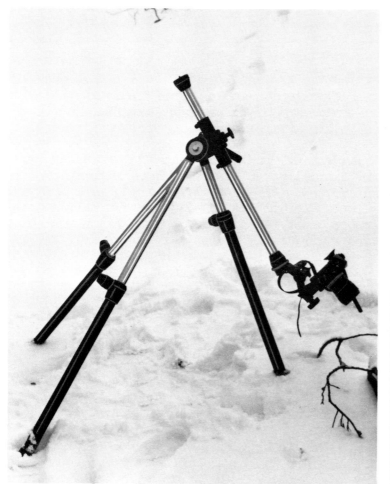

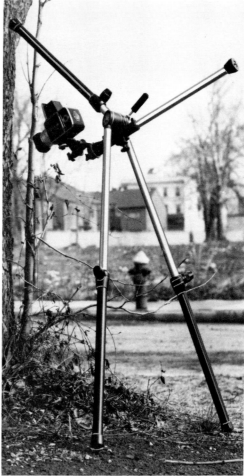

The Master Benbo is a strange-looking British tripod, distributed in the U.S. by Bogen. It is a contortionist of sorts that solves many positioning problems the outdoor photographer is likely to encounter.

similar public gathering) tripods are a hazard to people and equipment.

When I use slow, fine-grain film, however, or when I shoot landscapes or close-ups, or when I work out of a vehicle and don't mind the extra bulk, I use a tripod, because there is no better way to stabilize a camera. Indeed, there are some subjects that cannot be photographed without a tripod or similar stabilizing device. Night photography and effective waterfall photography, for example, call for long exposures that are impossible with a hand-held camera.

My search for the perfect tripod has been as unsuccessful as my search for the perfect equipment carrier. Consequently, I have owned a number of tripods over the years. The sturdy tripods are too big and heavy for lightweight backpacking. And the light, compact tripods that some of us get by with on backpacking trips are too flimsy for general use. You should ideally own two tripods—a heavy-duty, general-purpose model, and a compact lightweight for carrying afield for long distances.

Buy the best tripod you can afford. In a general-purpose tripod look for strength and rigidity. If weight is relatively light, all the

better, but stability is more important. I recommend three-section legs. Although there are some fine tripods available with four- or five-section legs that allow them to be folded to shorter lengths, the extra sections are something else you will have to fool with every time you set up a camera and tripod.

For backpacking, hiking, or other extended trips afield, I prefer a tripod that is smaller and lighter, but such an instrument is always a compromise. It won't be as stable as a larger tripod, and in strong winds may prove useless, but it is better than having no tripod at all, because it makes it possible to get photographs that require a reasonably sturdy stabilizing device.

Several years ago, when I was teaching at the University of Alaska, I was introduced to an excellent line of tripods. *National Geographic* photographer Emory Kristof was on his way back to Washington, D.C., via an over-the-pole flight from Scandinavia and had wired his former photography professor, Jimmy Bedford, of his plans to stop over in Fairbanks. While he was traveling in Scandinavia one of the airlines managed to lose his tripod, so he bought another. Later his original tripod caught up with him and he arrived in Fairbanks toting two. He donated one to the journalism department, which we later dubbed the "Kristopod." All of us in the department came to favor this Slik tripod for its light weight and stability.

The Slik Division of Berkey Marketing Companies distributes ten models and a number of accessories in the U.S. For 35mm photography my vote goes to the Model S103, which features three-section legs and interchangeability of all functional parts. This general-purpose tripod has a maximum height of 63 inches, folds to 25 1/2 inches, and weighs 4.6 pounds.

I have found no better tripod for backpacking than the Slik Model 500G. Remember, you always sacrifice something when you look for light weight and compactness. The maximum operating height is only 45 1/4 inches, but I can live with that, because this rugged miniature folds to less than 16 inches and weighs a mere 1.2 pounds. Its controls are relatively large for such a small tripod, and its center column can be reversed for close-up work.

Among the Slik tripod accessories, the accessory bag attaches to the legs of the tripod and provides a safe place to temporarily stow extra lenses and other accessories while shooting. In windy conditions, several rocks in the accessory bag will add weight and stability to the tripod and reduce camera vibrations.

A platform attaches to the leg of a Slik tripod on which a camera can be mounted for near-ground-level work. The close-up photographer can also use a 2-Axis Macro Adjust, which attaches between camera and tripod for precision focusing and composition of close-up subjects.

There are also two twin-camera platforms, several types of ball

Most long telephoto lenses are equipped with tripod mounting rings. Always attach the lens to the tripod as illustrated; mounting the camera to the tripod, instead, could cause damage to the camera or lens as the weight of the lens applies excessive pressure to the lens mount.

heads, a V-Lens Support (described later), a shoulder strap, and even showshoes which attach to the tripod legs to prevent the tripod from slipping and sinking in snow, mud, sand, or lake and stream beds.

If you don't own a tripod, spend a little time shopping around. Try a number of different makes and models to find the features that best suit your needs. You can write to Slik for a descriptive brochure and the name of your nearest dealer. The Slik line is available by mail from Norman Camera.

Other Camera-Stabilizing Devices

Many other devices are used to stabilize cameras. Some are highly specialized accessories; others are compromises for use when a tripod proves impractical. The devices include unipods, chestpods, rifle stocks, and camera clamps and brackets. You will find some of them at your local photo shops and discount department stores. They are also carried by such mail-order firms as Norman Camera, Spiratone, and Porter's Camera Stores.

A unipod, which is no more than a collapsible staff with a camera platform on top, can be carried and used where a tripod can't. It is lighter, simpler, and has fewer functional parts than a tripod, and is generally less a nuisance, though it is not quite as efficient as a tripod. Use especially for fast-action and wildlife photography. The Slik V-Lens Support attached to a unipod is a sensible and useful combination for telephoto work. Instead of attaching your camera or lens directly to the unipod, which can be restrictive, prop the lens barrel in the V-Lens Support, which features a lubricated base that allows smooth panning. Whenever necessary, you can lift the camera and lens away from the support

Camera-Stabilizing
Devices and Techniques

55

Author uses one of Sam Fadala's Moses sticks to steady his camera and 200mm lens. (Photo by Pat Oberrecht)

to cover fast action or different subjects. The support can also be used with a tripod.

A simple hiking staff can be used much like a unipod; it is less restrictive and is certainly cheaper. My close friend and colleague Sam Fadala has used his famous "Moses stick" in so many outdoor situations and has written of it so often that it has practically become his trademark. He has used it as a rifle rest, handgun rest, climbing aid, binocular support, and camera stabilizer. He even thanks the Moses stick for saving his leathery hide on several occasions when he has had to find his way out of pitch-black canyons after nightfall and used the staff to locate safe footing. And I remember once using the Moses stick to pull him out of an undermined snowbank one subzero morning in interior Alaska.

Sam has developed a number of techniques and positions for

The photographer who takes many pictures from a vehicle would do well to invest in a Bushnell Car Window Mount, shown here supporting a Nikkormat and Vivitar Series 1 600mm solid catadioptric lens.

maximum stabilization with the hiking staff. His own choice for telephoto work is a camera and lens mounted on a rifle stock, and the combination—effective in itself—is used in conjunction with the staff for a remarkable degree of stability.

Some years ago Sam gave me one of his Moses sticks—a staff of lightweight agave wood with a comfortable chamois grip, padded top, and light leather tassels that alert the user to wind direction. I have often used it to steady my camera. It is efficient, easy to use, quick to make ready, and doesn't interfere with picture taking.

For bird and animal photography there is nothing handier than a rifle stock. You can modify an old stock to accommodate a camera, or you can buy one designed for that purpose. A camera so fitted is well stabilized, even for offhand shooting, but it is always best to find something to prop it on. A camera equipped with an electronic exposure system and motor drive or power winder and mounted on a rifle stock is one of the most efficient tools for wildlife photography. The photographer can concentrate on focusing and composing without being bothered with shutter and aperture settings, cocking the shutter, and advancing the film. More and better pictures are the usual result.

For the photographer who takes many pictures from a vehicle, the Bushnell Optical Company manufactures a handy and highly efficient stabilizing device, the Car Window Mount, which clamps securely to a vehicle window and is equipped with a camera platform, similar to those found on tripods, that will tilt, pan, or hold a camera rigidly in place. I keep mine in the glove compartment where it is always ready for action if I encounter a suitable roadside subject.

Whenever you shoot with a tripod-mounted camera, be sure to use a cable release which allows you to keep your hands off the camera during exposure.

Cable Releases, Bulb Releases, and Self-Timers

As soon as you mount a camera on a tripod, attach a cable release to the shutter release button. (If you press the shutter release with your finger you may move the camera.) The cable release enables you to keep the camera still when you snap the shutter.

The bulb release employs air to trip the shutter instead of a cable. A squeeze bulb is attached to a rubber hose that has a threaded fitting with a plunger inside that is screwed into the shutter release button. When the bulb is squeezed, air is forced through the hose to activate the plunger. Few photographers use bulb releases these days, but I wouldn't be without mine.

My bulb release has an extra length of tubing which stretches to 20 feet. I can use it for remote setups, or I can use it to put myself in the picture. Most often I employ the bulb release for photo-

A bulb release with extension hose is handy for remote photography setups.

graphs in which I picture my hands at work on something. Since I don't have a third hand to trip the shutter, I use the bulb release with the bulb on the ground. When I'm ready to trip the shutter, I step on the bulb.

Most modern cameras have built-in self-timers that enable us to cock the shutter, press the button, and wait for the shutter to trip 10 seconds later. Cameras not so equipped can be fitted with auxiliary self-timers, which are found in many photo shops.

Most photographers use a self-timer when they want to get themselves in the picture; but of equal importance, the self-timer can assure minimum camera movement during exposure. Set the self-timer, press the shutter release, and remove your hand from the camera—by the time the shutter trips camera vibrations will have ceased. The technique provides as much stability as a cable or bulb release.

FILM 5

Film is to the outdoor photographer what fishing line is to the angler. The fisherman can own the best graphite rod, the finest precision-made reel, and a vest or tackle box full of essential gear, but it's all useless without line—the right line, balanced with his tackle and matched to the fishing conditions.

Likewise, you can own an elaborate system of camera bodies and lenses, filters, bellows, flash unit, tripod, and half-a-hundred other gadgets, but without the right film for your purposes, a film with which you are totally familiar, you are exercising in the realm of futility.

We're often told (preached at) by seasoned photographers that "film is cheap," which translates to "Relatively speaking, film is the cheapest aspect of photography." Nothing is cheap these days; wasting anything is expensive. I'm sure I'm not the first to tell you—nor will I be the last—that one of the secrets of top-quality outdoor photography is to shoot plenty of film. But you must plan and think as you shoot, and keep track of your results. Otherwise you will just burn up film needlessly.

On a recent trip I used more film than I had planned to, so I stopped by the photographic department of a local discount store. When the clerk asked if he could help me, I said, "Give me six rolls of 35mm Plus-X, four rolls of Kodachrome 64, and four Ektachrome 200—all 36-exposure."

As he was tallying up my bill, he said, "It sure is a pleasure to wait on someone who knows exactly what he needs. You wouldn't believe," he continued, "how few people know what kind of film they should be using."

"I would believe it," I assured him. Only the serious amateur and professional photographers know what kind of film they need, and even among serious and knowledgeable photographers there is disagreement and confusion.

There are certain facts about film that should help you choose. But just as important as the *what* are the *why, when, where,* and *how* of film selection and use.

Beyond the facts of film are the fancies and fantasies. By reporting on the facts I hope to dispel the fantasies—but the fancies are largely matters of personal taste, choice, and the kind of photography one is engaged in.

The value of any film preference is based first on the available facts and then—perhaps paramount in importance, or at least tantamount—practical experience and field testing. When I recommend a particular film, bear in mind that my selection is based upon extensive field testing and evaluation. Certainly you can find photographers who disagree with my recommendations. But my most important recommendation is one that no clear-thinking photographer can dispute: armed with the facts, perform your own field tests; then pick the film that best suits your personal needs.

Exposure Indexes

The crux of film performance is how films are rated according to response to light, and how this rating relates to the critically important shutter/aperture relationship.

In the U.S. we use a standard rating system, established by the American Standards Association,* and referred to as the ASA rating, ASA number, or simply ASA. The exact name of the rating is "the ASA exposure index."

When we use a different ASA rating we should no longer refer to it as ASA, although many photographers and photographic writers do. I will refer to ASA ratings as ASA 64, ASA 125, and so on; for other ratings I will use EI for "Exposure Index": EI 200, EI 800, and so on.

Through this standard rating of light sensitivity every film is logically and usefully related to the others. A film which requires the most light to record an image—which is least sensitive to light—is assigned the lowest ASA rating, while a film with the greatest light sensitivity will have the highest ASA rating.

We generally refer to low-ASA film as slow and high-ASA film as fast. We often speak of the relative speed of a film in terms of its ASA or EI. A film with an ASA rating of 80 or less is considered slow; 100 to 250 is medium; anything from 320 up is fast.

The ratings can be tied to the shutter/aperture relationship and are often expressed in terms of f/stops. The relationship is embodied in a simple geometric progression, so that a film rated at ASA 160 is twice as fast as one rated at ASA 80 and half as fast as one rated at ASA 320. Each rating in the series 25, 50, 100, 200, 400, 800, is twice as high as the preceding one, equivalent to one f/stop.

Ektachrome 400 (ASA 400) is twice as fast as Ektachrome 200 (ASA 200) and requires one f/stop less exposure. Kodachrome 25 (ASA 25) requires three f/stops more exposure than Ektachrome 200 and four f/stops more than Ektachrome 400.

*It has been reorganized and renamed and is now known as American National Standards Institute (ANSI), 1430 Broadway, New York, N.Y. 10018.

The DIN speeds that appear on most film packages and light meters are German ratings: DIN is the abbreviation for Deutsche Industrie Norm. German film speeds are doubled or halved with each interval of 3. For example, Kodachrome 25 is rated at ASA 25 and DIN 15; Ilford Pan F is rated at ASA 50 and DIN 18.

Exposure Latitude

Exposure latitude is the range of exposure change or error that a film will withstand without extensively affecting image quality. It is expressed in f/stops over and under correct exposure.

Modern film is more tolerant of exposure error than its forebears and is said to have wide exposure latitudes, but in good practice the exposure latitude of most film is rather small. A film will often tolerate one or more f/stops overexposure or underexposure, but we should always strive toward correct exposure. A wide exposure latitude may save some shots for you, but don't use it as an excuse to be sloppy.

Black-and-white film has far more exposure latitude than color film, although there are exceptions.

Some photographers relate exposure latitude to film speed, stating, generally and erroneously, that the faster the film the wider the exposure latitude. Such notions are based more on isolated experiences than on tested fact. The old Kodachrome film had virtually no exposure latitude, whereas the old Ektachrome emulsions were very forgiving of exposure error. Since Kodachrome II was slow and High Speed Ektachrome was a medium-speed film, some photographers concluded that slow film has narrow latitudes and faster film has wider latitudes.

But it's not that simple. A film's chemistry can affect its latitude, and so can your interpretation of what is correct and what is acceptable exposure.

After Kodak replaced Kodachrome II and X with Kodachrome 25 and 64, photographic writers cursed some of the "improvements" and praised others, such as the wider exposure latitude. While the newer Kodachrome film does seem slightly more tolerant of exposure inconsistencies, I still consider it narrow latitude for my purposes, and I expose it carefully.

When Ektachrome 64 and 200 replaced the old Ektachrome X and High Speed, some photographic writers moaned about narrower exposure latitudes, but I discern no change; the other improvements in the new Ektachrome were so dramatic that I praised its introduction. Some photographers are just opposed to any change, and they let that attitude affect their opinions of improved products.

The exposure latitude of black-and-white film favors the overexposure side of correct or normal exposure, with medium-speed film (such as Plux-X and Ilford FP4) exhibiting greater latitude

than higher-speed and lower-speed film. The practical latitude of such medium-speed film in good practice is from about one f/stop under to two or three f/stops over correct exposure; but with some subjects in good sunlight the latitude ranges broadly from two f/stops under to seven f/stops over. Under similar conditions with Tri-X or Ilford HP5 (both ASA 400) exposure latitudes can run from two f/stops under to five or six f/stops over. With Panatomic-X (ASA 32), however, I have found that underexposure by more than one f/stop results in negatives that are too thin and lack shadow detail. The latitude of this film, then, is from one f/stop under to four or five f/stops over. But again the exposure latitudes in good practice would be considerably narrower.

Color film generally tolerates more underexposure than overexposure. Many of us prefer to slightly underexpose most of our color transparencies (from one-half to one f/stop) to get better color saturation. Underexposures of more than one f/stop are usually unacceptable, as are overexposures of more than one-half to one f/stop.

I often find overexposures of Ektachrome 200 acceptable, but Kodachrome overexposures rarely appeal to me. The narrower latitude of Kodachrome causes the highlights to wash out in an overexposure. Also, since I prefer transparencies that are slightly underexposed, an exposure that is "correct" according to a light meter usually appears overexposed to me.

Grain

Grain is caused by the silver halide particles in the film's emulsion; the more particles in the emulsion, the more grain in the print or transparency. Since an individual particle is too small to be seen, what we call grain is the clumping and overlapping of particles.

In modern film it's those silver halide particles that are the light-sensitive agents in the emulsion which make the recording of an image possible. The more particles in an emulsion, the faster the film will be. It follows, then, that fast film is grainier than slow film.

But there are exceptions. Processing chemicals are constantly being improved to render finer grain in prints and transparencies. Some fine-grain developers can disperse the grain to minimize clumping and overlapping. The result is finer grain, even in faster film.

Film, too, has been vastly improved, to the extent that with some types (principally Ektachrome) we are able to get fine grain at moderate to fast speeds. In black-and-white photography, our medium-speed and fast film is so good now that most outdoor photographers rarely find a need to use a slow, fine-grain film.

The grain issue seems to bother some photographers need-

lessly. After all, graininess is a relative matter. For example, Tri-X (ASA 400) can be considered a fine-grain film for most purposes. But a close-up comparison of 16″ x 20″ enlargements from Tri-X and from Panatomic-X (ASA 32) indicates that the former has a relatively coarse grain and the latter, relatively fine. Note that such enlargements aren't meant to be hand-held and viewed at arm's length, but from about 8 feet. At such a distance grain does not interfere, just as the brush strokes in an oil painting don't bother us when we view it from a suitable distance.

Considering grain when selecting film, you must determine the kind of photography you will do most and what degree of graininess is acceptable for your purposes. If you do nothing but close-up work or texture studies and your camera is always on a tripod, a slow, fine-grain film may suit your purposes—although in a wind the slow shutter speeds required may not be sufficient to stop the movement of some close-up subjects. If you do nothing but wildlife photography with telephoto lenses, often hand-held and in low-light situations, you will have to use a fast film and learn to live with coarser grain.

Few of us specialize that much. We shoot a variety of outdoor subjects under constantly changing conditions. The sensible thing to do is to settle on a film that will provide adequate results under most conditions. When we're dealing with extremes we can always switch to an appropriate film.

The Best Film

I own a fair share of American-made gear, but I also use some foreign-made equipment: Nikon cameras and lenses, Olympus cameras, and a host of other Japanese and German items. So it's not out of chauvinism that I stick with Kodak film—with few exceptions—and heartily recommend its use to other American photographers.

If you live in Maine, I doubt that you buy African or Australian lobster. It wouldn't make good sense for Floridians to buy California oranges or for Ohioans to buy corn from Iowa. Where freshness is important, the wise person buys locally produced goods. And since it is important that your film be fresh, it's best to stick with locally produced film. In the U.S. that means Kodak for most of us.

Even in America we have no way of knowing how Kodak film has been stored and cared for from factory to dealer, but the chances of film being damaged in transit are greater if it is being shipped from Europe or Japan. En route it may be subjected to excessive heat or moisture, both of which can have disastrous effects on film.

The first-time film purchaser is faced with a vast, confusing array of film. I will pass on the best advice given to me: pick one

The variety of film available today can be mind-boggling.

film to do a particular job and learn all its capabilities before branching out to others. Work with one film at a time until you have learned each film well enough to make judgments that will aid you in selecting the best all-purpose film.

When you are working with a film, try it under every conceivable condition, and test its limits. Learn what it will and won't do, then settle on the film that works best for *you*. I admit it is a slow process, but in the end you will be working with a film that you know intimately. You will have learned its idiosyncrasies, attributes, and limitations. Most important, through such knowledge you will gain absolute confidence in the film. And that means one less thing to worry about during that whole complicated creative process.

Black-and-White Film

For starters there are three kinds of Kodak black-and-white film with which you should familiarize yourself: Panatomic-X, Plus-X, and Tri-X. These are panchromatic films, which means they come closest to recording in black and white what we see in color.

Panatomic-X is a slow (ASA 32), thin-emulsion, extremely fine-grain film suited to photography where detail is critically important and light is no problem. In bright sunlight, normal exposure for this film will be 1/30 second at f/16, 1/125 second at f/8, or a similar combination, so it will prove unsuitable for most low-light photography and for most telephoto or close-up work without a tripod.

Plus-X is a medium-speed (ASA 125) film with very fine grain

Opposite: When your purpose is to record critical details, the extremely fine grain of Panatomic-X film will best suit your needs.

Panatomic-X. *Panatomic-X enlargement.*

Plus-X. *Plus-X enlargement.*

and excellent contrast in most outdoor photographs. It's a versatile and durable film that some photographers find the choice as an all-purpose workhorse. Normal exposure in bright sunlight is 1/125 second at f/16, so the film is useful in a fairly broad range of lighting.

Tri-X is a fast (ASA 400) film capable of handling most requirements of outdoor photographers. The grain in this film, which is coarser than the two films mentioned above, can still be considered fine. Tri-X is the best choice for hand-held telephotography, fast action, and low light levels. Because of its adaptability

Tri-X. *Tri-X enlargement.*

and the clean, crisp 8″ x 10″ enlargements it consistently produces, Tri-X is the number one choice of virtually all professional photojournalists.

Since freshness isn't as critical a matter with black-and-white film, which, also, isn't affected as adversely as color is by improper storage and shipping practices, you probably won't run into any difficulties with foreign-made black-and-white film. If you want to try some, I recommend starting with British-made Ilford film, which some photographers prefer to Kodak film. The near equivalents to Panatomic-X, Plus-X, and Tri-X are Ilford Pan F (ASA 50), Ilford FP4 (ASA 125), and Ilford HP5 (ASA 400), respectively.

Color Film

The proliferation of color film, with new brands being introduced and old ones being improved, upgraded, or replaced, is enough to confuse the most knowledgeable photographer, but I'm going to make the selection process easier by drastically narrowing the choice. I'm probably asking for trouble from some photographers, but I think I can rely on practical field experience to put up a good argument.

I have already recommended that you stick with American-made film—particularly color film. Now I'm going to tell you to forget about color negative film and use only the color transparency (slide) type.

If you are accustomed to color negative film, it may be difficult for you to accept the recommendation. If you have your own darkroom and enjoy doing your own color developing and printing from negatives, you may want to stay with color negative film.

But color transparencies have a broader tonal range than color negatives do, and they won't give you as many problems with

harsh shadows in bright, contrasty light. Slides cost less to have processed than color negatives and prints. With slides you have images you can project as well as material from which prints can be made—either directly from the slide or via a color internegative. And that is the best of both worlds. Moreover, you won't waste money having prints made from bad negatives. Rather, you can pick the best of your transparencies for making enlargements. If you want to sell color photographs to outdoor magazine or book publishers or photo agencies you'll have to use transparency film, because that's what publishers prefer to work with.

Selecting Kodak color transparency film narrows your choice to Kodachrome and Ektachrome film. For the outdoor photographer that means Kodachrome 25, Kodachrome 64, Ektachrome 64, Ektachrome 200, and Ektachrome 400, with ASA ratings of 25, 64, and so on.

When I was doing a lot of experimenting with medium- and large-format cameras and film as well as with 35mm gear, I asked *National Geographic* photographer Emory Kristof why the magazine that publishes some of the best photographs in the world works predominantly with 35mm. He told me the usual advantages of weight and portability were important, but "the main reason," he said, "is Kodachrome. It's the best film ever made."

No color film renders colors exactly as we see them, but Kodachrome offers the truest colors of any film. With its warm tones, yellows and reds are particularly vivid. Grain is extremely fine in Kodachrome 25 and 64, and I find so little difference discernible between them that I rarely use the slower film. I like the added speed of Kodachrome 64, which I can use for much of my work without a tripod. Only when I am doing critical, fine-detail work with a tripod will I opt for Kodachrome 25.

I have been a Kodachrome fan for years, and that's the color film I use whenever possible. But I find only minimal differences between Kodachrome 64 and the old Kodachrome X. The newer Ektachrome films, first introduced by Kodak in 1977 and 1978, are dramatically improved over their predecessors. Even the untrained eye can discern the finer grain, improved contrast, warmer tones, and truer color rendition. Ektachrome still must be considered a cool-tone film, and the differences in color rendition are readily apparent when Ektachrome transparencies are compared with identical Kodachrome slides. In some lighting situations the overall bluishness, exemplary of cool-tone films, will be evident.

For many veteran outdoor photographers and editors of outdoor magazines the name Ektachrome is unfairly associated with older film's low contrast, coarse grain, and overall bluish cast, especially under adverse lighting. But the drastic problems were

brought on—or at least helped along—by the photographer. Although the new Ektachromes have a reputation to overcome, the photographer who is willing to test them objectively will more than likely find them perfectly suited to much of his outdoor photography—certainly his telephoto and low-light works.

I'll admit that a bad Ektachrome transparency is a sight to bemoan, but so is any poorly executed photograph. Some of my best color transparencies—especially those of wildlife—were made possible by Ektachrome: I was shooting with a hand-held telephoto lens and needed the extra speed that Ektachrome allowed me.

However, Ektachrome 64 is a slow, very-fine-grain film that is virtually useless for *my* purposes. Kodachrome 64, rated at the same ASA, exhibits even finer grain and better color rendition, and that's the film I use when I can get by with slow speed.

Ektachrome 64 fits the needs of some outdoor photographers. First, Kodachrome is available only in 35mm, so if you use a larger format you will probably want to use Ektachrome 64 when you need a fine-grain film. Developing of Kodachrome is complicated and must be performed by a commercial laboratory. Developing Ektachrome is relatively simple: Ektachrome E-6 chemicals are available at most photo shops. So if you want to develop your own transparencies, Ektachrome is the film to use.

Ektachrome 200 is a fine-grain, medium-speed film that I find perfect for most of my telephoto work and low-light photography. It is rated at ASA 200 but can be pushed to EI 400, and in a pinch even to EI 800, which allows me great versatility.

The photographer who specializes in wildlife or fast-action photography should probably use Ektachrome 400. The 400 rating is adequate for most such work, and when extra speed is needed, the film can be pushed to EI 800. If lighting is really bad, you can even push to EI 1200 or EI 1600, but expect coarse grain, reduced resolution, and possibly additional problems with excessive contrast.

Pushing Film

When a film is rated at an exposure index higher than its assigned ASA, we call this pushing or boosting the film. The increased speed is attained by overdeveloping or by using a high-speed developer formulated for the purpose.

If you process your own black-and-white film, check the directions for the developer you use to determine how far you can push the film and how much additional development time is needed. Or you can experiment with available high-speed developers to find the film/developer combination that best suits you.

If a commercial lab processes your film, you can still push it,

but be sure to check with the lab folks to determine what exposure indexes you can work with. If your lab won't push-process your film, find another lab that will or ask your local photo shop dealer to put you on to someone who will do the work.

You can't push Kodachrome, but Ektachrome can be boosted with overdevelopment. If you develop your own, follow the directions that come with E-6 developing chemicals. If you use the Kodak PK-20 and PK-36 prepaid processing mailers and you want to push Ektachrome film, buy a Kodak ESP-1 Special Processing Envelope to include with your film *and* the prepaid mailer when you send the film to Kodak. With the ESP-1 envelope and prepaid mailer Kodak will process Ektachrome 200 for EI 400 and Ektachrome 400 for EI 800. To boost films beyond these ratings you will have to have them processed by one of the commercial labs that do such work. I use Meisel Photochrome for such work and recommend that you write them for their latest catalog and price list. (See Directory at the back of the book.)

Pushing film can mean the difference between getting an acceptable photograph and no picture—but use some discretion. If pushing is accomplished by overdevelopment there will be some loss of image quality—usually increased contrast and loss of detail in shadow areas. So it only makes sense to use this technique when you must. It is better to use Ektachrome 400 than to push Ektachrome 200 to EI 400.

With black-and-white film it is much better to use Tri-X than to overdevelop Plus-X to gain more speed. But if you experiment with high-speed, fine-grain developers for black-and-white film, you may find one that will allow you more speed and high-quality negatives. I prefer Acufine, with which I can rate Panatomic-X at EI 80, Plus-X at EI 250, and Tri-X at EI 800.

One note of caution about high-speed developers: manufacturers' recommended exposure indexes are often optimistic. Whether you are developing your own film or having a lab use high-speed developer, shoot a few test rolls and bracket your exposures widely. By taking notes and comparing the various exposures against the manufacturer's recommended exposure index, you can establish an accurate rating for the film/developer combination. For example, if the instructions for a particular developer say to rate Tri-X at EI 1600, but you find your negatives turn out underexposed by one stop at this rating, rate the film for EI 800 instead.

Choosing the Ideal Film

There have been long times when, for learning purposes, I worked only in color or only in black and white.

Because my magazine and book writing and photography are varied, I must be prepared to handle color and black and white

most of the time, but I often wish I could stick to one kind. If I had to shoot only black and white, for example, I could get by with one camera body, a few lenses and accessories, and a supply of Plus-X and Tri-X film. How enjoyable that would be! But since we photographers are seldom satisfied I would probably find ways to complicate even that.

Most of us, within the limitations of our equipment, want to be well prepared for any circumstance in the field or while afloat. We're torn between matching the right film to particular conditions and finding one kind of film to do all the work. Perhaps the sensible solution is a compromise. I have worked out such a compromise, and can at least point you in the right direction and save you some time and possibly some expense. Maybe you can profit from my stumblings in this area.

In my search for the all-purpose film—the ideal, 100%-do-everything film—I, of course, didn't find one. What I did find was a film that would handle about 90% of my needs in black and white and two films to take care of most of my color needs.

With Plus-X, rated at EI 250 and developed in Acufine, I do black and white. This film/developer combination gives me very fine-grain negatives that exhibit excellent detail and contrast. I can do much of my telephoto work with this film, but there are times when I need the extra speed of Tri-X, so I usually carry several rolls of that film. Since I get such good results with Plus-X, I rarely carry Panatomic-X.

My color work is about equally divided between Kodachrome 64 and Ektachrome 200, but I substitute Ektachrome 400 for the latter when I take wildlife pictures with a hand-held telephoto. There are times when I make trips with the primary intention of photographing wildlife. For such excursions I stock up on high-speed film—Tri-X and Ektachrome 400—and carry only a few rolls of slower film for incidental work, such as landscape or camp photography.

Aging and Expiration of Film

The effects of aging are more pronounced in color film, and aging periods are shorter than for black and white. I don't recall ever having a roll of black-and-white film reach its expiration date. I have some Ilford films that I bought recently for field testing—they won't expire for four more years.

As a film ages beyond its expiration date it begins to slow down, that is, it requires more exposure to record an image. You can compensate by increasing your exposures by one-half to one f/stop, and this will work for about a year after expiration. This works fine for black-and-white film, but expired color film does more than slow down: it changes color. Speed, contrast, and color balance are all affected as color film ages.

Not only does no color film render colors precisely as we see them, but color balance shifts throughout the expected life of the film, so that factory-fresh film renders colors differently from film nearing its expiration date. Just as fine wine ages to a point of perfection, after which it begins to deteriorate, color film ages toward an aim point. Before or after the aim point the film will be slightly off-color.

Brand-new color film has a bluish or greenish cast; as it ages it shifts toward yellow or magenta. For most of us these color variations are of little consequence; they are barely perceptible.

Professional Ektachromes are aged at Kodak until they reach their aim point; then they are released to dealers and must be kept refrigerated until use and processed promptly after it has been exposed.

Since the outdoor photographer would find it a bit unhandy to keep his film refrigerated, most of us use an "amateur" film, whether we make a living at photography or not. Amateur film is put on sale before the aim point and is allowed to age on the shelf. It should be stored at room temperature, say between 70° and 75°F.

If you have a lot of film that is within a couple of months of its expiration date, it's a good idea to refrigerate it until you can use it. Then have it promptly processed to guard against deterioration of the latent image.

Caring for Film in the Field

Before and after using 35mm film, keep it in the plastic film canister it comes packaged in. The container affords maximum protection against dust and moisture. Keep roll film in the foil/plastic wrapper until you need it. After exposure, seal it in a small plastic sandwich bag to keep it protected from the elements.

Always load or unload a camera in the shade to shield your film from intense, direct sunlight. If you are in an open area with no nearby shade, turn away from the sun and use the shadow cast by your body.

Excessive heat is particularly harmful to film; take measures to guard your film from the intensity of the sun and its heat. Don't keep your film and loaded camera closed up in the trunk or glove compartment of a car during hot weather. While afloat, protect film and cameras from the blazing sun. A cooler or ice chest is handy, but be sure to keep the ice sealed in plastic bags and do likewise with your film to protect it from the high relative humidity inside the cooler. An ice chest is a good place to keep film and loaded cameras while driving during hot weather.

Some Money-Saving Tips

You will often find expired film on sale at half-price or less at photo shops and discount department stores, but this is not a smart or safe way to save money on film. There are ways to save money on film, though. Mail-order discount suppliers usually buy in large quantities and can pass savings on to you, so you almost always do better to buy film by mail. If you buy in quantity you can usually reduce the per roll price. I buy most of my film from Norman Camera. Their normal price is a bit below retail, but if I buy 20 rolls or more of one kind, the savings can be 50% or even more.

There have been times, though, when sales at a local discount department store have beat the mail prices. I keep watch for such sales, and when I find them I stock up.

You should be able to talk your local photo shop proprietor into offering a substantial discount on purchases of 20 rolls or more of one kind of film—and other supplies for that matter. If you don't need large quantities of film, get together with a few of your photographer friends and share the costs and savings.

Another good way to save money on film is to buy it in bulk rolls of 50 or 100 feet and load your own cassettes. You will need a bulk film loader and a supply of reusable cassettes, and you can realize savings of 30% or more, depending on how much film you use.

A few words of caution about bulk film loaders. If you live in a dry climate, or it is winter when home and apartment interiors are often very dry, static electricity can give you serious problems in the form of little lightening streaks across your film, so in dry conditions, wind the film very, *very* slowly.

Don't keep reusable cassettes in your pocket unprotected, because they will pick up dirt and grit that can scratch your film. Keep them in plastic film canisters or plastic sandwich bags. Toss them out after they have been used three times: dirt particles may have lodged in the film slits.

LIGHT AND LIGHTING

Light is the primary ingredient of any picture, because without light there could be no photograph. The sun is the principal light source for the outdoor photographer. Even if you shoot night scenes by moonlight, you are using solar light reflected from the lunar body. When you use an electronic flash unit—for fill-in flash, close-ups, or simply to increase the light to a picture-taking level—the artificial light emitted by the unit is in effect canned sunlight, because it matches the color temperature for which your daylight color film is balanced.

Unlike the studio photographer who can increase or decrease the number of floodlights to suit his purposes, can move lights about to highlight his subjects and to control shadows and contrast, or can use reflectors, umbrellas, diffusers, "barn doors," spotlights, and other devices to get the right amount and quality of light, the outdoor photographer must rely on a light source over which he has relatively little control. The outdoor photographer who is aware of the characteristics of sunlight and who knows how and when to exploit the varying qualities of natural light can at least control his photography.

The typical beginner is concerned only about the amount of light. If his light meter indicates a sufficient light level, he is satisfied to shoot away, only to wonder why his pictures don't have the quality of those taken by seasoned photographers.

Light intensity is important, but so are angle of light, light quality, sky conditions, shadows, time of day, time of year, and position of the sun relative to your subject. Being aware of these aspects of outdoor lighting and ability to use them to your advantage are essential to photographic excellence.

Light and lighting are as simple or complex as you care to make them. I prefer to keep matters uncomplicated, so I will leave the troublesome analysis of electromagnetic energy, the application of cumbersome formulas, and the discussion of atoms and molecules to the more scientifically inclined. It is more important for the outdoor photographer to develop a "light sense," an awareness of his light source and what he can do with it to improve his pictures.

Left: *From this camera position, with strong afternoon sun frontlighting the inn, the subject is flattened against the background.* Right: *By moving left of the inn down a boat dock the photographer was able to use sidelighting to add depth to the subject. He utilized the inn's reflection on the water to improve composition.*

Direction and Angle of Light

Frontlighted subjects turn out adequately exposed with the most consistency. Here the sun is behind and above the camera, where it spills great amounts of light over the subject; from an exposure standpoint, it's hard to go wrong with frontlighting. That's one reason why manufacturers of simple, fixed-focus, nonadjustable cameras instruct the user to put the sun over his shoulder for best results, and it's one reason why the world is deluged by mediocre, unimaginative snapshots.

Frontlighting often flattens the subject into a two-dimensional rendering. For some pictures, in which the appearance of depth and dimension can be accomplished by other means or is of little significance, frontlighting is fine. But it is only one of several kinds of lighting at your disposal, and often a frontlighted subject can be improved by sidelighting or backlighting.

The most useful kind of lighting for outdoor photographs is sidelighting, where subjects are illuminated by a sun above and left or right of the axis of the lens at about a 45° angle. This kind of

lighting creates distinct highlights and shadows and adds depth to photographs.

Shadows are lengthened by sidelight, and it is longer shadows that make many pictures possible and elevate them above the status of thoughtless snapshots. Sidelighting is the best kind for most outdoor portraits, landscapes, seascapes, and pictures in general.

For close-in work the photographer can often get his subject sidelighted by placing his camera properly, relative to the sun. For outdoor portraiture he may move the subject instead. In animal and bird photography we usually take what we can get and hope for the best, but the patient and thinking photographer will manage to get good sidelighted shots.

The panoramic view is another matter, since the photographer may have to travel many miles to reposition his camera for better lighting and would get a different picture anyway. Since the subject can't be moved, lighting becomes a matter of time of day, time of year, and latitude.

For distant shots of landscapes, seascapes, and the like, morning and afternoon are generally the best times. In northern latitudes, spring and fall are seasons which offer abundant sidelighting.

In the northern hemisphere the midday summer sun is the least desirable for photography: it produces toplighting, which is seldom effective in any picture. In the winter, however, when the sun is lower in the southern sky, shadows are often long and dramatic. The farther north you are the lower the sun will be, and the longer the shadows. Many subjects will be crosslighted.

Crosslighting can be problematical, but like backlighting it can produce exciting, unusual pictures. Crosslighting is exaggerated sidelighting in which the light approaches a subject from an angle 90° to the lens axis. Subjects are more equally divided between highlight and shadow. Shadows are long, and grow longer yet when the sun is near the horizon in early morning or late afternoon—or in midwinter in the north. Crosslighting is perfect for texture studies of such subjects as sand dunes, driftwood, and tree bark.

Whenever the light approaches the subject at an angle between 90° and 180° to the lens axis, the subject is backlighted. This is the most troublesome kind of lighting to deal with, and will have disastrous effects on pictures taken by photographers who are oblivious to light direction and angle. The unintentionally backlighted picture will be a dismal underexposure, or if sufficiently exposed, will be spattered with distracting little flare spots and ghost images which result from extraneous light entering the lens and reflecting off the multiple elements, bouncing around a bit, and finding its way to the film. Despite some photographers'

attempts to convince us that flare can be used creatively, the spots and images it causes are just distractions, and the lowering of overall contrast—another by-product of flare—is nothing to strive for.

Well, that's the bad news about backlighting. The good news is that when carefully and thoughtfully executed, a backlighted picture can be a striking representation with great impact. Backlighting is equally effective in color and in black and white. It will provide you with the means to take those stunning silhouette shots of a fisherman against a red-orange sunset, a bull moose on a ridgetop against a bright horizon, or patterns of tree branches against a clear sunlit sky. For such shots the sun is near the frame edge of the viewfinder or is even included in the frame, sometimes behind the silhouetted subject. To get a silhouette effect the photographer exposes for the light sky, thus under-exposing the subject and making it a blackened form with no internal detail.

Backlighted plants, birds, and animals can be effectively photographed without a silhouette effect, using a light source farther from the viewfinder's frame edge, but still at an obtuse angle to the lens axis. Proper exposure of the subject will cause the light rimming it to overexpose its outline, creating a kind of halo effect.

If your light meter gives average readings of the entire subject area, you will need to open the lens diaphragm about 1-1/2 f/stops more than indicated to bring out sufficient detail in the subject. It's a good idea to bracket such exposures widely at half-f/stop intervals to create a photograph with sufficient detail and contrast and a narrow halo that will emphasize the subject's outline. Fuzzy plants and antlers in velvet are particularly exciting when backlighted this way.

Direct sunlight need not be your source of backlight. Reflected sunlight—off water, sand, snow, or another bright surface—will often do a splendid job.

When you work with backlighted subjects you must guard against flare. Use a lens shade to minimize the possibility of extraneous light reaching the lens and ruining the picture. Pay attention to your viewfinder and look for flare spots and ghost images. If your camera has an open metering system (automatic diaphragm), stop the lens down with the depth-of-field previewer before snapping the shutter. Flare spots and ghost images that may not appear in the viewfinder when the lens is open usually show up when the lens is stopped down.

If you don't have a lens shade, use your hand to shield the lens from flaring sunlight. If the sun is high but in front of your camera, hold your hand above the top of the lens while pressing the depth-of-field preview button and watching for flare spots and ghost images. Move your hand back and forth until all or most of

the spots and images disappear from the field of view, but be careful not to get your hand into the picture—especially if you are using a wide-angle lens.

If the backlighting is from the side or is reflected from beneath, put your hand at the side or bottom of the lens. If you are dealing with direct and reflected light, use both hands to shade the lens, and make your exposure with the camera's self-timer or a foot-operated bulb release.

Quality of Light

Morning and afternoon hours provide the best light angles for most outdoor photographs, and the quality of light is better then too; that is, pictures taken in morning and afternoon light display the best contrast. Contrast is partly a product of light direction, since for good contrast you must have distinct highlight and shadow areas. But lighting in morning and afternoon is warmer than midday lighting: reds and yellows will be at their most vivid. As the sun moves toward its zenith, the color temperature of sunlight decreases and reds and yellows will not stand out so much, since subjects reflect more blue light then.

In black-and-white photography the panchromatic film we use today is more sensitive to blue light than our eyes are, and if the

Left: Backlighting can provide stunning results, rimming subjects in halos of light, but flare is a constant threat. The lens shade on the 35mm lens was not enough protection against extraneous light for this shot, so the photographer used the bill of a cap to further shield the lens and eliminate flare. Right: Same shot without the cap-bill shade. Exposure was identical, but flare caused spots and ghost images, uneven lighting, and reduction in overall contrast.

sunlight is too bluish, we have problems with washed-out subjects that reflect the blue light.

The reason for the change in light quality from morning to noon and from noon to evening is simple and easy to understand if you consider that the earth is enveloped in a layer of gases, water vapor, smoke, and dust particles: the atmosphere. When the sun is nearest to directly overhead at noon, sunlight passes almost perpendicularly through the atmosphere. The farther the sun is from the noon position, the greater the sunlight's angle of entry into the atmosphere. The light must travel farther through the atmosphere before reaching the earth's surface, and since the atmosphere acts as a filter, the character of the light is altered.

At noon your photographic subjects are bombarded by the blue light that is scattered in the atmosphere then. The farther the sun is from its zenith, the warmer the color will be, ranging from yellow to orange to red-orange.

The sun itself appears to change color from deep red-orange at sunrise to yellow in midmorning to almost white at midday, back to yellow in the midafternoon, and to red-orange again at sunset.

The quality of sunlight is further affected by the condition of the sky. Atmospheric haze, fog, smog, and overcast change the quality and character of sunlight, tending to scatter and diffuse the light rays. In a dense fog, for example, scattered light reaches subjects from all directions rather than from a distinct source, and is said to be nondirectional. Shadows are softened or nonexistent, which causes subjects to go flat.

Another problem associated with overcast is scattering of ultraviolet radiation—which we cannot see, but to which film is sensitive. The only remedy is filtration (chapter 8).

Stormy skies can produce dramatic effects, especially when giant black thunderheads roll across the sky and the sun pokes through intermittently. Right after an afternoon thunderstorm some of the most amazing lighting conditions available to the outdoor photographer will occur. As the western sky begins to break up into silver-rimmed clouds and bright, warm sunlight, the eastern sky is often gray and foreboding. Yellows, reds, and greens look fresh and vivid, and a light-colored object photographed against the dark eastern sky will stand out dramatically.

An awareness of the changing character and quality of sunlight, and an eagerness to take advantage of those changes, can only make a better photographer of you.

Exploiting Light

In outdoor recreation, if we want to succeed we must know about the various aspects of the sport and must work and think to put our knowledge to good use. We may have to make some sacrifices or suffer some discomfort in order to achieve success. This may be true of the photographer too.

We all happen on a suitable subject from time to time that is in perfect lighting, and all we have to do is point the camera in the right direction, pick the correct shutter speed and aperture setting, and shoot. But usually we have to work hard to get good pictures, and must plan for the right kind of lighting. We must know what sort of lighting to expect at different times of day and during the seasons of the year.

Every serious photographer should have his local area mentally mapped out with many vantage points that will allow him to fully exploit the changing nature of sunlight. You should know your area well enough to determine in advance whether the lighting at a given spot will be favorable.

We recently had a stretch of several days of clear blue skies and warm weather in the middle of February. And where I live—the south coast of Oregon—that kind of weather during the rainy season gets everybody outdoors.

My wife and I decided to spend a full day taking pictures, and the first step was to make a list of some of the subjects to photograph. We have a large population of waterfowl that winter in the vicinity, so ducks were at the top of our list. With the weather as beautiful as it was—especially in the midst of what had been a very wet rainy reason—I figured there would be plenty of activity on the bay, so a drive to the boat basin would be in order. I also wanted to get pictures of the bridge over Coos Bay, and I thought we might head out the coast to Simpson's Reef to look for seals and sea lions.

I knew of a flock of widgeon that were wintering on a pond in a nearby city park, but during late winter the lighting for photographs from the south shore of the pond would be best in mid-morning. So that went on our list for 10:00 a.m.

The bay, I knew, was full of diver ducks—mostly bluebill and canvasback—and the best spot for photographing them would be a refuge on the south shore of the bay. I decided on midafternoon lighting. From that same spot there is a clear view of the bay bridge, so those subjects were next on our list, and we would try them about 2:00 p.m., after a leisurely lunch in the open air and sunshine.

Then we would head out to the boat basin and on to the coast and Simpson's Reef.

The morning light at the city park was perfect, and we got some excellent shots of widgeon, mallard, coot, and black brant. The afternoon light was adequate for photographing diver ducks on the bay, but they didn't want to cooperate. The huge rafts bobbed in the slight chop well beyond the range of my largest lens, a 600mm. Although the bay bridge stood in the path of the afternoon sun, the lighting seemed too flat to me. So we passed on that too and headed for the boat basin.

As we drove along the bay we found the water full of sailboats

and I knew that from the Coast Guard observation station, high above the south jetty of the Coos Bay bar, the sun would be in the right position for photographing the boats. I burned two rolls of film there before leaving for Simpson's Reef.

At the reef we found a few sea lions and about a dozen seals, but they were far out on the reef and out of range of my lens. But the raging surf pounding against the reef and shooting vertical walls of white water into the deep blue sky was a subject worth photographing, so we spent some time experimenting with the awesome seascape.

On the way home we stopped by the boat basin, where we photographed some of the pleasure boats as well as commercial trollers and activity along the docks. Then we went back to the refuge to see how the bay bridge looked in the late afternoon sun.

The bridge looked no better than before, and I concluded that if I wanted to photograph it from this spot I would have to wait until later in the year when the setting sun would light it more directly. I made a note of my discovery for later reference.

All in all, we had a full, successful day of photography. Not all our plans worked out, but half of them did, and we were able to draw some conclusions about the best kind of lighting for the bay bridge. And as we always do, we picked up some photos that weren't previously planned.

Remember, you must be aware of your light source and must use it wisely to get good results. A haphazard, unthinking approach might have had me on the bay in the morning when, from the Coast Guard lookout, I would have been shooting into the sun. Or I could have been at the park in the afternoon when the high hills, trees, and houses west of the pond would have obscured the sun.

You will never be able to fully exploit the sun or completely plan all the pictures you will take. How boring and unchallenging that would be. But you can predict what your lighting conditions will be if you take the time to think about them, and that will put you well on your way to becoming a competent outdoor photographer.

Measuring Light

Contrary to what some photographers think, a meter reading is the last step that should be taken before setting the shutter and diaphragm and exposing the film. Unlike our friend the inexperienced beginner, who is first, last, and only concerned with light intensity, and consequently will often use a light-meter reading as the primary determinant of photographic feasibility, by the time the seasoned photographer is ready to measure the light he has already done the planning and thinking required for the photo. He has analyzed the direction and quality of the light. He has seen to the details of composition and has considered the

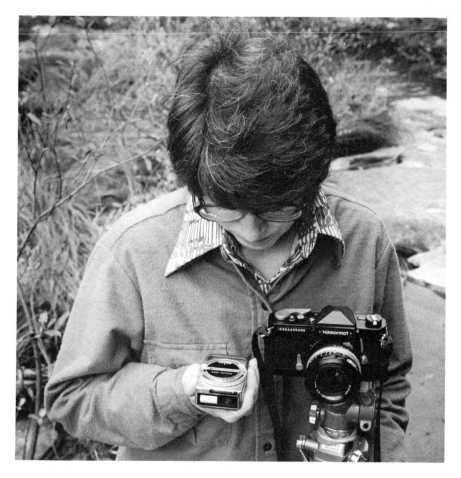

To take a reflected-light reading with a hand-held meter, point the meter toward your subject from the camera position.

creative aspects of the image he is about to record. He has chosen the camera, lens, and film and has determined what filtration is necessary. He has picked a camera position and angle. This process may have taken him an hour or more, or perhaps only a few seconds. He may have hiked five miles into the backcountry or halfway up a mountain to get the shot, or he may have merely walked across a road or stepped into his own backyard. It may be a picture the photographer has been planning for months—waiting for the right time and conditions—or it may be a subject he discovered only moments earlier.

The one important step remaining before making the exposure is to measure the intensity of the light reflected from or falling on his subject. Most photographers rely upon some kind of light meter for this task, whether a self-contained, hand-held unit or one built into the camera.

Hand-Held Meters

There are dozens of makes and models of hand-held light meters, of three types: incident-light meters, reflected-light meters, and spot meters.

Incident-light meters measure the light that falls on the sub-

Left: *When your subjects are unapproachable, you can get an average reflected-light reading by aiming your meter at a gray card that is in the same kind of lighting as the subject.* Right: *In the absence of a gray card you can take a reading off the palm of your hand.*

ject. Reflected-light meters measure the light reflected from the subject. Spot meters also measure reflected light, but in a small area (spot) within the subject frame.

Most exposure meters operate like this: When light strikes the meter cell, an electrical reaction occurs that moves the meter's needle. The more light, the more current, and the farther the needle will move. The meter, preset according to your film's exposure index, provides you with a relative reading, usually by pointing the needle to a number that can be quickly decoded into aperture and shutter settings.

If you are going to invest in a hand-held meter, purchase one that can take reflected-light and incident readings, using a small white, opaque bubble or light diffuser that slides over the light-admitting opening in front of the meter to take incident readings.

To use such a meter in the reflected-light mode, make sure the light diffuser is not covering the light-admitting opening. Then, from your camera position, point the meter directly at the subject and take a reading. The reading is an average of the subject area.

But all square inches are not equal. If your lighting is contrasty you may have an abundance of bright highlights or deep shadows. Move in close and get one reading from a bright part of your subject and another from a dark part. Then average the two.

There are times you can't get near your subject to take a meter reading (grizzly bears come to mind!). A spot meter would be

When a meter is fooled by strong overhead sunlight, you can shield it with your hand.

good, but you can get an accurate reading with a reflected-light meter. If the subject is sunlit, pick something of a similar color or hue that is near you and similarly lighted and take your reading from it. If the subject is in the shade, find a substitute in the shade near you—if there is no shade near you, position your body to provide a useful shadow.

Since for most exposures you want a good average reading, you can carry a gray card (available at most photo shops) on which you can make meter readings when the subject is unapproachable. The *Kodak Master Darkroom Dataguide* and the *Kodak Color Dataguide* booklets have gray cards in them.

If you don't feel like carrying a gray card, you can take a reading off the palm of your hand. Since skin shades vary, you might check your palm against a gray card once, but most people's palms will reflect about twice as much light as a gray card; this means expose for twice the length of time indicated or open the aperture by one f/stop.

If you are taking a reading under a bright sky, the excessive sky light can fool your meter and cause it to read too high for an average measurement, resulting in underexposure. You should shield the light-admitting opening of the meter by holding your hand above the front of the meter.

To measure incident light with the meter in the incident mode, stand between the subject and camera and point the meter back

toward the camera, making sure that no shadow falls on the meter. This measures the light falling on the subject; this technique is accurate for average subjects. If your point of interest is in a shaded area, move to that point and aim the meter back toward the camera to get a good reading.

Reflected-light readings are preferred for most outdoor photography, as they are accurate and convenient. But incident readings are usually more accurate for seascapes and marine photography, where bright light reflected from the water can fool a reflected-light meter. Similarly, incident reading is preferred on sunny days in desert and beach areas and for most snow scenes.

Spot meters are useful for precise measurements in some unusual situations, but are of limited value to the outdoor photographer. Besides this, my objection to spot meters is that they are too large, too heavy, and too costly. I admit I'm sometimes faced with critical lighting conditions in which a spot meter would be useful, but I can get the picture I want without one, through thoughtful analysis of lighting, careful use of a reflected/incident meter, and bracketing of exposures.

If your camera does not have a built-in light meter, you should own a good hand-held light meter. Even if your camera is equipped with a light meter, you should have a hand-held meter capable of taking reflected/incident-light readings, since built-in meters are incapable of giving you incident readings. Also, when light levels are low (early morning and late evening), a good-quality hand-held meter will give you more accurate readings than a built-in meter will. One of the greatest values of the hand-held meter is for cold-weather photography, when built-in meters are of little or no value. (See chapter 15.)

Built-in Meters

It is said that professional photographers prefer hand-held meters to built-in ones. This may be true of studio, portrait, and architectural photographers, but where light levels change rapidly and shooting is fast, or when subjects may pop up in a moment—in other words, in most outdoor photography—built-in meters, particularly the through-the-lens meters found in most SLR cameras, are advantageous. I rely on the built-in meters in my cameras for about 90% of my photography.

Built-in meters measure the light reflected by the subject; most of them are averaging-type meters. Some cameras have spot meters, and some have both averaging and spot meter capabilities. The center-weighted meter found in some cameras is a sort of compromise between an averaging meter and a spot meter. It takes up to 70% of its light reading from the central part of the subject frame.

Photographers seem to lean toward the averaging meters, but

the best type is whatever you find most accurate and convenient. I have used them all, but I prefer the center-weighted meter.

A built-in meter has point-and-shoot simplicity, whose convenience is handy for many kinds of outdoor photography. For fast action—boat races, canoe trips, fishing, waterfowl, birds, and most animals—the built-in meter is more than a convenience; it's a necessity. Sure, you can wing it with a hand-held meter or no meter at all, but if you want consistent exposure accuracy, the built-in meter is the only way. The best built-in meter is the through-the-lens (TTL) type in SLR cameras, especially if you are using filters, because what you see through the viewfinder is usually what you will get on film.

No light meter is infallible: both the hand-held and the built-in meter can be fooled by unusual lighting, so you must exercise judgment and analyze the lighting thoroughly. Even if you don't own a hand-held meter (as recommended above), you can get accurate exposures, even under the worst conditions.

If the built-in meter is the averaging type, use it as you would a hand-held reflected-light meter to handle tricky situations. If your subject is in confusing lighting and is approachable, move in on it and get your camera close for a reading. If you can't get near, use a gray card or the palm of your hand.

If a bright sky comprises a third or more of your picture, an averaging meter—even a center-weighted meter—can be fooled into measuring too high. So tilt your camera slightly downward to take your reading.

There is one catchall safeguard that will assure you of adequate exposures even in the most confusing lighting circumstances—bracket, bracket, bracket!

Learn to Read Light

It should be clear that there is more to lighting than pointing a meter in the general direction of your subject, setting your camera, and snapping the picture. You must acquire a "light sense" to be able to interpret light and distinguish among its many shades and nuances. You must know how to use a light meter effectively. But what happens when your light meter fails?

A light meter that doesn't work is better than one that is giving false readings; at least you know you should take other measures or cease shooting. If you have developed the ability to read light you don't have to put your camera away when the light meter fails. But to develop light sense you must pay attention to lighting situations and their values relative to film speeds, shutter speeds, and aperture settings.

Avoid relying too much on the light meter. Don't just put a needle in the proper slot and shoot away. Pay attention to shutter and aperture settings in relation to existing light. It takes prac-

tice, and at first it helps to take notes. Learn to estimate the right shutter and aperture for any type of film in any type of lighting.

Jimmy Bedford, one of my professors at the University of Alaska, was an expert at reading light with the "Kentucky wind-age" method. He would lick his forefinger and point it skyward, as if making ready for a long shot with a flintlock rifle, and say "f/11 at a hundred twenty-fifth of a second," or whatever the lighting would call for. Of course the wetted finger was only for show: his darting eyes would be reading the light, and most of the time he was right on. His light reading was rarely off by more than a half-f/stop. And he would hasten to remind us that if we bracket we can't miss.

There's nothing magical about his ability. It comes from more than the many years of photographic experience that Jimmy has. He pays attention to lighting and its relationship to camera settings and film exposure.

A hand-held meter is a backup for the built-in meter, but you also need the ability to read and interpret light—without it you can't tell that your meter is giving you false readings.

The data sheets packed with the film you use will help you determine correct exposure until you have gained confidence in your ability to read light. Also, there is a simple formula that you should commit to memory.

On a bright, sunny day, convert the ASA of your film to the nearest shutter speed, and set your aperture at f/16. If you are using Kodachrome 64, for example, the proper setting for a subject in bright sunlight is f/16 at 1/60 second, f/11 at 1/125 second, and so on. Now, under a light overcast, open up two stops. On a dull, heavily overcast day or on a clear sunny day in open shade, allow three f/stops additional exposure—a setting of f/5.6 at 1/60 second, or a similar combination.

With that handy little formula, and by bracketing your exposures, you should be able to handle most lighting situations without the aid of a light meter.

Canned Light

One reason I took to the outdoors early in my youth is that I was never any good on a football field, baseball diamond, or basketball court. I have difficulty jogging and chewing gum simultaneously, so you can imagine what a sight I am when I try to wrestle with a flash unit, fumble with cords and brackets, adjust the aperture, find the right shutter setting, advance the film, focus the lens, and try to keep a subject reasonably near my viewfinder—all at the same time!

I have owned about a dozen flash units over the years and have three in operating order now. There are times when I have to use flash and other times when I should for best results. But that

doesn't mean I have to like it. I've never enjoyed using flash units, but I have found some units more tolerable than others.

The less confusing and more foolproof a flash unit is, the better for my sanity. And, as an equipment-laden boondocker, I want the flash unit to be compact and lightweight. I don't want unnecessary clutter in my equipment carrier or backpack. That's one reason I haven't used flashbulbs for years. And, unless I get into nighttime remote photography of wildlife, I may never use a flashbulb again.

I am among the greatest fans of those wonderful folks who gave us electronic flash. And I'm ready to pay homage to all the designers and engineers who have worked to simplify, automate, and computerize electronic flash units or strobes.

Cost used to be a prohibitive factor for strobes and the sometime flash user. But today there are strobes to fit anyone's budget, no matter how often the unit is used. Certainly strobes have a cost advantage over flashbulbs for the photographer who does a lot of flash photography.

The average outdoor photographer won't use a flash as often as a news photographer or wedding photographer, but there are times when a good strobe is a must and times when it will provide a means of improving otherwise mediocre photographs.

You will need some sort of flash to take pictures in the dark. And in the wee hours of morning or the waning hours of evening there may not be enough light for adequate exposure of even the fastest film, so a strobe can mean the difference between getting a good picture and a dismal underexposure.

In daylight hours outdoor photographers find strobes useful for close-ups, for filling in harsh shadows in outdoor portraits, and for shooting inside zoo buildings and public aquariums. A strobe can be a big help shooting inside tents, travel trailers, cabins, lodge buildings, boat cabins, and anywhere else where light levels are low.

There are hundreds of models of strobes. All of them are balanced for daylight; they can be used with daylight color films, indoors or out, with no worry about color shift.

Power sources are fairly uniform too. Strobes are either powered by battery packs, rechargeable nickel-cadmium (ni-cad) batteries, or nonrechargeable alkaline penlight (size AA) batteries. Some will operate on AC current too.

Battery packs allow up to 1000 flashes and instant recycling, but they are heavy, bulky, and impractical for most of us. Ni-cad batteries allow 50 or 60 flashes (perhaps 600 or more in automatic units with storage capacitors) before recharging via AC current, which takes from 3 to 14 hours. Some units will take a quick partial charge in 1 1/2 hours or less. Alkaline penlight batteries are disposable and allow 100 to 200 flashes before being replaced.

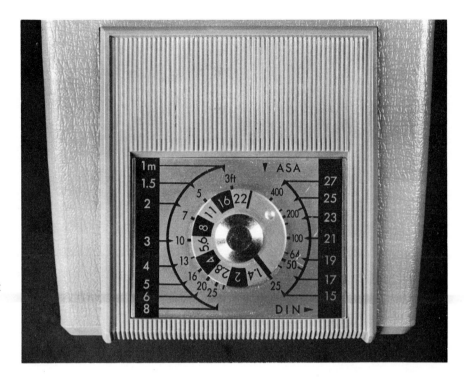

By reading this strobe's scale you can determine its guide number. With dial set for ASA 25, 10 feet on the distance scale aligns with f/5.6 on the aperture scale. Multiplying 5.6 by 10 gives the guide number, 56.

If a strobe goes unused for long you should take measures to protect it from damage. If you use a rechargeable unit irregularly, don't allow it to remain idle for more than a month, which can damage the capacitor. Turn the unit on and flash it several times to rejuvenate the capacitor and run it down completely every couple of months, following with a complete recharging. If you have a strobe powered by disposable batteries, remove the batteries when storing the unit. About once a month, put the batteries in and flash the unit several times.

Manufacturers assign guide numbers to strobes, indicating the power of the unit. The higher the guide number the greater the power. Guide numbers are based on average exposure with ASA 25 film at 10 feet. For example, guide number 40 means f/4 at 10 feet, 56 means f/5.6, and so on. The guide numbers are often a bit higher than actual performance. Overly optimistic guide numbers are becoming less of a problem as manufacturers standardize guide number assignments, but it still pays to test a new unit, and certainly any older, used unit you buy. If you have a strobe which has no guide number, use the same simple test.

Most strobes are equipped with a scale or dial that allows you to determine proper aperture for given film speeds and distances. You can use the distance/aperture scale to ascertain the manufacturer's assigned guide number. Determine what the recommended aperture setting is for ASA 25 film at 10 feet. Multiply by 10 and you have the guide number: f/4 = 40, f/5.6 = 56, f/8 = 80. Simple, eh?

Now to test the validity of the guide number, get several sheets of white posterboard, mat board, or something similar. Use a

black felt marker to write on these sheets, in bold numerals, the aperture settings of your standard lens—2, 2.8, 4, 5.6, 8, 11, and 16—one aperture number per sheet. Place a chair against a wall and put your camera and strobe exactly 10 feet from the chair. Have someone sit in the chair and hold the first numbered sheet toward the camera. Set your shutter on the appropriate speed that will be synchronized for electronic flash—usually marked with an X on the shutter speed dial, or you can check the owner's manual—and set the aperture for the number on the white sheet. Make an exposure; then have your helper go to the next sheet as you change to the appropriate aperture. Do this until you have checked every aperture. When you have developed the film or when it comes back from the lab, pick the best average exposure. The number on the white sheet in that picture, multiplied by 10, is the actual guide number for your unit.

The actual guide number will probably be the same as the one assigned by the manufacturer, or lower. If your strobe proves to have a guide number of 40 instead of 56, that's f/4 instead of f/5.6 at 10 feet and ASA 25. Just remember to open up one stop more than the distance/aperture scale indicates for other films and distances.

Strobes are getting better all the time, and the automatic units are nearly foolproof. Like electronic exposure cameras, automatic strobes, used properly, take a lot of the agony out of flash photography and allow the photographer to concentrate his efforts on creativity rather than on gadget manipulation.

An automatic strobe will let you set the aperture in advance. A sensor built into the unit monitors the illumination of the subject, taking ambient light into consideration. When the strobe is fired, the sensor automatically stops the light emitted by the strobe when there is a sufficient level of illumination. There are automatic strobes available that allow you to use one, two, even three aperture settings. Some have pivoting flash heads so that the units can be effectively used for bounce flash in the auto mode. Several manufacturers offer accessories that add even more versatility.

Automatic strobes equipped with storage capacitors have some advantages. If the level of existing light is such that a full potential duration of flash is not required, the unused energy is stored in the capacitor, ready to be doled out the next time the unit is fired. This shortens recycle time and increases the number of flashes the unit can deliver before recharging or changing batteries.

Assume a strobe that fires at full duration for each flash, that provides 60 flashes before it needs to be recharged, and with a recycle time of 5 seconds between flashes. But if the unit only has to use one-tenth of the flash it is capable of delivering, the other

nine-tenths go into reserve. We should be able to get 600 flashes instead of 60 before recharge and recycle time of less than 1 second assuming identical shooting conditions.

The automatic strobe will do a good job most of the time in the auto mode, but if ambient light is already at picture-taking level—as when the strobe is used for fill-in flash—the unit will have to be switched to the manual mode to function.

Strobe Techniques

Pictures are made up of highlights and shadows. Photographs in which it is difficult to distinguish between shadows and high-lights are dull and flat. As outdoor photographers we never want to eliminate shadows, but harsh shadows, especially facial ones, should be lightened for a pleasing effect. One way to do this on a bright, sunny day is to move the subject into open shade where the highlights will be toned down a bit and shadows will appear lighter. But this is not always possible. If you're out in a boat and you want to capture the excitement of the moment as your part-ner hoists a trophy bass aboard, there's no way to get the subject into the open shade. And likewise, if you're taking pictures of people on the beach, in the desert, on the snow-covered slopes of a mountain, or anywhere else in bright sunlight, you will have to deal with the shadows. Depending upon the angle of the sunlight, such facial features as noses and eye sockets will cast unfavorable shadows on the face; hat brims are notorious shadow makers.

To fill in ugly shadows, use a strobe. By using fill-in flash you can have your subject looking away from the sun instead of squinting into it. It's an effective method, but to master fill-in flash technique takes some practice. For those who like to work with formulas, I wish I could offer a simple one that would solve your fill-in flash problems, but I can't. Don't get me wrong: there are some formulas. I have seen several—or perhaps they were all the same one confusingly written in different ways. But I find they do more to complicate than to simplify, so I'll offer some of my own findings instead.

First, depending on flash guide number, intensity of existing light, and harshness of shadows, most strobes will effectively fill in the shadows in bright sunlight when used between 7 and 10 feet from the subject. As distance increases, the effect of the flash decreases. Conversely, as you move nearer to your subject, the flash effect increases.

Select the shutter speed that synchronizes with your flash, and set the aperture according to the meter reading. Remember that the sun is your main light source, and you are using the flash only as a fill light, so ignore the distance/aperture scale on your strobe and make the exposure as you would if you were shooting without a flash.

By testing your strobe you may find that you can get nearer to or farther from your subject. The effective fill-in flash range of your strobe may be 5 to 8 feet, or with a more powerful unit, 9 to 12 feet. With the little strobe I carry for such purposes (guide number 40) I like the results I get at 7 or 8 feet.

These distances sound restrictive, but these are good ranges for most outdoor pictures of people taken with a 50mm lens. If you want to crop tighter, switch to a lens of longer focal length—80mm to 105mm—or reduce the intensity of the strobe as you move closer. If your unit has a half-power switch, go to half power when moving closer to your subject, or cover the front of the strobe with a finger or a layer of clean handkerchief, which will effectively reduce the light output by one f/stop. Two fingers or two layers of handkerchief equal two f/stops.

By shooting a few test rolls and trying these techniques at various distances, you will get the appropriate combination.

You can use the same techniques to reduce the output of a nonautomatic strobe: for example, if you are using your strobe as the main or only light source and you want to get closer to the subject than the minimum distance recommended on the distance/aperture scale, you can use a finger or handkerchief over the strobe. Note that a finger will not alter the character of

Left: You can reduce the output of a strobe by placing a finger over the front of it. Right: You can also reduce strobe output by covering the front of the flash with a clean white handkerchief. One layer of handkerchief will cut the light in half and will soften the lighting by diffusing it.

Light and Lighting

light, while a handkerchief will. The cloth acts as a diffusing screen which softens the light reaching your subject.

You may find bounce flash useful at times; it produces a softer light than direct flash does. Bounce flash reduces the effective output of a flash, so remember to open your aperture if you need the full lighting effect of the strobe.

If you are shooting inside a room with light-colored walls and ceiling and the normal ceiling height of 8 feet, aim your flash toward the ceiling, and when you trip the shutter, the strobe's light will be reflected or bounced from the ceiling to your subject with a loss of output of about two f/stops. A pure white ceiling will cause a loss of about one f/stop. A higher ceiling requires more compensation, a lower one less. Inside the light interior of a boat you may need to open your aperture by only one f/stop when using bounce flash.

To utilize the soft light of bounce flash outdoors you will need a reflector to bounce the light off. Some photographers use a small white reflector umbrella, but I find the bounce-flash attachment for the Vivitar 283 automatic strobe more convenient.

Bounce flash also drives distracting shadows down behind the subject. You can accomplish the same effect by elevating the flash at arm's length above the camera and pointing it down toward your subject. This is also an effective way to eliminate the flash photographer's bugaboo known unaffectionately as "red eye." This phenomenon, generally explained by the light being reflected off the iris of the eye and back into the camera lens, results from the flash being too near the lens axis. In color pictures some subjects will appear with red eyes. In black and white, the eyes will be a ghoulish white.

Red or white eye will be more of a problem in dimmer light, because the darker it is the more the pupils of the eyes will dilate, allowing more light to enter the eye, and consequently, more to be reflected back.

Another way to eliminate red eye is to keep the subject from looking into the lens, but this doesn't always work. Ever tried to shoot a profile of a rabbit without having that sideways eye staring right at you?

You needn't worry about red eye in fill-in flash. Your main light source will be the sun, and it's not going to be beaming directly at your subject from the camera. Furthermore, the subject's pupils will be contracted and won't reflect enough light back to the camera to make any difference.

COMPOSITION 7

Composition can be defined simply as the selection and arrangement of the visual elements in a scene. But that's where simplicity ends, for composition is a personal matter. There are basic rules of composition of which every serious photographer must be aware, but the photographer's intention and interpretation of what he sees influence the result. That's why a dozen different photographers can be given an identical subject to photograph and get a dozen different—sometimes, dramatically different—photographic interpretations.

Most of the rules discussed in earlier chapters are hard and fast; for example, if you want a shallow depth of field, shoot with wide aperture. If you want to stop action, use a fast shutter speed. If you want fine grain, sacrifice speed. These principles can be compromised at the photographer's discretion, but the results are predictable.

A photographer who knows the principles of composition will get better results than a snapshooter who doesn't. A good photographer doesn't *let* pictures happen; he *makes* them happen. But composition depends on seeing and thinking; while we are all capable of both, we do them differently. We impose a viewpoint, a frame of reference, and perhaps most important, our subjectivity.

Visual Elements

To be successful, a photograph must have a subject. Sounds simple, doesn't it? Well, that means it must have *one* subject—a dominating subject. If subordinate details are allowed to compete with the subject, they become subjects too, and a photograph with many subjects really has no subject at all. So the question every photographer must ask himself about a picture is: What is the subject? Once that has been determined, other visual elements can be dealt with.

Ask yourself how the subordinate details in the picture relate to the subject. Do they support your interpretation of the subject? Do they help the viewer focus on the subject? Do they help balance the overall scheme? If so, they should probably be a part of the picture. If they do not relate to the subject, or if they interfere with

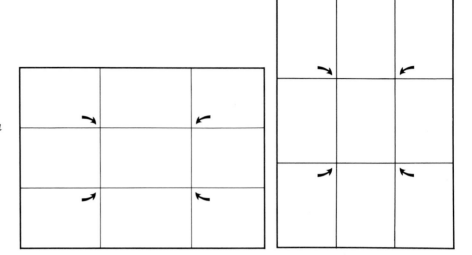

According to the rule of thirds, when you compose a picture you should divide the scene in the viewfinder into thirds—both horizontally and vertically—with imaginary lines. Place the point of interest at one of the spots where two lines intersect.

the subject or your interpretation of it, they must be eliminated.

The process of composition is not in adding pictorial elements, but rather in subtracting them. As in carving a decoy from a block of wood, you pare away the excess until any further removal of material would detract from the final product.

Visual Impact

For a picture to be interesting, exciting, or pleasing it must have a visual impact which depends largely on how the elements in the picture are arranged. The most important element is the subject, and subject placement is the first step in composing a photograph.

The basic rule of subject placement is the rule of thirds. Use imaginary lines to divide the frame of the viewfinder into thirds—horizontally and vertically—superimposing an imaginary ticktacktoe grid on the field of view. Most often the subject should be located at one of the points where the imaginary lines intersect. A subject off center will generally have more impact than a centered subject. ("Dead center" is a good term to keep in mind.) I avoid the term "center of interest," which some photographers use when discussing visual impact. I prefer to think of the picture's "point of interest." Each photograph should have a point of interest, toward which the viewer's eye is drawn.

Visual Tension

Visual impact of a picture with a point of interest is strengthened by analysis of the picture's inherent tension, and selection of the proper format for that tension.

Despite what some fans of the 6cm x 6cm (2 1/4" x 2 1/4") format would have us believe, square pictures are seldom as exciting as rectangular ones. They are often too static and lacking in internal force to emphasize the inherent tension of the subject.

Determine whether the action is horizontal or vertical. An eye-

level view of a passing fishing boat, for example, lends itself to horizontal presentation. A squirrel descending the trunk of a tree suggests vertical tension. In other pictures the force is more subtle and requires careful study. A subject that appears to be naturally horizontal might be strongly emphasized in a vertical interpretation. Examine the subject horizontally and vertically in the viewfinder before taking the picture; if you are in doubt which way to photograph it, shoot it both ways.

Beginners hardly ever shoot a vertical picture. They photograph subjects from too far away, in order to fit vertical subjects into a horizontal frame. One reason is that a 35mm camera in normal upright position takes horizontal pictures.

To cure chronic "horizontalitis," begin thinking more about your subjects, and realize that the camera functions just as well standing on end. Move in closer to the subject and the viewfinder itself will often dictate how to take the picture.

Visual Control

You must control the visual elements of a photograph to compose it properly. Outdoor photography is a means of visual communication: you are pictorially expressing your observations and interpretations of the outdoors to those who view your work. Self-gratification and art for art's sake aside, most of us shoot for an audience, whether the viewers be friends who will notice our photographs displayed on the walls of our homes, neighbors who have been invited over to see slides from the trip to Baja, local Ducks Unlimited members who have gathered to attend a lecture and slide show on the Louisiana Lakes Project, judges of a photo contest, potential buyers at a gallery exhibit, or art directors and editors of magazines.

Don't let your viewers be puzzled about your photographs. They shouldn't be asking what the subject is, what your purpose was, what you are trying to communicate. Make the interpretation obvious and the presentation pleasing to look at.

Sometimes control of visual elements means no more than taking advantage of an existing situation or having the patience to wait for the right circumstances. Unusual or exciting lighting conditions may be all that is needed to focus the viewer's attention on the picture subject. Most often, you will have to manipulate the elements. I don't mean you will have to physically rearrange them—though this is sometimes necessary—but you must manipulate them in your viewfinder to emphasize the subject and suppress the details.

Selective focusing can make a subject stand out. With a large aperture you can blur the background in an outdoor portrait, a close-up of a flower, or any other where details should be eliminated or toned down.

An otherwise mediocre scene can be transformed into a visually pleasing picture by the addition of framing elements.

A small aperture is a better choice in landscapes, as it will bring the foreground and subject into sharp focus. (A blurred foreground or periphery in a landscape distracts the viewer.) Subordinate details can be more prominent, but not so much as to overwhelm the subject. Their being kept in focus helps suppress them.

Many photographs are improved by framing: the placement of available objects along the edges of the field of view. Trees and overhanging branches are good for this task, and the enterprising photographer is on the lookout for other suitable objects: a fence, the spokes of an old wagon wheel, the rigging on a boat, the girders of a bridge.

Balance is important in composition, but don't confuse balance with symmetry. Good photographic balance is asymmetrical. Some photographs are so symmetrical that they appear to have been composed with tape measures and pocket calculators: subjects dead center, horizons equidistant from the top and bottom edges, foreground and background in equal proportions.

Think of the elements of a photograph as having visual weight. Some are visually heavy, others are light. Thus pebbles in the foreground of a streamside photograph are light compared to foreground boulders. A clear, cloudless sky often looks heavier than a blue sky laced with wispy clouds, but large puffy, well-

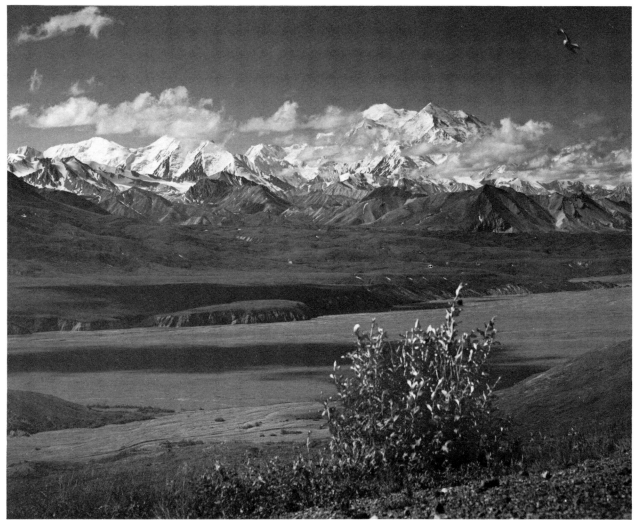

defined cumulus clouds are often among the heaviest elements in a photograph; their weight needs counterbalancing.

You must control the heavy details to maintain proper balance; otherwise the picture can become top-heavy or bottom-heavy or laterally out of balance. A boulder or massive piece of gnarled driftwood prominently placed in the foreground of a scenic picture can overwhelm the subject. Subdue it by changing your camera angle, or use a different lens that will allow you to emphasize the subject more. And don't be so impressed by a dramatic sky that you allow it more prominence than your subject.

It helps to know what the human eye does as it views a picture. A well-composed photograph draws the viewer's eye into it from the lower left or lower right corner. The eye is then attracted to the lighter or brighter parts of a photograph, so be sure that light areas are important. A light, washed-out sky will pull the viewer's eye right off the top of the picture.

Use forceful lines to steer the viewer's eye; don't inadvertently allow them to interfere with your purposes. Obvious lines are

It may be difficult to imagine balancing something as visually heavy and dominating as Mount McKinley, but the humble bush in the foreground keeps this picture from becoming top-heavy. A passing sea gull helped to fill some dead sky in the upper right corner.

Composition
101

The contours of rugged mountain country are visually heavy and are used to offset the bulk of the butte and weight of the sky. To accomplish this, a 35mm wide-angle lens was used. The camera was tilted downward to raise the horizon and to include vast expanses of foreground. An aperture of f/16 allowed maximum depth of field.

railroad tracks, roads, rows of telephone poles, electrical wires, and fences. But a stream can also be a line, and so can a fishing rod, a pair of skis, or the barrel of a rifle.

Forceful lines should lead into the photograph. A picture taken across a road has a line that runs from left to right off the edge of the photograph. When you change the camera angle and make the road enter from one of the lower corners and run diagonally into the photograph, the viewer's eyes are pulled into the heart of the photograph. Lead your viewer directly to the subject for maximum visual impact.

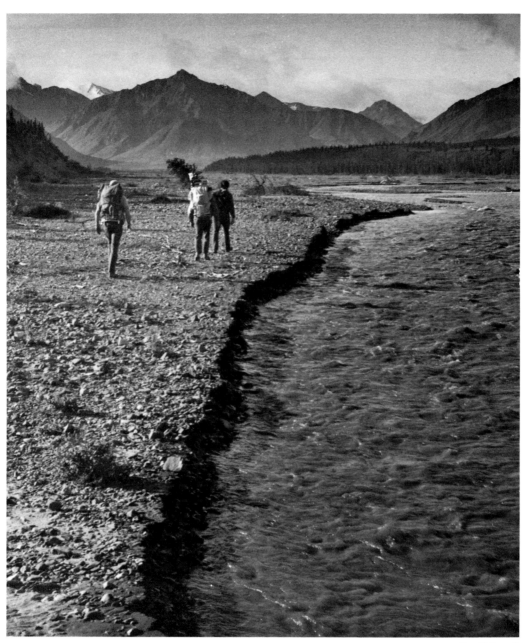

In this photograph the eroding stream bank becomes a jagged line that pulls the viewer into the photograph from the lower left corner and leads naturally into the picture's point of interest.

Parallel lines—fences, rows of telephone poles, the edges of a road, the tracks of a railroad—seem to converge in the distance when they are placed so they lead into the picture. This gives a three-dimensional effect, while parallel lines that run horizontally across the photograph make it flat, two-dimensional.

The most dominating and troublesome line in many outdoor photographs is the horizon, which has to run from left to right. Keep the horizon level: a tilted horizon makes it look as if the subject is ready to tumble off the edge.

Beginners place the horizon equidistant from the top and bot-

Composition

103

tom edges of the photograph. This dulls the photograph visually and has the effect of dividing it in half. A good rule of thumb (with some noteworthy exceptions) is to place the horizon about two-thirds of the way up the photograph. Think of this when you are placing the subject according to the rule of thirds.

But if the sky is dull or ugly, don't give it a third of your photograph. Ignore the rule and get rid of more of the dismal sky.

To depict the vastness of an expanse of desert or prairie, drop the horizon nearly to the bottom of the picture, so that the sky will dominate and give an impression of wide-open spaces. Putting the horizon up near the top of the picture tightens up the composition, giving the picture a more confining character. Try it when photographing subjects in mountainous country.

Watch out for visual elements that will clutter the picture or distract the viewer. Police the subject area for trash such as beer cans and potato chip bags—unless, of course, your purpose is to photograph litter. Other, more natural elements may be distracting and removable.

Cropping with the Camera

Unwanted elements that cannot be physically removed from the subject area can be cropped out with the camera. The easiest way is to move in on your subject; if this is impractical, try changing the camera angle or camera position, or if the subject is movable, place it in a more photogenic setting.

Many photographs that disappoint beginning photographers—and repulse the viewer—result from subject/camera distances that are too great. A summer vacation snapshot, for example, may show Uncle Ben and Aunt Lucy standing near the entrance of the botanical gardens the family visited; to make sure that everybody back home will recognize who was there, the photographer backs up enough to include the family flivver, most of the kids, and other family members who are handy. To get all of the botanical gardens sign into the picture the photographer takes a few more steps backward, but this lets passersby spill into the picture area. With all the activity, the snapshooter doesn't notice the two kids standing in front of the camera waving into it, the overturned litter barrel to the left, and Fido off to the right exchanging greetings with a fire hydrant.

Few photographs are improved by backing up and adding more elements to the picture area: this only diminishes the subject and equalizes the importance of the abundant details, resulting in a confused, unplanned, boring snapshot.

Get in the habit of moving in on your subjects. When you bring your camera to your eye, try to move in even closer, cropping out the distractions and extraneous details.

If your subjects are active, don't crowd them. Give them proper

The photographer did not allow sufficient room for his subject to move. The boat appears ready to move right out of the picture area.

By paying attention to subject movement and placing the subject in the proper position, composition is markedly improved.

direction: for example, with a running antelope, a canvasback in flight, or a speeding bass boat, allow a little more space in front of the subject than behind it. If the subject is moving from left to right, picture it left of center. Placement right of center would give the impression that the subject is about to exit the picture area.

You can often get dramatic results by cropping ruthlessly. A head shot of a trophy deer or fish can be more effective than the obvious full body shot. Outdoor portraits are often improved by cropping to head-and-shoulders "bust shots." But don't inadvertently cut a deer off at the knees, lop off the tail of a fish, or let the camera amputate a foot or hand. Crop; don't chop.

Practice and Study

The well-composed photograph doesn't happen by itself. You have to work at composition, thinking about what you are trying to accomplish, and paying attention to everything in your field of view. If you still have to fumble around with camera controls and accessories, you can't give your undivided attention to composition. So get intimate with your camera and equipment by shooting plenty of film.

Look for potential pictures everywhere you go. Try to carry a camera with you most of the time, but even when you don't have a camera, stay aware. View your surroundings in terms of the horizontal and vertical framework that a camera's viewfinder would impose upon them. When you are caught without a camera and have found a good subject, make note of it and return later to get the photo.

Study the composition of the best people in the business. Spend some time in the photography section of your public library. Page through the books that show the works of the masters. When a picture pleases you, analyze. Find out what attracted you to the photograph. Determine how the photographer emphasized his subject, what he did to subdue the details. How did he frame the picture? Where's the horizon? Was his focusing selective? What about depth of field? Lighting? Subject placement? Action? Motion?

Attend photo and art exhibits; visit galleries. Study the photographs in magazines such as *National Geographic*, *National Wildlife*, and *International Wildlife*. Of the magazines I subscribe to, these are the ones I keep intact. From time to time I page through back issues of them, looking for and analyzing the most striking photographs.

Finding Subjects

You probably already have some favorite subjects, such as waterfowl, big game, or boats, but stay alert for subjects that rouse your interest in the photographs of others. Note them, and plan to photograph them at your first opportunity.

List the kinds of photographs you want to add to your file or portfolio, and make notes on possible ways to execute them. Try to imagine as many different ways as possible to photograph your favorite subjects.

Look for *humor*, which is rare but always adds interest; wild animals doing humorous things are among the most appealing outdoor photographs.

Look for interesting *textures*, such as wind sculpture of sand dunes. Watch for *patterns* in nature—anything repeated, such as the grain structure in a piece of driftwood, the annual rings in

the end of a log, the arrangement of leafy plants on the floor of the forest, the veins and ridges in a leaf. Keep a photographic eye out for strange rock formations, oddly deformed trees, and other *shapes* to be photographed.

Don't overlook *man-made objects*. Don't automatically exclude them from "natural settings." Often they suggest man's relationship with his environment. A lighthouse, a windmill, or even an oil derrick can be used effectively. My favorite subjects include lighthouses, weathered barns, dams, bridges (especially covered), old mills, waterfront buildings (such as old canneries), and commercial fishing boats.

People in Your Pictures

You don't need to include (or exclude) people in all your pictures. Put people where you need them or where they fit best, and have them doing something besides staring at the camera. Picture them fishing, hunting, exploring a tide pool, looking for salamanders, cooking over a campfire, hiking along a trail, crossing a creek, looking through binoculars, even taking pictures.

People can be main subjects of pictures or can be used to improve composition or to express an idea. An empty trail in the mountains is not as interesting as one with several backpackers trekking along it. A photo of a creek meandering through a meadow can be improved by putting a fly fisherman on or by the side of the stream.

When you add people, be conscious of the color of their clothing. Try to get red and yellow jackets, hats, backpacks, and rucksacks in the pictures, especially if you are using a cool-color film or if there is an abundance of blue and green in your subject area—as is often true of landscapes and waterscapes. However, don't let warm-colored garments overwhelm your subject. Warm colors have visual weight.

In a panorama where there is nothing very interesting in the foreground, place a person glassing the countryside with binoculars in the lower left or right of the picture. They should be glassing (or photographing) toward the subject area, to help lead the viewer's eye into the picture.

Dare to Be Different

Don't be different as a result of being ignorant of the rules of good composition. Only bad pictures will result. But when you have a thorough knowledge of the rules, you will know when to bend or break them for effective results.

Be alert for the opportunity to present a subject differently. Give it another point of view or interpretation. Break down photographic clichés by offering an alternative to triteness. Study the

In composing a photograph with many visual elements, it is often necessary to move about, studying the subject area and looking for the best position and most suitable format. These five pictures illustrate the composition process. The subject is a waterfront scene. The problem is how to best depict waterfront scenery and activity.

Above Left: *From a position right of a pier and boat dock, the photographer has pictured commercial trollers at rest at their berths. Rocks were used in the foreground to help balance the picture, but lighting conditions caused loss of detail in shadow areas. Right side of picture just seems to fall away, as there are no elements there to keep the viewer's eyes from wandering off the edge of the picture.* Above Right: *By moving closer to the pier, the photographer was able to use the structure to add perspective to the picture, but the fishing boats are diminished in the distance. The picture was deliberately timed to catch the breaking of a small wave, but the ripply water creates a distracting line across the bottom of the picture, which effectively cuts off the photograph there and squares up composition too much. Finally, there is too much dull open water in the photo.* Opposite Top Left: *By moving to a position left of the pier, the photographer was able to utilize strong sidelighting to bring out detail in the structure, but the picture exhibits about as many flaws as the preceding one. Furthermore, the photo falls away at the left edge.* Opposite Top Right: *When the photographer positioned his camera on the pier, composition was vastly improved. The pier railings lead naturally and forcefully into the subject area from the lower corners. Boats are nearer and become more prominent. Land masses on the left and right keep the viewer's eyes from straying off the edges. Can composition be improved? Certainly. One obvious flaw is that the picture is too static. Nothing is happening.* Opposite Bottom: *The photographer waited until later in the day when he could picture one of the returning fishing boats. Composition is similar to the preceding photo, but format is now horizontal because of the tension dictated by the movement of the boat. The picture was timed to catch one of the fishermen walking up the pier. A stroke of luck dissipated some of the distant haze and brought a mountain*

range into view. With fewer boats moored at the dock, composition is less cluttered now. A perfect picture? Not by a long shot. Any photograph can be improved in some way. This one would have been better with the troller moving toward the center of the frame instead of away from it. But despite that flaw and possibly others, it is a well-composed shot. Compare it to others in this series and judge for yourself.

postcards available in your locale and where you travel to; study the view that everyone else sees and photographs—then do it differently, if you can.

Experiment with subjects. Picture them in different ways. Expect to fail sometimes, but also expect to get some mighty exciting pictures.

Dare to be different. Dare to be creative.

FILTERS 8

Some photographers wouldn't dream of snapping the shutter of a camera without first placing a filter in front of the lens. They carry a vast assortment of filters to cover every possible situation. Before taking a color picture, they will take a color temperature reading and select a filter or combination of filters that will precisely balance the light to the film in use.

Other photographers consider all filters a burden, a hindrance to photographic expression, and an unwarranted pain in the wallet. They may have been confused by what they've read about filters or may not have bothered to investigate practical filter applications.

Between these extremes is the sensible outdoor photographer who has gained an understanding of filters, has decided which filters are best for his purposes, and uses them when he needs to. He has started out with a few of the most useful filters and gradually added to his personal selection as his needs dictated and his budget allowed.

Types of Filters

The four most common types of filters are gelatin film squares, gelatin film cemented in glass, glass squares, and glass disks.

The gelatin filters are cheapest, but they are fragile, require great care in handling, and are difficult to clean. They are more for the studio photographer than for the outdoor photographer. Gelatin filters mounted in glass are more durable, but also more expensive.

Outdoors, where harsh extremes of the environment are likely to be encountered, top-quality optical glass filters are best. The most popular glass filters are disks mounted in metal rims; they are available in several mounting configurations to accommodate the photographer's preferences or equipment.

If you use several lenses with different objective diameters, you will probably want to use series filters, which have smooth, unthreaded rims. The filters are held in place in front of the lens by means of adapter rings that come with screw-in, bayonet,

setscrew, or slip-on mounts. You can buy adapter rings of different sizes to fit your various lenses and one set of filters for the adapter rings.

For example, if you have three lenses with objective diameters of 44mm, 48mm, and 52mm, you can buy three threaded adapter rings to match and series #7 filters for use on all three lenses.

Series filter accessories include lens shades and retaining rings that allow you to use two filters simultaneously.

For lenses with the same objective diameter, you might prefer direct-fitting thread-mount filters. I find them to be convenient filters; any of my 52mm filters will fit my five Nikkor lenses that have identical objective diameters, with focal lengths from 28mm to 200mm.

Series or thread-mount filters can be extended in use with inexpensive step-up or step-down rings. Step-up rings, with external threads of one size and internal threads of the next-larger size, allow one size of filter to be used on lenses of different sizes. Step-down rings allow the same kind of interchangeability, but using a smaller filter than the lens calls for can cause vignetting, the cutting off of the corners of the image on a negative or transparency. Exercise caution when selecting step-down rings, especially if they will be used on wide-angle lenses.

What Filters Do

An aquarium filter is used to *strain* impurities from the water. The oil filter in an automobile engine *screens out* unwanted contaminants. A cigarette filter *traps* some of the harmful tars and nicotine. Filters are designed to subtract elements from whatever they screen.

Photographic filters subtract unwanted portions of the light spectrum. They absorb (stop) some kinds of light and transmit (pass) others.

The visible spectrum is composed of seven principal colors (red, orange, yellow, green, blue, indigo, and violet) and shades of these colors, but for photographic purposes we can consider only the primary colors seen by the eye: red, green, and blue.

If an object absorbs all colors and reflects none, it is black. If it absorbs no colors and reflects all of them, it is white. (White light is the sum of all colors, or a mixture of red, green, and blue.)

If an object absorbs green and blue and reflects red, it is red. Similarly, a blue object reflects blue. What we see as yellow is a combination of red and green.

A red filter absorbs green and blue and transmits red. A blue transmits blue, while a yellow filter transmits red and green.

Like the colors we encounter outdoors, the most useful filters for outdoor photography are not completely pure: they do not totally absorb and transmit any color.

Why Use Filters?

Perfect picture-taking conditions rarely, if ever, exist. Photography depends upon light, but light is not always dependable. It can be too bright, dim, warm, or cool, too flat or contrasty.

What our eyes see and what a film records may not be the same. Most film is sensitive to ultraviolet radiation, which is invisible to the human eye. Panchromatic film—the black-and-white film most used by outdoor photographers—nearly duplicates images as we see them, but is a little more sensitive to blue light and less sensitive to yellow. What we see as different colors may have very similar gray tonal values in black and white.

The color film we use outdoors is balanced for "daylight," which turns out to mean noon on a clear summer day at 5500° Kelvin. Color temperature can be affected by time of day or year, shade, haze, overcast, and geography.

When you take a picture through a window or through the surface of a tide pool, reflections can cause problems. Daylight color film used indoors under artificial light, and indoor-type film used outdoors, gives poor results. Other problems come up when you take pictures in the mountains or from an airplane.

The most effective, reliable way to deal with these problems is the proper use of filters, with which you can correct, compensate, convert, balance, penetrate, absorb, reduce, eliminate, and polarize.

Filter Designations

A big source of confusion for the photographer who wants to buy a few filters is the seemingly haphazard way the manufacturers have labeled them. It is hoped that now that some attempts have been made to standardize filter nomenclature, the manufacturers will get together and settle on labels for all filters.

What one company calls a deep red filter is dark red elsewhere, and one manufacturer's light green is another's yellow-green. A simple yellow filter may be called a #8, K2, Y2, Yellow-2, Medium Yellow, or Yellow filter. However, Kodak has discontinued some alphanumeric designations for a simpler numerical code for Wratten filters, and Tiffen, the largest filter manufacturer in the U.S., uses the same filter labels as Kodak Wratten.

The way the most popular filters for black-and-white films are numbered by Wratten is 0 to 2, colorless or only faintly tinted; 3 to 15, yellow and yellow-green; 16 to 22, orange; and 23 to 29, red.

For the sake of sanity, the Wratten/Tiffen designations, plus color, where applicable, will be used in this chapter.

Filter Factors

There are a few filters, such as the skylight and ultraviolet, that do not significantly reduce the amount of light; others require an

OLD AND NEW FILTER DESIGNATIONS

COLOR	FORMER DESIGNATION	CURRENT DESIGNATION
Light Yellow	K1	#6
Yellow	K2	#8
Deep Yellow	K3	#9
Yellow-Green	X1	#11
Deep Yellow-Green	X2	#13
Deep Yellow	G	#15
Red	A	#25
Deep Red	F	#29
Deep Blue	C5	#47
Deep Blue	C4	#49
Dark Green	B	#58
Dark Green	N	#61

New filter designations of Kodak Wratten and Tiffen. Perhaps other filter manufacturers will follow their example.

increase in exposure through selecting a slower shutter speed or a wider aperture.

The most common filters call for one to three f/stops increase in exposure. The required increase is usually expressed as a filter factor, such as 1.5X, 2X, and 4X. To determine the adjustments you need to make, multiply the exposure, as indicated by your light meter, by the filter factor. If the meter gives proper exposure without a filter as f/5.6 at 1/60 second, and you want to use a 2X filter, multiply the exposure by 2, giving f/5.6 at 1/30 second—or open up one stop and maintain the 1/60-second shutter speed.

If you want to think in terms of f/stops instead of filter factors, check the accompanying Filter Factor Conversion Chart and commit to memory the factors that apply to the filters you use. Whenever you use more than one filter at a time you must *multiply* the filter factors or *add* the f/stops. If you use lots of filters and can't remember all of the factors and f/stops, keep a list in your billfold.

The manufacturers should imprint the filter factor or required exposure increase on the metal rims of their filters, but they don't. Of course, you can etch the information on your filters yourself.

FILTER FACTOR CONVERSION

FILTER FACTOR	PRACTICAL EXP. INCREASE REQ'D	PRECISE EXP. INCREASE REQ'D
1.25X	1/2 f/stop	1/3 f/stop
1.5X	1/2 f/stop	2/3 f/stop
2X	1 f/stop	1 f/stop
2.5X	1 f/stop	1 1/3 f/stops
2.8X	1 1/2 f/stops	1 1/2 f/stops
4X	2 f/stops	2 f/stops
5X	2 f/stops	2 1/3 f/stops
6X	2 1/2 f/stops	2 2/3 f/stops
8X	3 f/stops	3 f/stops
10X	3 f/stops	3 1/3 f/stops
12X	3 1/2 f/stops	3 1/2 f/stops
16X	4 f/stops	4 f/stops
32X	5 f/stops	5 f/stops
100X	6 1/2 f/stops	6 2/3 f/stops
1000X	10 f/stops	10 f/stops

For precise exposures use figures in the right-hand column. For practical purposes, though, the center-column conversions will do and are easier to remember.

Exposure Through Filters

Overexposure usually cancels the effect of a filter; slight under-exposure (about a half f/stop) often increases the effect. So accurate exposure is important—especially using film with narrow exposure latitude—and bracketing is recommended.

Some magazine and book authors tell you that if you use anything but an SLR camera with through-the-lens metering you will have to compensate for the required exposure increase, but that if the camera is an SLR with such metering filter factors can be ignored, since the meter is reading the light through the filter. This sound advice has some important exceptions. The light meters on some non-SLR cameras do read the light through a filter that is attached to the lens. Such cameras should be treated like SLRs for exposure compensation.

Also, not all light meters read light the same way. For example,

when I first started using filters on an SLR with TTL metering I paid no attention to filter factors and let the camera do all the calculating. I experienced little difficulty, and blamed the occasional exposure failure on my own inadequacies.

For black and white I used a #8 Yellow and a #11 Yellow-Green filter and, from time to time, #25 Red. After a while I noticed that the red filter exposures consistently underexposed. I checked the camera by taking meter readings with and without the red filter. The light meter indicated a required exposure increase of 1 1/2 to 2 f/stops, depending on lighting conditions; yet the #25 Red filter has a factor of 8X, calling for an increase of 3 f/stops. The yellow and yellow-green filters came out the same on the meter as the filter factors indicated.

The reason is that the cell in my camera's light meter was more sensitive to blue and green (the colors absorbed by a red filter) and less sensitive to red (the color transmitted by a red filter). Other light meters could produce other irregularities in overexposure and underexposure. Try a test like the one I did.

If your light meter is located away from the lens—as in many viewfinder, rangefinder, and TLR cameras—or if you use a hand-held light meter, compensate for filter factor whenever you use a filter. This can be a bit of a nuisance. But if you use one filter for most of your black-and-white work, instead of trying to remember to open up the aperture or slow down the shutter on every shot, reset your light meter.

Using the #8 Yellow filter, for example, on your lens simply cut your film's exposure index in half when you set the meter. If you use Kodak Tri-X or Ilford HP4 at ASA 400, set the meter for EI 200 (increases exposures by a factor of 2, or one f/stop). Using a #11 Yellow-Green, which has a 4X factor (two f/stops), set the meter for EI 100 for the same film.

Filters for Black-and-White Photography

I have heard photographers say color photography is more difficult than black and white. But what we see sharply in color is not always so distinct in black and white. I myself consider black-and-white photography to be a more challenging problem in some respects.

Panchromatic films "see" ultraviolet rays, which do not focus the same way as visible colors. Whenever ultraviolet radiation is excessive, image sharpness deteriorates—for example, in atmospheric haze (which scatters ultraviolet), at high altitudes (mountain or aerial photography), in most marine environments, and in northern latitudes during the first six months of the year when ultraviolet is abundant in the atmosphere.

You should invest in a UV (ultraviolet-absorbing) filter for black-and-white photography. It is a clear filter that requires no

USEFUL FILTERS FOR BLACK-AND-WHITE PHOTOGRAPHY

NO.	COLOR	FACTOR	EXP. INCREASE	PURPOSE OR EFFECT
6	Light Yellow	1.5X	2/3 f/stop	Outdoors, absorbs excess blue to slightly darken sky and emphasize clouds. Recommended for low sun use.
8	Yellow	2X	1 f/stop	With pan films renders most accurate tonal correction. Increases contrast, emphasizes clouds, absorbs blue. Recommended for most black-and-white photography outdoors.
9	Deep Yellow	3X	1 1/2 f/stops	Increases overall contrast, darkens sky, emphasizes clouds slightly more than #8. Improves distant scenes.
11	Yellow-Green	4X	2 f/stops	Improves flesh tones, produces fair sky effects and natural foliage. Recommended for woodscapes and plants.
21	Orange	4X	2 f/stops	Absorbs blue and blue-green, penetrates haze. Recommended for darkening water in marine photography and for mountain and aerial photography. Not recommended for flesh tones.
23	Light Red	5X	2 1/3 f/stops	Darkens sky and water, emphasizes clouds, penetrates haze, darkens foliage, lightens flowers. Not recommended for flesh tone.
25	Red	8X	3 f/stops	With pan films produces dramatic skies, darkens foliage, lightens flowers, penetrates haze. Slight underexposure produces moonlight effects in daylight. Not recommended for flesh tones. With infrared films produces extreme contrast in sky, turns foliage white.
47	Dark Blue	5X	2 1/3 f/stops	Lightens deep blue, darkens reds and yellows, accents fog and haze. Good for photographing light objects against snow.
56	Light Green	6.4X	2 2/3 f/stops	Produces good flesh tones, darkens sky, lightens foliage. Recommended for outdoor portraits.
58	Dark Green	8X	3 f/stops	Lightens foliage, darkens flowers, absorbs red. Recommended for woods, meadows, and gardens.

exposure compensation. If you use correction and contrast filters for black-and-white work you won't need the UV filter, since the other filters absorb ultraviolet.

Correction filters are used to correct the spectral sensitivity deficiencies in black-and-white film. A #8 Yellow is most often used for complete correction of panchromatic film.

If you take pictures of puffy white clouds suspended in deep blue skies and are disappointed with prints where the skies wash out and nearly disappear, you should invest in a yellow filter, which absorbs ultraviolet and some blue and transmits red and green. Colors that are absorbed appear darker in a print; transmitted colors are lighter. Thus the #8 Yellow filter will darken the blue sky, emphasizing the clouds. Foliage and flowers will be lightened somewhat.

The denser the filter, the more pronounced the effects. The #6 Light Yellow filter does less than the #8, which does less than the #9 Deep Yellow.

Some photographers use the #11 Yellow-Green as a general-purpose correction filter. It renders skies more as the eye sees them than unfiltered film does, but not as naturally as the #8 filter does. It improves flesh tones and lightens foliage more than

Filters

117

Top: *This photograph was taken on a visibly clear day with a 600mm lens at a distance of more than 1/2 mile over open water. No filter was used.* Bottom: *Here a #25 Red filter was used to improve overall contrast. This picture appears sharper than the preceding one, even though both were taken with the same lens focused on infinity and the camera mounted on a tripod.*

the #8 Yellow does. It is the filter to use indoors under tungsten light to fully correct panchromatic film.

When you photograph two colors that have similar gray tone values, they seem to blend together and reduce image sharpness. A contrast filter will increase the contrast between the two colors,

Left: *Detail enlargement of the unfiltered shot shows the devastating effects of invisible ultraviolet radiation on conventional panchromatic film.* Right: *Detail enlargement of the filtered shot shows much better resolution. Note the details apparent in the girders near the smokestack.*

giving a crisp, sharp delineation. Remember: a filter lightens its own color.

When you take a low-angle shot of a yellow flower against a clear blue sky, a #8 Yellow filter will absorb some of the sky's blue and transmit the flower's yellow, providing more contrast between the two colors. A blue filter would add contrast but would lighten the sky and darken the flower—a rather unnatural effect.

Similarly, with red berries against a background of green leaves, you can darken the foliage and lighten the berries with a #25 Red filter, or you can use a #58 Dark Green filter, with the opposite effect.

Consider a bird against the clear blue sky. If it is a nearly white seagull, you will want to darken the sky. A #8 Yellow will absorb some blue and provide some contrast, but a #25 Red will greatly darken the sky, causing the subject to stand out dramatically.

If the bird is a crow or raven, however, both filters would reduce the contrast between the subject and the sky. The best choice is a #47 Dark Blue, which will turn the blue sky white. In the absence of a blue filter, take the picture with no filter: the blue-sensitive panchromatic film will overexpose the sky, causing it to print lighter than it looks.

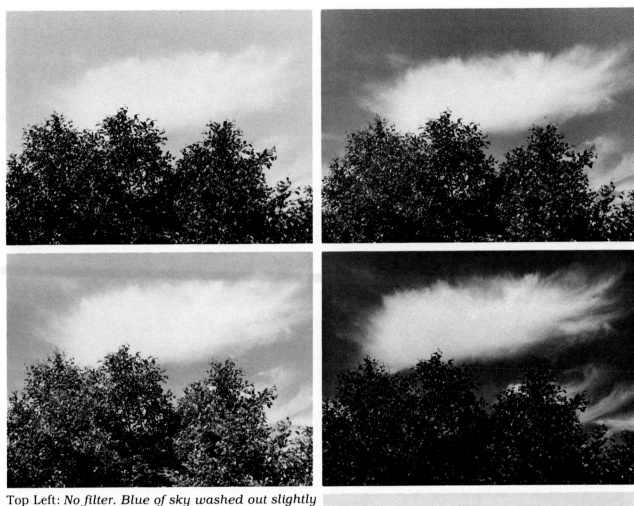

Top Left: *No filter. Blue of sky washed out slightly and recorded too light, resulting in insufficient contrast between clouds and blue sky.* Top Right: *Shot with #8 Yellow filter which absorbed excessive blue of sky, improving contrast between white clouds and sky.* Center Left: *Shot with #11 Yellow-Green filter, which some photographers use as a standard filter instead of a #8 for correction of panchromatic film. Foliage is lightened with this filter and sky appears more natural than in the unfiltered exposure, but the blue of the sky is only slightly darkened.* Center Right: *Shot with #25 Red filter. The blue of the sky is darkened considerably, creating dramatic contrast with clouds. Foliage is overly darkened. Consequently, this filter is not recommended for scenes where foliage is prominent and important. It is an excellent choice for dramatic seascapes.* Right: *Shot with #47 Dark Blue filter to illustrate nearly total transmission of blue light, which causes the blue of the sky to wash out almost entirely. This filter is not recommended for general scenic photography.*

Top Left: *A red rose (or any red subject) photographed against a background of green foliage without a filter will lack sufficient contrast between subject and background, since red and green have similar gray tone value when photographed with panchromatic film.* Top Right: *When a #25 Red filter is used, the red of the flower is transmitted to the film, recording the rose in lighter tones. The green of the foliage is absorbed by the filter and is darkened.* Left: *A #58 Dark Green filter has the opposite effect — transmitting the green of the foliage and absorbing the red of the flower for a very natural rendition.*

The light tan color of a deer can blend into a background of foliage in an unfiltered shot. Use the #25 Red filter, which will darken the foliage and increase the contrast. But don't use a red filter for a moose or black bear. You want to separate the dark subject from its background by lightening the foliage. The #58 Dark Green filter is best.

Recommended Filters for Black-and-White Photography

You don't need all of the many correction and contrast filters available. You can get by with a few if you carefully consider your needs and choose filters accordingly. Let me give you a brief rundown of the filters I carry with me and why I picked them.

The #8 Yellow filter I use for most of my black-and-white outdoor photography (see above) is the only yellow filter I own. Some photographers like a #6 Light Yellow for fast action or low light levels, but it only partly corrects panchromatic film, and its factor of 1.5X offers little significant exposure advantage over the #8. The #9 Deep Yellow only renders effects similar to those of the #21 Orange.

I often use the #21 Orange filter in the mountains. It adds a little more character to the sky in landscapes than the #8 Yellow, and it penetrates haze. I use it when I'm photographing boats or other marine subjects, since it substantially darkens the water without adding excessive overall contrast like a red filter.

Dramatic skies—especially above a crashing surf—tempt me to use a #25 Red filter. It absorbs most of the blue from the sky and water, greatly emphasizing white clouds and the froth of the breakers. Otherwise, I use it mainly for contrast when photographing flowers and other plant life.

For landscapes where trees and other plants are abundant, I prefer the #11 Yellow-Green filter, which I also use in wooded areas, meadows, marshes, and gardens. I use it for pictures of people and hands at work, because it markedly improves the rendition of flesh tones.

I don't often need to lighten a blue sky, but when I do, I'm glad I have a #47 Dark Blue. The main reason I own this filter is its superiority in emphasizing fog or haze in a landscape or waterscape.

My #58 Dark Green filter mainly enables me to lighten foliage significantly. It is a handy filter to have along to darken a red subject.

So a mere half-dozen filters take care of all my needs in black and white. At $7 apiece, it's the best 42 bucks I've ever spent.

Skylight and Haze Filters

The first filter recommended to most outdoor color photogra-

phers is the #1A Skylight. The skylight filter absorbs ultraviolet radiation that can cause distant scenes to be rendered out of focus, and its slight pinkish tint helps absorb excessive bluishness and warms the colors of cool-color film. Its effects are greatest on hazy or overcast days and in open shade, where the difference between filtered and unfiltered photographs can be dramatic.

Many photographers keep a skylight filter on the lens all the time to protect the expensive lens. Others argue that (1) the filter can reduce the performance of the lens; (2) if the filter gets dirty or scratched, it will diminish photographic quality; and (3) the filter can produce overly warm tones, especially with warm-color film.

The first argument is usually posed by antifilter oldtimers who remember when many filters—especially glass filters from many foreign manufacturers and importers—were of inferior quality. But today any optical quality filter from a reputable manufacturer is safe to use—unless it exhibits an obvious flaw, in which case it should be exchanged.

Argument number two is ludicrous. You can clean a dirty filter as you would a dirty lens. If a filter gets scratched, throw it away and buy a new one; it's cheaper than replacing a scratched lens.

The third argument is true for some photographers who prefer cooler colors. I happen to prefer warmer tones. Consider your preferences and act accordingly.

I keep skylight filters on my normal and telephoto lenses all the time. I'm comfortable with the extra protection for my lenses, and since I generally use Ektachrome 200 and Ektachrome 400 with telephoto lenses, I need the slight warming effect of the filter to get more natural colors.

I don't keep skylight filters on my wide-angle lenses because I tend to forget to remove them when I use other filters (resulting in vignetted negatives and transparencies, particularly on any lens wider than 35mm), or when I stack several filters, or when I'm using a wide-rimmed filter or lens attachment such as a polarizer. So I carry an extra skylight filter that I can use on wide-angle lenses when no other filters are required.

The #1A Skylight is useful in the mountains and for aerial photography or distant landscapes where scattered ultraviolet can cause problems. If haze is excessive, one of the haze filters such as the Tiffen Haze 1 or Haze 2A is better.

Skylight and haze filters can be considered clear, requiring no exposure increase.

Color-Compensating Filters

Color-compensating filters are used primarily in color printing, but they can be used in the field to deal with unusual lighting problems. They have descriptive designations. In the designation

USEFUL COLOR CONVERSION FILTERS

NO.	COLOR	FACTOR	EXP. INCREASE	PURPOSE OR EFFECT
80A	Blue	4X	2 f/stops	Balances Daylight film (5500°K.) for use indoors with studio floodlights (3200°K.).
80B	Blue	3X	1 2/3 f/stops	Balances Daylight film (5500°K.) for use with tungsten lights (3400°K.).
85	Amber	1.5X	2/3 f/stop	Balances Type A Indoor film (3400°K.) for use outdoors in daylight.
85B	Amber	1.5X	2/3 f/stop	Balances Type B Indoor film (3200°K.) for use outdoors in daylight.

CC30R, for example, CC is for Color Compensating; 30 refers to a density of 0.30; and R is for Red.

The filters are available in densities from 0.025 to 0.50; and they come in the primary colors (blue, green, and red) and the secondary colors (magenta, cyan, and yellow). They are usually gelatin filters; some are available as gelatin cemented in glass at a substantial price increase.

If you do a lot of night photography or other photography requiring long exposures, reciprocity failure can result in under-exposure and color shift. The exposure problem is easily remedied with the camera, but to control color shift you will need CC filters. There is complete reciprocity data on Kodak color films in the *Kodak Color Dataguide*. For data on other films, write the manufacturer.

Another specialized use of CC filters is color correction in underwater photographs with the CC30R filter, which is also useful for photography in some public aquariums where excessive blue-green light must be absorbed.

Conversion Filters

Color film is balanced for a certain quality of light; when it is put to use in other lighting conditions the color rendition will be incorrect. Use a daylight film indoors, under artificial light, and your slides will be veiled in yellow-orange or amber. Expose indoor film to daylight and the result is an overall bluish cast.

The accompanying table indicates which filters you need for conversion of daylight and indoor color film. If you only do a little indoor work and don't care to keep indoor film on hand, you might invest in a blue conversion filter. But if you do much indoor work consider using an indoor film for your color photography (indoors and out) and using an amber filter for conversion. The

reason for this is that amber filters require only a two-thirds f/stop increase in exposure, while the blue filters require as much as two f/stops.

My recommendation, however, is to match the film to its light source and forget about conversion filters.

Polarizing Screens

The polarizer is my most useful filter by far, especially for color photography. It is the only filter that can darken a blue sky and emphasize clouds in color film. It is equally effective in black and white and can be used along with other filters for startling effects on panchromatic film.

You don't need to know all the technicalities of polarized and nonpolarized light to use a polarizer, so I won't burden you with them. What you must know is what a polarizer will do, what it won't do, and how to use it.

There are polarizers available with series-type adapter rings, but the most popular ones are the direct-fitting, thread-mount type: a rotating filter with an outer rim that is threaded for mounting on the lens, and an inner rim that holds the filter and turns freely inside the rim.

A polarizer can be used to reduce or eliminate glare and reflections from smooth, nonmetallic surfaces; effectiveness will depend on the position of the lens, the angle at which the light is striking and reflecting from the photographed surface, and the angle at which you are photographing.

Look through the polarizer and rotate it until you get minimum glare. If you cannot gain sufficient reduction, try the shot from a different position. You can vary the angle at which you are photographing; you'll get the best results at about 30° to the reflecting surface.

If you are using a single-lens reflex camera you can view the subject through the lens with the polarizer attached, watching for changes as you rotate the filter, change position, and adjust camera angle. With a non-SLR camera, hold the polarizer in front of your eye until you get the right position, then keep that position when you mount the polarizer on your lens. The rotating rim is equipped with a small handle or is etched with a position-indicating mark such as an arrow or delta sign.

By eliminating reflections, you can get otherwise impossible photographs. I have used the polarizer to clearly picture alligators in the Florida Everglades, spawning salmon in the shallow headwaters of Alaskan streams, and the creatures that dwell in the tide pools along the Oregon coast.

There are limitations to use of the polarizer to darken a blue sky. Maximum darkening occurs when you photograph at a 90° angle to the sun. With the sun in that position, rotate the filter,

Used along with other filters and panchromatic film, the polarizer can create dramatic sky effects.

No filter.

Shot with polarizer and #8 Yellow filter.

watch the sky change color, and pick the effect you want. At maximum effect the position indicator will be pointing at the sun. The farther you get from a right angle to the sun, the less the sky will be darkened.

When you use a polarizer to darken the sky the subject must be frontlighted or sidelighted, because the part of the sky near the

Shot with polarizer only.

Shot with polarizer and #25 Red filter.

sun will not darken. When the sun is most directly overhead (noon in summer) the sky along the horizon will darken most. Northern and southern skies will darken best just after sunrise and before sunset, because north and south are at right angles to east and west.

The sky is darkened in varying degrees by a polarizer at differ-

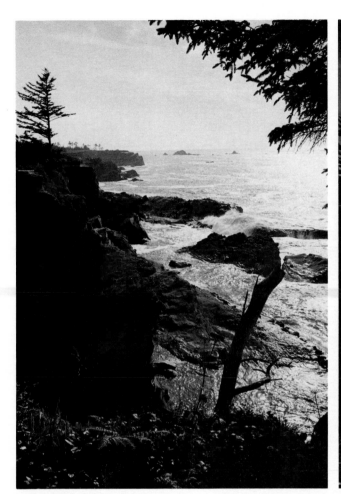

Left: *Backlighted seascape shot with no filter is rather dull and uninteresting.* Right: *The same seascape shot with a polarizer and #25 Red filter and underexposed by one f/stop is transformed into a stunning "moonlit" scene.*

ent times of day, according to your position relative to the sun. It's not as complicated as it sounds; with a minimum of experimentation, you'll get the hang of it. Anyway, with a polarizer you can see what the result will be before you snap the shutter. It's rather foolproof.

This wonder filter also provides better color saturation and improved color rendition in landscapes, because it reduces a good bit of glare you may not be aware of. While you are positioning yourself and your camera properly and rotating the filter to darken a blue sky, the polarizer will also be getting rid of a lot of silver-bluish glare reflected from the shiny surfaces of leaves and grasses. When this extraneous light has been controlled, other colors such as reds and yellows really come to life.

The polarizer is useful with black-and-white film when you need to control glare and reflections, or when you want to darken the blue of the sky without increasing overall contrast. If the sky and clouds are important elements of composition, you can emphasize them by coupling the polarizer with a #8 Yellow filter. If you're photographing waterscapes and marine subjects under a dramatic sky, use the polarizer with a #21 Orange filter. The #25

Red and polarizer will turn a blue sky black, and slight underexposure with this combination will give the impression of a moonlit scene.

We are told that a polarizer only works with sidelight and frontlight, but that should not prevent us from experimenting with backlighted subjects. I have used the polarizer shooting with the sun in front of me and have produced some arresting effects in scenes that include sparkling water. I suspect, too, that the polarizer helps control flare in such pictures.

The polarizing filter works best on clear days. Visible haze will reduce its effects, and on a completely overcast day the polarizer is of no value.

Exposure with a Polarizer

Polarizing screens are neutral gray and do not alter color rendition except indirectly, but, like most other filters, they reduce the amount of light reaching the film. Even the experts disagree on what the proper exposure compensation should be.

The directions for the first polarizer I owned gave the filter factor as from 2X to 8X, which meant that exposure compensation was one to three f/stops. How to narrow this down was left up to the user.

The editors of *Modern Photography* state in the *Photo Information Almanac '78* that ". . . unlike a regular filter which has a non-changing filter factor providing a constant-exposure compensation, the polarizing filter factor would be variable depending on the amount of polarization the filter was accomplishing."

Author Robb Smith, in his discussion of polarizers in *The Tiffen Practical Filter Manual*, writes, "Because average scenes will contain mostly non-polarized light, the polarized light held back by the filter is ordinarily unwanted. For the exposure, a polarizer can be assigned a general factor of 4X (2 f/stops)."

In the eighth edition of *Filters & Lens Attachments for Black-And-White and Color Pictures*, the Kodak editors state, "A polarizing screen has a filter factor of 2.5X (increase exposure by 1 1/3 stops). *This filter factor applies regardless of how much you rotate the polarizing screen*." (Their emphasis.)

Obviously this is a multifaceted problem, which is a toned-down way of saying "a real can of worms." The question is: Who is right? All these quotes are probably true in part.

Using SLR cameras with TTL metering, the meter reading for a polarizer can vary from one camera to another, depending on the camera's internal design and location of the meter cell. Hand-held light meters differ from model to model too.

Experts seem evenly split on whether the filter factor is affected when the quench ring or inner rim of the polarizer is rotated. My tests agree with Kodak. Test shots with the polarizer adjusted for

maximum darkening of the sky required the same exposure compensation as those for which the polarizer is rotated 90° from that setting.

On the two-thirds f/stop discrepancy between Robb Smith's and Kodak's recommendation on a general filter factor for the polarizer, I think individual preference and camera handling have a bearing. With my cameras and my polarizer, the *average* exposures made with a polarizer that appeal to me most are ones where I assigned the polarizer a factor of 2.8X (1 1/2 stops). But when I bracket normally, my additional exposures move one stop in each direction, so that in shooting three frames of a subject, my compensation ranges from a half stop to 2 1/2 stops. Or, working with a narrow-latitude film, I may bracket at half-stop intervals.

To determine how to use your polarizer, perform a field test. Load your camera with a narrow-latitude film such as Kodachrome 25, and pick a subject that includes a variety of details (a good landscape, for example). Be sure the sky is blue, preferably with some white clouds and no haze. Position your camera at a right angle to the sun for full darkening of the sky.

Shoot the first series of test shots without a polarizer, bracketing one-half and one f/stop over and under your meter-set exposure. With the polarizer on the lens, rotate it for maximum darkening of the sky, adjust your aperture according to the meter reading, and shoot another series, bracketing again at one-half and one-stop intervals. Rotate the polarizer 90° and repeat the series.

Take notes, recording frame numbers, shutter and aperture settings, and noting the frames exposed through the polarizer and the position of the polarizer. When the transparencies come back from the lab, project them on a screen in a dark room and compare.

Now you can not only determine the filter factor for your polarizer on your camera, but whether or not your light meter gives you accurate readings through a polarizing screen.

Some SLR cameras, because their meter cells are behind a semitransparent mirror, will internally polarize the light, causing a false meter reading when a conventional polarizer is used. If you have such a camera, use one of the circular polarizers, such as the B + W Circular Polfilter, distributed in the U.S. by E. Leitz.

Neutral Density Filters

This group of neutral gray filters, used with color or black-and-white film to reduce the amount of light that reaches the film, is available in densities ranging from 0.1 to 4.0, which transmit from 80% to 0.001% of the available light to the film and require from 1/2 to 13 1/3 f/stops increase in exposure.

MOST USEFUL NEUTRAL DENSITY FILTERS

NEUTRAL DENSITY	LIGHT TRANSMISSION	FILTER FACTOR	EXPOSURE INCREASE REQUIRED
0.3	50%	2X	1 f/stop
0.6	25%	4X	2 f/stops
0.9	13%	8X	3 f/stops
1.5	3.2%	32X	5 f/stops
3.0	0.1%	1000X	10 f/stops

If you are using a fast film in bright sunlight with your fastest shutter speed and smallest aperture and there is still too much light for proper exposure, a neutral density filter can solve your problem. Several neutral density filters can be used in combination for further light reduction.

Sometimes even medium-speed and slow film can be too fast. If you want to use the widest aperture possible to blur the background in an outdoor portrait or close-up of a flower, your fastest shutter speed may not be fast enough. You may still need the equivalent of a stop or two reduction in light. Use a neutral density filter.

Or perhaps you want to use slow shutter speed to pan a fast-moving subject and blur the background to give the impression of speed and motion, or to give fluid motion to a photograph of a waterfall, brook, or incoming wave. Your smallest aperture may not be small enough to reduce the amount of light sufficiently. Use a neutral density filter.

No outdoor photographer needs all of the available neutral density filters. Most of us can get by with two or three that reduce light in full f/stop increments; partial f/stop adjustments can be made with the camera's diaphragm.

The accompanying table should help you pick the neutral density filters that are best for your purposes.

Spiratone makes a neutral variable-density filter called the D-A-D (short for Dial-a-Density). By rotating the calibrated front component of the filter you can select densities from 3X to 10X. It is available in Series 7, Series 8, and in six thread-mount sizes from 49mm to 67mm.

Combination Filters

Many filter combinations besides those discussed above can be useful. Did you know that you can combine a #23 Light Red filter and a #56 Light Green filter to create nighttime photographs in daylight? If this strikes your fancy, and you'll be doing a lot of it, you'll be happy to learn that Tiffen makes a combination 23A + 56 filter for the effect.

COMBINATION FILTERS

DESIGNATION	MFGR.*	DESCRIPTION
3N5	W, T	#3 Yellow, plus N.D. 0.5
8N5	W, T	#8 Yellow, plus N.D. 0.5
85N3	W, T	#85 Conversion, plus N.D. 0.3
85N4	T	#85 Conversion, plus N.D. 0.3
85N6	W, T	#85 Conversion, plus N.D. 0.6
85N9	W, T	#85 Conversion, plus N.D. 0.9
85N1.0	T	#85 Conversion, plus N.D. 1.0
85POL	T	#85 Conversion, plus polarizer
85BN3	W, T	#85B Conversion, plus N.D. 0.3
85BN6	W, T	#85B Conversion, plus N.D. 0.6
85BN1.0	T	#85B Conversion, plus N.D. 1.0
85BPOL	T	#85B Conversion, plus polarizer
K-POL	B&W	#85B Conversion, plus polarizer

* Manufacturer abbreviations: W = Wratten (Kodak); T = Tiffen; B&W = B&W Filterfabrik (Kalt Corp.)

That's pretty specialized. One advantage of combination filters is convenience, one filter doing the job of two. Another plus is not having to stack two filters on the end of your lens—which is important when you use wide-angle lenses, since filter stacking can cause vignetting.

Check the table to see what combination filters are available.

Keeping Filters Handy and Organized

Photographic accessories are a nuisance when they aren't readily available and in some order. Filters are no exception.

Most filters come in plastic cases with friction-type or threaded lids that will keep filters clean and secure. If you use only a few filters, you should have no problem storing them in their original cases.

If you use a lot of filters, you will want a system for keeping them handy, organized, and protected. Filter cases and pouches are available from filter manufacturers and mail-order suppliers—you should be able to find something suitable. One I like is a padded flat pouch that folds and snaps closed and will hold six filters in clear plastic pockets. It slips into a carrying case or jacket pocket with no trouble, or it can be stored in any available narrow

slit between camera bodies and lenses, or will lie flat atop your equipment. The one I have is from Nikon, and a similar one is available from Porter's Camera Store.

A convenient, inexpensive way to store direct-fitting thread-mount filters is to screw them all together and cover the ends with a set of Spiratone Stackaps, consisting of a metal cap with male threads and another with female threads matched to the size of your filters. You can keep any number of filters between the Stackaps, which means you don't have to buy more pouches as you get more filters.

For More Filter Information

I heartily recommend *The Tiffen Practical Filter Manual*, by Robb Smith, as the best book I have seen on the subject. It is available for $4.95 from Tiffen or Amphoto.

You may wish to write some of the filter manufacturers and importers for literature. See A.I.C. Photo, Amcam International, Harrison & Harrison, Kalt, Ritz Camera Centers, Rollei, Spiratone, Tiffen, Uniphot/Levit, and Vivitar in the Directory at the back of the book.

WILDLIFE

Patience is the most important thing in photographing animals. Whether you are making your way through a dense rain forest to approach a black-tailed deer, crawling up a gully in a sagebrush prairie to close in on a herd of pronghorn antelope, or just sneaking down a backyard hedgerow to photograph a neighborhood cottontail rabbit, a slow, cautious approach is called for.

Many large animals, such as a big bull moose, a trophy whitetail buck, or a handsome Dall ram, make strong graphic images. Any adequately exposed and reasonably well-composed picture of such an animal will be eye-catching. With other animals the photographer must work harder to create a pleasing photograph. And often, working hard means waiting for the right moment.

Lighting is important in any picture; when you are working with live subjects that are free to move about at will, they often place themselves in unfavorable lighting. Since any movement to reposition your camera might startle the animal, you can only wait and hope.

Animals at rest can be uninteresting subjects, but the patient photographer who maintains a constant vigil—camera cocked and focused, aperture and shutter set properly—can catch moments of activity that can provide the impact to give you an appealing photograph.

You will also learn much about animal behavior and communication—not only communication among the animals, but communication between animal and photographer. You will learn, for example, that when a snowshoe hare that has remained dead still as you made your approach moves almost imperceptibly, as if to make sure its feet are still under it, it is about to bolt, and if you want its portrait you'd better get it now.

A young bull moose that obviously knows you are nearby but doesn't seem to care has allowed you to move slowly and cautiously toward him as he feeds on succulent vegetation. When he lays his ears back flat against his head, that's his polite way of telling you not to get any closer, buster, if you know what's good for you.

Some animals are easy to approach, even when they are aware of your presence; but if you rush in on them you will frighten

Two of the lightweight, portable Mini-Blinds available from Sports Haven.

them away. The porcupine, for example, is easy to overtake in the wild, but if you alarm it, it will aim its defensive hind end at you. If you try to circle, as most of its predators do, it will pivot on its front feet, keeping its rear-end quills pointed at you. But a slow approach and a reassuring posture will normally cause it to drop its defenses. Eventually its curiosity will overcome its fear, and it will turn for a look at you. That's when to snap the shutter.

The Importance of Cover and Concealment

Just as many wild creatures—predator and prey—depend on cover and concealment for survival, the wildlife photographer must learn to blend in with his surroundings. The necessity of concealment depends to some degree on what kinds of birds and animals he is seeking, but in general the less noticeable he and his equipment are, the better his chances.

Our human reasoning and planning enable us to outwit the most wily of wild creatures, but we should have due regard to the vastly superior senses possessed by most animals—senses we must try to elude if we are to get within photographic range of wild creatures.

Camouflage for Photographer and Gear

Camouflage clothing is not absolutely necessary for wildlife photography, but I recommend it. Unless you own such attire, wear subdued colors such as dull browns and greens, and select clothing that is soft and won't rustle as it scrapes against branches and bushes. Cotton, flannel, and wool are good choices.

Since my legs are often concealed in underbrush (or are inside

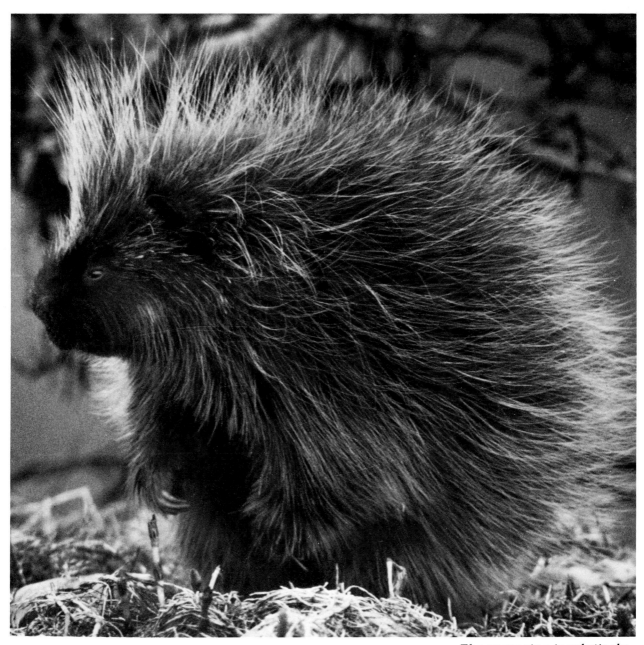

hip boots in wet, swampy terrain) I am most concerned with camouflage from the waist up. Nevertheless, I wear dull brown or olive pants. I wear a camouflage jacket—over warmer garments in cold weather—and a camouflage hat.

Two attention-grabbing areas are hands and face. Hands that move to adjust shutter and aperture or to focus a lens are easily detected unless camouflaged. And you must face toward your quarry to take its picture.

Camouflage gloves are available, but a pair of cheap brown cotton work gloves will suffice. They might not be warm, but they will let you feel the camera controls better than heavier gloves will.

The porcupine is relatively easy to approach, but if you rush in on him he will turn his quilled rump to you. A slow, reassuring approach can result in portraits like this one.

Wildlife
137

In cold weather, carry a pair of overmittens on a lanyard around your neck. When your gloved hands get too cold plunge them into the mittens, which are easy to slip off when you need to make camera adjustments.

You can cover your face with a mosquito head net or a camouflage ski-type mask designed for bow hunters. In warm weather you may prefer black, brown, or olive camouflage creams that you can spread on your face and hands. Cream kits are available at sporting-goods stores and archery centers. Use all three creams in a splotchy, camouflage pattern.

You will find camouflage clothing at sporting-goods stores and military surplus stores, and in mail-order catalogs. Kolpin Manufacturing offers one of the largest lines of camouflage clothes (see Directory at the back of the book).

Bright, reflective surfaces of equipment are another problem. The black finish available as an option on most camera bodies and some tripods is not as durable as the cheaper chrome finishes, but it is less likely to be detected by sharp-eyed birds and animals. Some outdoor photographers recommend wrapping bright surfaces with black tape, which is feasible for cameras but not for tripods. It is better to use camouflage bow-limb covers (available from archery suppliers) over the legs of your tripod and secure them with dull-colored twine or strips of Velcro.

Scraps of camouflage cloth are handy for covering equipment. With a few rubber bands, Velcro strips, or twine you can wrap cameras, lenses, and tripod. Camouflage material is often available at military surplus stores as old parachutes, artillery netting, and old clothing. Burnham Brothers (see Directory) sells camouflage material by the yard.

Natural Cover and Blinds

Even wearing camouflage clothing it is important to keep your outline broken up—a backlighted or silhouetted person in camouflage clothing, for example, is readily discernible.

Stay aware of your surroundings and the direction and intensity of the existing light. Try to move in shadow areas and to conceal yourself in the shadows. Use trees and brush to break up your outline; when settling in an area to take pictures look for natural cover, such as rock outcroppings, uprooted tree stumps, shrubbery, tall weeds, small thickets, and fallen trees, behind which you can conceal yourself. Such cover should offer an unobstructed view of a relatively open area.

When you use a tripod, if you and your equipment are properly camouflaged, you can often place yourself in front of a large tree and remain unnoticed. But if you are shooting with a hand-held camera or one mounted on a gunstock, hide behind something that offers a suitable rest for your camera.

In remote areas it may be impossible to carry in materials for building a blind, and you must use locally available materials. In fairly open woods, or at the edge of a woods opening onto a meadow or field, you can build a simple and efficient blind from whatever is there. Tie a branch horizontally, about 3 feet off the ground, to two saplings or small trees. Prop dead branches or willow sprigs against the horizontal branch for a blind to crouch behind. The branch also serves as a place to prop your camera.

You should be able to find plenty of driftwood along a river or creek to build a simple blind. A stacked-up pile of driftwood provides a blind that needs no further refinement. If driftwood is not available, willows are the best bet for building a natural blind.

On many lands—private and public—the cutting of live timber is prohibited, and rightly so. Even if cutting is permitted, try to get by with deadfall timber or driftwood. If you must cut, confine your cuttings to such plants as willow, rushes, and tall, sturdy weeds. Often you can use a sapling without cutting it down. Carry some heavy twine with you (I use decoy anchor rope) and use it to tie down a bent sapling, which will form the foundation of your blind, and stack a few dead branches and weeds against it.

Other Blinds You Can Make or Buy

Photography of birds, especially of the shyer species, calls for an efficient blind. Such a blind doesn't have to blend into the environment with a natural appearance, but must rather conceal the human form and all body movement. Tents are often modified to function as blinds, or a blind is built from a wooden framework to which cardboard is tacked or stapled. Holes are cut in the cardboard for observation and photography.

Specialists in bird photography often go to great pains and even place themselves in dangerous blinds. Blinds used to photograph nests in the tops of tall trees or on the sides of cliffs may have to be built on scaffolding to dizzying heights or placed precariously over the edge of a canyon rim.

You won't learn much from me about such blinds. I bow to the expertise of such renowned bird photographers as Karl Maslowski ("Photographing from a Blind," in *Outdoor Photographer's Digest*, edited by Erwin and Peggy Bauer, DBI Books).

I usually make blinds from natural materials, but I have constructed portable blinds from wooden stakes and chicken wire (to which brush and branches can be attached), rolled them up, and easily carried them afield. I have made semipermanent blinds with lumber and plywood, and have used light canvas and burlap with some success. Burlap does tend to shed lint, and when backlighted its coarse and loose weave will reveal body movements. Cloth used in constructing a blind should be secured to keep it from flapping in a breeze.

There are complete plans for building your own aluminum frame blind in Kodak's booklet *More Here's How* (Publication AE-83). You can substitute poplin for camouflage material if you don't want to put up with lint from the recommended burlap.

Relatively inexpensive portable blinds are available from Sports Haven (see Directory). Trademarked as Mini-Blind, they come in several configurations and sizes with prices starting about $60. The frame system consists of three legs, pointed at one end so that they can be pushed into the ground, and six hoop sections. Covers available include mesh or nylon in brown or green camouflage, Marsh Mat (a natural fiber mat material), and white mesh for use in snow.

The Mini-Blind covers are made in three sections so the photographer can part the cover at any of three spots to poke a lens through. The Model 10 Extra Tall (51-inch height) nylon models feature a perforated viewing screen at the top so the photographer can view his subjects while remaining concealed.

These versatile blinds assemble quickly (about 4 minutes) without tools. Heavy-duty nylon carrying bags are available too.

Handy Tools for Building Blinds

Carry a good knife and some strong, dull-colored twine for blind-building purposes. I carry a Buck Folding Hunter knife in a belt sheath at all times, and I keep several coiled lengths of decoy anchor rope in my pockets. With the twine I can tie back branches or secure a bent sapling for concealment. The heavy-duty knife is not only handy for cutting the twine, but for cutting brush and willow branches to dress up a blind.

For cutting larger branches from deadfalls or for felling small willow trees, nothing is better than a top-quality camp saw. For cutting brush and weeds to use in a blind or to clear underbrush for a blind site, a good machete can't be beat.

A staple gun is handy for tacking up camouflage material or sheets of cardboard, and can also be used to secure small willow sprigs in open portions of a natural blind.

A half-dozen lightweight tent stakes are useful in setting up a natural blind in relatively open country. You can use heavy twine or rope for guy lines running from the blind's supporting poles and secured to the tent stakes. A hammer or small camp ax is good for driving the pegs.

Comfort Afield

Being comfortable in the woods or on the marsh can be as important as being a competent photographer and knowledgeable naturalist, because even minor discomforts can impede the photographic process. If you're shivering from wet clothes and chill winds, you're going to find it difficult to hold a camera steady, much less to concentrate on a creative approach. And not

even the toughest outdoorsman can concentrate on photography if mosquitoes, flies, and other biting insects are raising painful pink welts on his otherwise leathery hide.

In the comfort category, adequate clothing is the primary concern. Naturally, in cold weather you want to dress warmly, and in hot weather you want to be able to combat oppressive heat. In either case, dress in layers.

A cold morning may warm up or get still colder. You should be prepared to shed layers of clothing if the temperature rises. If you are dressed comfortably when you set out, it's a good idea to have an extra sweater, wool shirt, or down vest along in case the mercury dips. Keep in mind that while you may be toasty warm hiking to where you plan to set up your gear, and certainly while erecting a blind, long hours of minimal activity inside the blind can chill you.

During the warmer months mornings are chilly in many parts of the country: a wool shirt under your camouflage jacket can keep you comfortable. Then as the sun raises the temperature at midday, it's easy to shed the wool and keep cool.

In the summer, even in the morning, don't make the mistake of going afield in short pants and a short-sleeved shirt. These clothes may keep you cool, but they provide little protection from insects and thorny plants. Covering your skin affords you better concealment, and better protection too. Wear lightweight trousers and a long-sleeved shirt and make sure the garments are loose fitting. The loose fit allows better circulation of cooling air and keeps mosquitoes and other insects from biting through the material.

Insect repellent is a must where pests are abundant. A good repellent is an aid to photography, since the sight and sounds of a photographer swatting bugs are likely to alarm any bird or animal. Apply the repellant to your clothing as well as exposed skin.

For face and hands I like Cutter lotion, the best for long-lasting protection of exposed skin. I use Deep Woods Off aerosol to spray collar, cuffs, and hat brim. Using this combination I am rarely bothered by bugs.

It's easy to get cramped while crouching in a blind or hiding behind a clump of rocks. Take something along to sit on. You can't depend on being able to find a suitable rock or log to use as a seat; anyway, such objects don't make the most comfortable of seats.

The Igloo Corporation sells a dandy little seat called the Hunt'n Seat Cooler, a three-gallon item that will hold plenty of ice-cold beverages for you and your partner. The deep top tray holds sandwiches and extra film, and the lid functions as a seat that will support up to 300 pounds. Its bail-type handle makes it easy to carry.

For years I have used a camouflage folding stool featuring a

zippered pouch under the seat and a shoulder strap attached to the folding frame. The storage pouch is large enough to carry a quart thermos bottle, rain suit, extra film, and odds and ends. It is also a place to lay equipment while switching lenses, loading cameras, or sorting through a selection of filters. The stools are available from Gander Mountain and Burnham Brothers.

Some photographers have criticized folding stools for their tendency to sink into soft mud, and it *is* a disadvantage in muddy terrain as in a waterfowl blind. But I rarely sit on my folding stool. I prefer to crouch and kneel in a duck blind for maximum concealment and a degree of mobility while operating a duck call. The stool serves as a table and a place to keep extra gear and a flashy thermos out of sight. When I get cramped up after a couple of hours of kneeling, I have a seat to use as a break in my routine.

One thing that makes kneeling in a blind more comfortable is a boat cushion. I can kneel on it for several hours at a time, and the loops attached to it make excellent carrying handles. You can carry a boat cushion into the woods to use as a makeshift seat.

Stalking Animals

One of the greatest challenges in wildlife photography is to get close to your subject without alarming it—close enough to adequately compose frame-filling photographs. Most mammals have better eyesight than yours, and if you are able to see your quarry, nine times out of ten it has spotted you. And if it is one of the few animals with poor eyesight, there's a good chance it has heard you or picked up your scent.

Most ungulates have supersharp senses of sight, smell, and hearing. Wild pigs, like bears, are myopic by human standards, but they more than make up for nearsightedness with an extra keen sense of smell.

A primary concern while stalking is wind direction. Approach the subject from downwind, and check the wind frequently to make sure it hasn't shifted. A brisk breeze will drive your scent away from the quarry and mask your sounds—if you're downwind. If you're upwind, the opposite is true.

Keen animal ears pick up not only obvious sounds like snapping twigs and crunching leaves, but branches rubbing against coarse material, loose change and car keys jingling in pockets, and hard boot soles clopping over rocky terrain. Leave loose change behind, and if you must carry car keys, wrap them in a handkerchief or tape them together. Try to avoid hard, rocky ground. Walk carefully, feeling with your feet as you go and watching for noise-making objects in your path.

Use available cover and land contours for concealment; walk upright only when the quarry can't see you. Despite what Hollywood would have us believe, man is the only mammal who walks

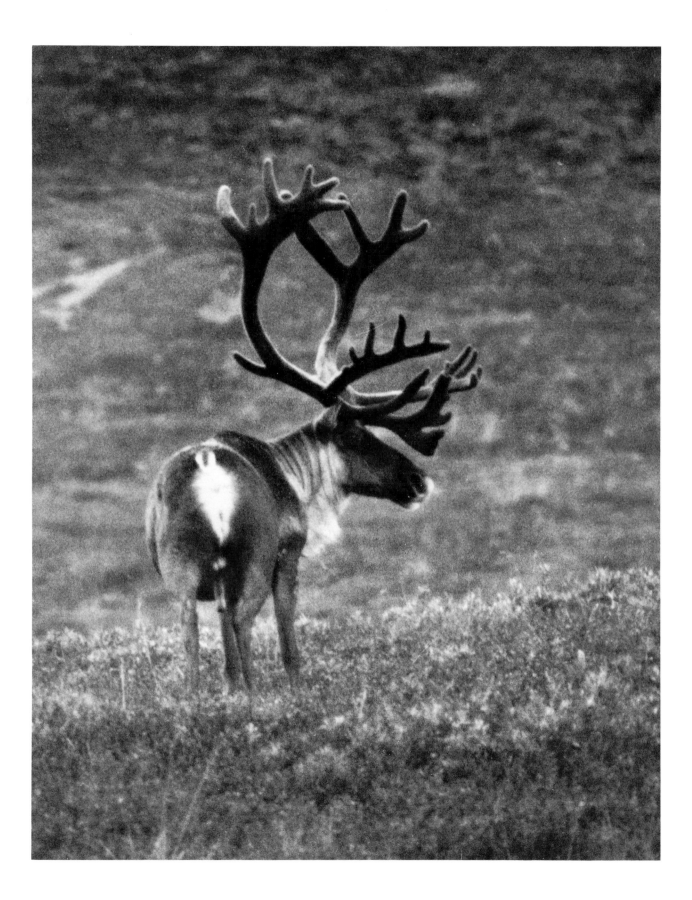

upright; since most animals fear man, they avoid anything that appears to be walking upright. So when crossing an open area or moving on the fringe of cover where your quarry might see you, crouch low, or crawl if necessary.

Take advantage of anything that distracts your quarry and draws its attention away from you. When it puts its head down to feed and is turned away from you or when its head is obscured by high grasses, that's your signal to move. But keep watching. When the animal lifts its head, stop, and remain still until it resumes feeding.

Courting and mating rites, territorial demonstrations, sparring, and fighting are other attention-diverting animal activities. Stay alert for them.

Spend some time, if you can, observing the subject before trying to stalk it. Often you can tell what the animal is going to do or where it is going. You may decide that stalking would be impractical or dangerous, or that the animal is moving in a direction that calls for your making a stalk at a different point. Animals that feed on the move—such as caribou—or animals that are traveling can often be intercepted along their course. You need only pick a point that you can get to with enough time to get your gear ready. Then hide and wait.

Scent Sense

A number of animals have been credited with strong or even foul odors, but the truth is that in nature few creatures are as smelly as a sweaty outdoor photographer. The natural human scent is strong and distinctive, and many animals have learned to associate that scent with danger. The smart photographer will not only try to keep his scent from reaching the animals he is pursuing, but will try to neutralize it.

Among the bottled scents or lures that hunters use to mask the human odor are glandular musks, anise oil, apple scent, and cedar oil. I prefer other ways of controlling my scent.

The musks that are supposed to appeal to the sex drive of the target animal may or may not be effective. My worry is that *they just might work*, and having to fend off the romantic overtures of a heavy-breathing bull moose is not my idea of good, clean fun.

Anise oil is sweet smelling with the odor of licorice. I have used it for scent-masking purposes for years when fishing. But anise oil is said to attract bears, and where those critters are concerned, I would rather be the hun*ter* than the hun*tee*. For the same reason, I wouldn't use apple scent in bear country. Also, during the warm months when insects are out in force, a sweet-smelling scent can attract pests. Cedar oil is known to repel moths and so might fend off pests while effectively masking the human scent.

The best way to neutralize your scent is to bathe well and use an

MAXIMUM ATTAINABLE SPEEDS OF NORTH AMERICAN WILDLIFE--MAMMALS

BIG GAME ANIMALS	MAX. SPEED MILES/HOUR	SMALL GAME ANIMALS	MAX. SPEED MILES/HOUR
Bear, black	30	Bobcat	15
Bear, brown/grizzly	35	Coyote	35 to 43
Bear, polar	25 to 30	Fox, arctic	20 to 25
Bighorn sheep	35 to 40	Fox, gray	26 to 28
Bison	32 to 35	Fox, red	26
Caribou	35 to 40	Hare, arctic	35
Deer, black-tailed	30 to 35	Hare, varying	30
Deer, mule	35	Jackrabbit	40 to 45
Deer, white-tailed	30 to 35	Lynx	10 to 12
Elk	35 to 40	Marmot	5
European wild boar	30	Raccoon	15
Javelina	30	Rabbit, cottontail	18 to 20
Moose	45	Squirrel, fox	10 to 12
Mountain lion	50 to 55	Squirrel, gray	12 to 14
Pronghorn antelope	60 to 70	Woodchuck	11
Wolf	35 to 40		

odorless antiperspirant deodorant. Avoid highly scented soaps, and don't use after-shave lotion, cologne, perfume, or cosmetics—they not only attract pesky insects, but can alert animals to your presence. The fragrances may mask the human scent but their unnatural odors can rouse the curiosity of your quarry and cause it to be wary.

Wildlife Action Photography

In chapter 2 I told you when you multiply the estimated speed (in mph) of your subject by 10 and convert the number to your nearest shutter speed, your subject will travel 1 inch while the shutter is open.

When photographing moving birds and animals from a fixed position, use the fastest possible shutter speed if you want to give the impression of stopping the subject. By studying the charts on maximum attainable speeds of North American mammals and birds you can take much of the guesswork out of determining minimum shutter speeds. For example, if you photograph a running marmot at 1/500 second, he will move only 1/10 inch while the shutter is open and will appear stopped in the photograph. The same shutter speed used to photograph a pronghorn antelope running past you would allow the animal to move more than an inch, and motion would be detectable in an enlargement or projection.

I prefer to shoot fast-moving subjects with a hand-held camera or one mounted on a rifle stock. Even then, I use the fastest possible shutter speed and pan the subject as it moves. With any moving animal or bird—even one moving horizontally—there is vertical movement too. If you are using a telephoto lens, camera

MAXIMUM ATTAINABLE SPEEDS OF NORTH AMERICAN WILDLIFE--BIRDS

WATERFOWL	MAX. SPEED MILES/HOUR	UPLAND BIRDS	MAX. SPEED MILES/HOUR
Black duck	45 to 50	Band-tailed pigeon	45
Brant	50 to 55	Dove, mourning	60
Bufflehead	40	Dove, white-winged	50 to 55
Canvasback	72	Grouse, blue	25 to 30
Eider: all species	45	Grouse, ruffed	50
Gadwall	45	Grouse, sage	25 to 30
Goldeneye: Barrow's, common	50	Grouse, sharp-tailed	35 to 40
Goose, blue	50 to 55	Grouse, spruce	30
Goose, Canada	45 to 60	Partridge, chukar	40
Goose, emperor	40 to 45	Partridge, gray	45
Goose, Ross's	40	Prairie chicken	30 to 35
Goose, snow	50	Ptarmigan, rock	40 to 45
Goose, white-fronted	45 to 50	Ptarmigan, white-tailed	40 to 45
Harlequin duck	40 to 45	Ptarmigan, willow	40 to 45
Mallard	60	Quail, bobwhite	50
Merganser, American	50	Quail, California	40 to 45
Merganser, hooded	45	Quail, Gambel's	25 to 30
Merganser, red-breasted	50	Quail, harlequin	25 to 30
Oldsquaw	45	Quail, mountain	35 to 40
Pintail	65	Quail, scaled	35 to 40
Redhead	50 to 60	Ring-necked pheasant	40
Ring-necked duck	45	Wild turkey	55
Ruddy duck	40		
Scaup: greater, lesser	50		
Scoter: all species	50 to 60		
Shoveler	60 to 65		
Teal, blue-winged	50		
Teal, cinnamon	45		
Teal, green-winged	50		
Widgeon	50 to 55		

motion will be magnified. Only the fastest shutter speeds can correct these problems.

Focusing a long lens on a fast-moving subject is difficult. Practice until you can focus quickly and naturally as a bird or animal moves toward or away from you. Sometimes you have time to move the lens ahead and focus on an area that the subject will probably reach. Then you can move the lens back to track the subject, and as it reaches the focus area, snap the shutter. This technique has worked best for me with waterfowl, especially when the ducks or geese are moving toward the camera.

Follow-through is as important for the wildlife action photographer as it is for the shotgunner. As you track the subject in the viewfinder, begin pressing the shutter release when the subject is properly framed and focused, and continue panning the camera. If you stop the tracking motion of the camera as you press the shutter release, your subject will not be in the same position on

the negative or slide as it was in the viewfinder. You may even decapitate the subject at the leading edge of the frame.

Be prepared for spur-of-the-moment photographs during a stalk or when you are moving from one area to another. Keep your camera at hand and set for taking pictures. Take meter readings as you move and make necessary adjustments of shutter speed and aperture. More than once I have been stalking one animal only to come face to face with another animal before I reached my quarry. Only by being prepared can the photographer get these bonus photographs.

Anticipate action, and be sure you have enough film to see you through it. Pay close attention to your film counter, and if you expect action, reload if you don't have at least a dozen frames left on a 36-exposure cassette.

Calling Wildlife

Those who haven't tried calling wildlife or have never been out with a competent caller are often skeptical about the results. My younger brother Phil and a college buddy of his were two such skeptics who, during hours of practice with duck and goose calls I gave them, had only succeeded in terrorizing the local barnyard fowl with their squawks and wails.

By the time I accepted their invitation to their blind on the banks of Ohio's Scioto River, they had been trying for weeks to call ducks into their decoys with no success. I had been introduced to calling two years earlier by an expert. I had purchased a calling record, had experimented with a half-dozen different calls until I found one I preferred, and had practiced for several hundred hours while commuting to the university—a nearly 50-mile round trip, four times a week.

We were in the blind well before sunrise on a frigid, blustery December morning, and within an hour I had made believers of my brother and his friend. Shortly after pulling in a lone mallard that talked back to me all the way into the decoys, I had a chance to show the worth of all that practice on an especially wary flock of black ducks. After their initial pass, the ducks circled the decoys six times, responding to every call in my repertoire—from a high-balling "greeting" to a pleading "come back" to the chattering "feeder" call. On their seventh pass they disappeared behind the trees along the far bank, only to appear at treetop level with wings set, necks outstretched, and landing gear down.

Later that day Phil's buddy told me, "If I live to be a hundred, I'll never forget the sight of those ducks gliding over the treetops, coming into our decoys straight at us—just as if we weren't even there!"

Since that memorable morning, my brother has become an expert caller in his own right. Every year we share a blind on

Idaho's Boise River, where we call in hundreds of mallards, as well as widgeon, gadwall, teal, and other waterfowl.

Get expert instruction in calling, or buy a calling record. Practice calling and observe and listen to the wild creatures you are trying to cajole.

Bird photographers often record calls afield and listen, practice, and imitate them on later outings. Cassette tapes are in wide use among bird-watchers and photographers. Get a cassette recorder/player with adequate fidelity for reasonably accurate reproduction and volume. My Sony Model TC-60, with carrying case and shoulder strap, has served me well for seven years, although I must admit it is due to be replaced.

Electronic callers are so effective that their use by waterfowl hunters is prohibited. They can be used by waterfowl photographers, but I prefer the traditional mouth-operated calls, because I have more control and can choose suitable calls.

When it comes to predator calls, though, I have come to prefer an electronic caller to the mouth-operated call I began with. These are distress calls that bring predators in close to investigate.

The best electronic calling equipment catalog is available from Burnham Brothers of Marble Falls, Texas, including a wide selection of electronic callers, cassette and eight-track recorder/players, more than three dozen cassette calling tapes, and a variety of eight-track cartridges.

Many mouth-operated predator calls and calling tapes imitate the distress cry of a grown cottontail rabbit, which is considered a universal call for predators. If you have heard this cry, it is easy to duplicate it with a mouth-operated call. If not, listen to a recording and practice until you have mastered it. Invest in an inexpensive mouth-operated call, even if you plan to use an electronic predator caller. A wooden or plastic mouth-operated call is small and light enough to go on outings where electronic gear would be impractical. If my purpose is photographing predators I take my electronic gear; on other trips where my purpose is general outdoor photography, I take a little mouth-operated call instead.

A predator call will bring in fox and coyote most readily; also wolf, bobcat, and lynx.

I have found calling predators within camera range to be less successful than waterfowl calling—perhaps I call ducks better. I am amazed at the number and variety of birds and animals that will respond to a predator call in some way. Crows, ravens, and gulls are usually the first creatures that come to investigate. I have also seen vultures soar high above, and have seen small songbirds land in nearby branches, chirping and carrying on nervously, as if worried about the nonexistent dying rabbit. Gray jays, Steller's jays, and magpies come investigating too, as do small nonpredatory mammals and deer.

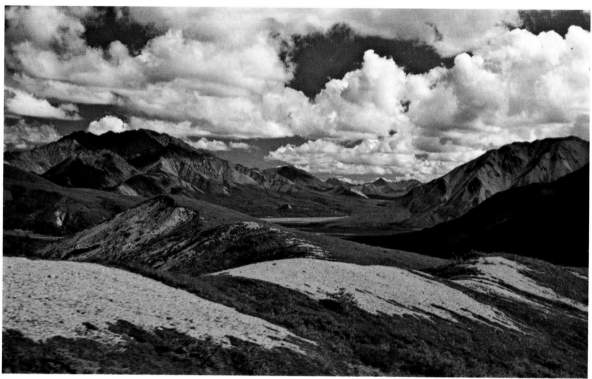

A valley in the Alaska Range.

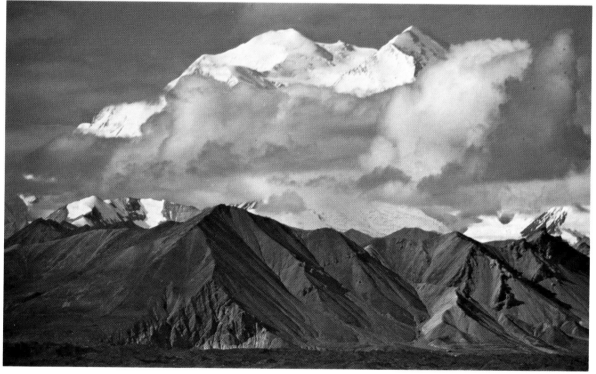

Mount McKinley photographed with a 200mm lens to emphasize gathering weather.

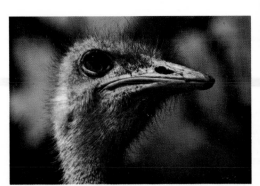

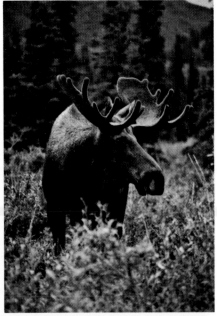

Top left: Portrait of an ostrich.
Top right: Alaskan bull moose.
Left: Cow moose feeding in a pond.
Above: Crowned crane in hazy backlight.

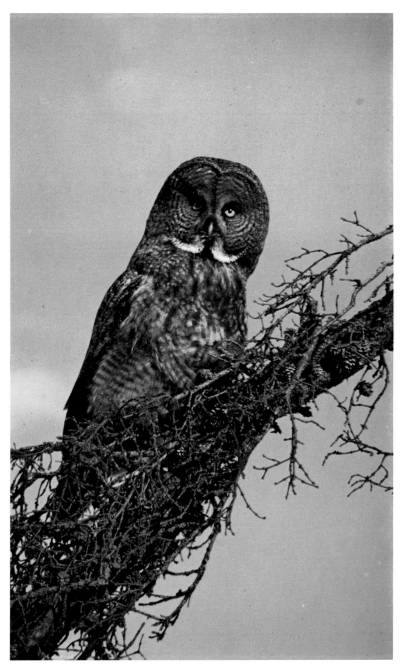

The rare great gray owl.

Black bear in Yukon Territory.

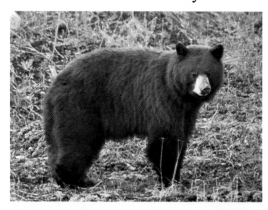

Prairie dog.

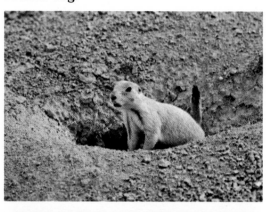

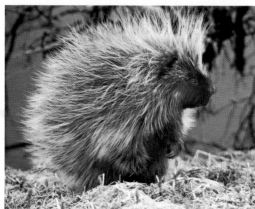

Porcupine.

Bull caribou.

Spike buck mule deer.

Top left: Backlighted cactus shot with black-card background and foreground reflector. *Top right:* Butterfly photographed on a cool early morning when it was sluggish. *Above:* Fireweed.

Left: Highbush cranberries in autumn; medium depth was selected in order to focus on the stumps in the foreground. *Center:* Dead weed against blue sky using a polarizer for contrast. *Right:* Alpine flowers photographed with Kodachrome for maximum detail.

Elfin Cove back harbor using f/16 for foreground flowers, overhead branches to fill dull sky, and a polarizer for color warmth and saturation.

Left: Yellow perch. *Right:* Jim Martin and leaping king salmon.

Haines harbor with derelict *Mary Ann* in the foreground, f/16.

Left: Snaking riverbed in the frozen Brooks Range.
Right: Aurora Borealis over the Bering ice pack using pushed high-speed Ektachrome.

Ice fog rising from Chena River.

Once I went where I had observed a pair of lynx hunting, concealed myself in the cover of some low-hanging spruce branches heavy with crusted snow, and made rabbit distress cries on my predator call. Within a few minutes a snowshoe hare loped up to within a few feet of where I was crouched and peered into my makeshift blind. With each succeeding muffled wail, the hare inched closer, as if trying to locate a friend in trouble. A minute or so later, a second hare showed up and sat beside the first. The two animals stayed two or three minutes more, then ambled off into the woods.

Without a calling device you can make a high-pitched squeal by pressing your lips tightly together and making an extended kissing sound. Purse your lips tightly. If you have trouble, press your lips against the back of your hand and make a prolonged kissing sound. You should learn to make the sound with your lips only, so you can do it while holding a camera to your eye.

Many small mammals have responded to this call. Once a sassy fox squirrel came charging down from its treetop perch, ran out to the end of a limb only a few feet from me, leaned out as far as it could, and with its rasping squirrel bark gave me the scolding of my life.

Birds and mammals will often come to a rather low-volume, high-pitched whistle made through the front teeth, with a *psssss-psssss-psssss* sound.

A loud shrill whistle is effective on animals large and small. A feeding deer whose head is obscured by foliage or whose rump is turned to you will lift its head and turn toward you after you have whistled at it. I have even had running deer stop and turn. The whistle will usually cause smaller mammals—woodchucks, marmots, and ground squirrels—to sit high on their haunches and pose for a portrait.

A memorable calling experience happened several years ago when I had a group of outdoor photography students with me at Mount McKinley National Park. I had rousted them out of their sleeping bags at 3:00 a.m. in the hope that we could make the 40-mile drive from the campground to Mount McKinley before the mountain became enshrouded in clouds as it usually does about midmorning.

About ten miles from camp a small animal skittered across the road from right to left and disappeared in the dense roadside growth. I pulled the van to a stop on the right side of the road and told my students we might be able to get a photograph of the little critter. Most of them were half asleep, all were skeptical, and nobody bothered to ready a camera.

I took a quick light reading and propped my camera on the van door; then I made a high-pitched kissing sound. The weeds and brush along the roadside rustled and were still again. Another

kissing call brought more movement in the foliage. Then several sharp, quick kisses drew the curious least weasel (rarely photographed in the wild) out of the leaves and branches where it posed for three quick bracketed shots. Everybody in the van started scurrying for cameras, switching lenses, and opening packages of film.

I continued calling and the little weasel walked across the road right up to the side of the van, and looked at me with beady black eyes, then turned and shot back into the foliage. The students complained that they had been unable to get their cameras ready in time; the weasel refused to respond to new kissing calls.

I switched to the *psssss-psssss-psssss* sound, whistling through my teeth. Out came the weasel, but this time it darted around the front of the van and looked up at the student in the seat beside me. The little critter stayed there just long enough for several students to fire off a few frames, then hurried back to the roadside cover.

Tips on Photographing Birds and Waterfowl

The abundant, varied birdlife in America offers every outdoor photographer—even the city-bound—unlimited photographic opportunities. The more you know about the habits and habitats of birds, the better your chances for success. So I recommend that you seek out and consult a good guide to American birds (see Selected Bibliography).

Many birds are tiny and most are hard to approach, so we must find ways that make it easy to fill a frame with avian subjects. Blinds and calls can bring birds closer, as can a long lens; telephoto optics are essential to good bird photography. Lenses capable of close focusing on small birds are necessary. Standard telephoto lenses can be fitted with bellows units, extension rings, or auxiliary close-up lenses to shorten their minimum focusing. Before trying to get good bird photographs with such a lens, practice focusing on bird-size objects to test out the lens.

Birds are creatures of habit. They are predictable. A given bird may perch on the same branch, time after time, day after day. On a larger scale, migratory birds navigate with pinpoint accuracy every year, flying as much as halfway around the world, adhering to schedules that our masters of modern mass transit should envy.

Birds keep using the same feeding areas, the same graveling spots, the same nesting grounds, the same flyways, the same watering holes. Some birds are always in the woods, others are in fields, coverts, marshes, along lakeshores or seashores, or in the mountains.

In my locale several varieties of gulls are native. Gulls are scavenging birds, so I can count on finding them near fishing boats, processing plants, and refuse areas. They are fond of soar-

ing on updrafts, so I can go to any area along the coast where there are cliffs, breakwaters, and seawalls that create good soaring currents to take in-flight pictures.

I can count on finding great blue herons in fair abundance along our coastal lakes and in the tideflats, year round. In the summer I'll find herons and snowy egrets sharing some spots. Another summer visitor to our tree-lined lakes and rivers is the osprey.

In the fall great flocks of waterfowl descend on our little chunk of coastal Oregon—some travel on south for hundreds, even thousands of miles; others live out the winter on our lakes, ponds, bays, and marshes.

In the nearby Coast Range Mountains I find mountain quail, California quail, and blue grouse. Throughout the coastal terrain are great varieties of songbirds, shorebirds, and raptors. Some are native, year-round residents; others visit us seasonally.

Feeding Stations

One of the best ways to attract birds and photograph them is to set up a bird feeder. An area that has few birds can be brought to life in a matter of days with one or more feeding stations. The birds will keep returning as long as they find food there.

You need not own a country estate in order to attract birds with feeding stations. City apartment dwellers can make good photographic use of bird feeders. A little over three years ago, when my wife and I moved into our town-house apartment, birdlife was sparse in the area. The first few months I noticed birds in the parking lot and in the adjacent trees and shrubs, but irregularly and rather infrequently. Within a week after putting out a small feeder, though, we had several dozen birds of five species showing up every day. The number of species and individuals increased during fall and winter, and has continued to grow annually.

In the summer native birds and summer visitors bring fledglings to the feeding station; we now have several generations of birds feeding here.

The varied thrush is a winter species that lives in the nearby mountains in summer. During our first winter here we had 4 of them (perhaps two mated pairs) at our feeders every day. The following year we had a flock of 11. Last winter I counted 19 feeding at one time, and I expect this year's flock to be even larger.

We have four permanent feeding stations now and other seasonal ones. Our hummingbird feeder goes up in late February to accommodate the first arrivals of these diminutive acrobats and is kept full of nectar until early August, when the birds disappear en masse. We hang other feeders in the trees to handle increased populations during the winter months, or to keep our birds fed when we are traveling.

Feeding activity is greatest during the winter, because natural

foods are scarce. It is important to keep the birds well fed through the winter if they have come to rely on the food supply.

At first we used wild birdseed, but now I save a good deal of money with 25-pound sacks of grain from a local feed store. We use chicken scratch that is processed for young chicks and is made up of several varieties of cracked grain. During the summer we use 50 pounds of feed, but in the winter we use a 25-pound bag every two weeks.

We scatter several handfuls of grain on the ground each day for birds that prefer to scratch and peck.

Try to make your feeding station natural looking. An old tree stump is good: make sure it has maximum visibility—yours and the birds'. (You need a clear unobstructed view for picture taking; the birds need to keep watch for predators, especially stray and feral house cats.)

Place the feeding station in a natural setting with nearby trees and shrubs. This provides you with a good background for photos, and the birds with cover.

Set up a perching branch 1 to 3 feet from each feeding station, and many birds will alight there before moving to the feeder. By focusing your camera on the perching branch and being prepared for the pause birds will make there, you can get some excellent shots. Use several feeders and a number of different perching branches to add variety to your bird shots.

When feeders are within camera range of windows in your house, garage, or outbuilding, the building functions as an efficient, permanent photographic blind. You can use a vehicle as a blind, as I do. Our feeding stations are near the edge of our parking lot, and the birds are accustomed to seeing vehicles parked there, so when I'm in our car or pickup truck, the birds pay no attention to me.

As birds keep coming to a feeding station they seem to get used to your photographing them. But they can be wary of objects that aren't normally near their feeders—such as a tripod-mounted camera. You need to get the birds used to a tripod so you can set one near a feeder for remote photography. Of course, it's risky to leave a tripod sitting outdoors, but it's easy to lash three straight branches together—tepee-style and tripod height—give them a coat of black or silver paint to match your tripod, and leave the assembly within camera range of a feeder. Then, when it's time to take pictures, substitute the real tripod. The birds won't know the difference.

Using Decoys Effectively

Another way to bring birds nearer your camera is decoys. Counterfeit birds won't attract all species, but some birds flock to decoys like relatives to Thanksgiving dinner: crows, doves, shorebirds, and migratory waterfowl.

Decoys play on the gregarious nature of birds which like to be with others of their kind. Decoys also can be used to incite anger, to indicate a feeding area or resting spot, to instill confidence of sanctuary, or to appeal to mating instincts.

Crows are most often decoyed by anger or hunger. They are sharp-eyed, elusive critters, but the sight of an owl drives them wacky. A great horned owl decoy set in a tree or on a fence is a good crow attractor. Seeing crows attacking an owl is impressive. The raucous birds gather in flocks, swooping, diving, cawing frantically, and harassing the hapless owl with reckless abandon. During their frenzy they appear to have no concern for anything but tormenting the owl, and are easily approached.

Place the owl decoy in an area of high visibility where you have observed crow activity. A lone tree that stands apart from a nearby woods is a good choice. If it is dead and has no leaves, all the better. Spring and fall, before and after trees have leafed out, are good times to use an owl decoy.

Erect a natural blind a day or more before you set out the decoy. Don't assume the crows will let their guard down; make sure you and your equipment are well camouflaged.

On the day of shooting, set the decoy out and be in the blind before daybreak. By working under cover of darkness you can make all necessary preparations without rousing the suspicions of the wary subjects.

When it is light enough to take pictures, if your decoy has not already attracted the crows, use a call to pique their curiosity.

Crows are also attracted by a spread of crow decoys in an open field. Pick a field adjacent to a woods or thicket where you can conceal yourself. Shuck a few ears of corn and scatter the kernels amid the spread-out decoys. Use a crow call or electronic caller to attract the birds.

Concealment is important when you attract shy birds like doves. Hang dove decoys in trees where you have observed roosting doves in the past. Watering holes frequented by doves are another good bet.

In the market hunting days shorebird decoys were plentiful and easily obtained. Today they have become valuable collectors' items. (Consult *The Art of the Decoy: American Bird Carvings*, by Adele Earnest, for many photographs and drawings of early shorebird decoys.) Many decoys were homemade; if you are so inclined and have a bit of spare time, you can make your own shorebird decoys of wood, cork, tin, even leather, fashioned to resemble herons, egrets, cranes, sandpipers, curlews, yellowlegs, bitterns, willets, dowitchers, plovers, and snipe.

The most readily available decoys are those used by waterfowl hunters. Try sporting-goods stores, department stores, and the mail-order catalogs of such companies as Gander Mountain, Orvis, and L. L. Bean.

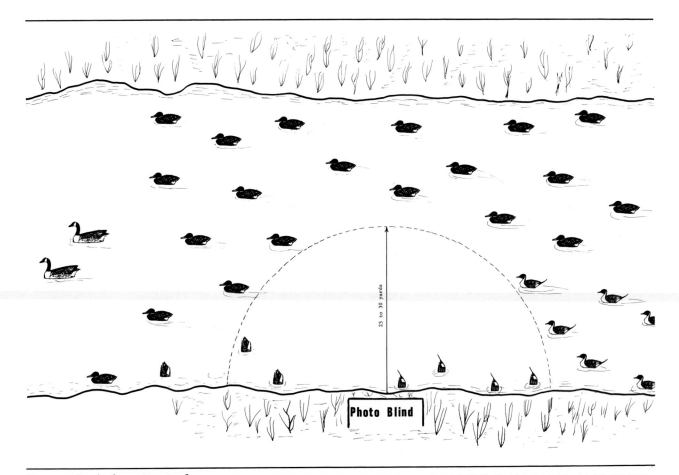

25 to 30 yards

Photo Blind

The author's favorite rig for decoying waterfowl on small rivers.

The subject of rigging decoys could fill a book—in fact, it has: *Duck Decoys and How to Rig Them*, by Ralf Coykendall, recommended for its in-depth study of effective waterfowl decoy sets.

Again, to fool waterfowl, learn their habits and habitats. The kind of decoy spread depends largely on the kind of duck you want to photograph. Rigs set for puddle ducks differ from those set for diver ducks. Of course, there are areas where you will encounter both, and rest assured, you'll have bluebills slipping into a puddle duck rig just as often as you'll draw mallards into a diver duck rig.

Divers are big-water ducks, to be found on bays and large lakes. You will find puddle ducks on rivers, sloughs, ponds, and marshes—especially near grainfields—although they are commonly found on large lakes too.

Diver ducks rest and feed in large, tightly grouped rafts, while puddle ducks are scattered randomly on the water. Be aware of this, not only to make your sets look more natural, but to keep from alarming your quarry. It is hard to pull puddle ducks into a set of closely rafted mallard decoys, because a tight group tells incoming ducks that the birds on the water have just arrived and have not had enough time to investigate the area, or something has made them uneasy and they are about to fly off. The incoming birds will probably flare and retreat.

To the nonwaterfowler or inexperienced waterfowl photographer this may sound too simple and even silly, but when you set out decoys, leave an open space in front of your blind for the ducks to land. It really works. The ideal spot for a blind is near a good resting area, a place rich in food—or, if on a river, a spot where the current is slack. On a lake I like to put a blind on a point with maximum visibility in most directions. On a stream I prefer the outside bank on a gradual bend that allows a clear view up and downstream. Small islands are a good choice, as are gravel bars, especially at forks in the stream.

You can get by with a dozen decoys on small ponds and streams. On larger rivers, use two or three dozen puddle duck decoys. The more decoys you set out for diver ducks on large lakes and bays, the better. Consider three or four dozen the minimum, especially during the fall when your spread may have to compete with many others.

Big-water logistics can pose problems for the waterfowl photographer. Since you need a large set to draw the attention of ducks passing over large expanses of water, rigging and retrieving decoys will take a lot of time. Deep water requires the use of a boat. I recommend that you concentrate your efforts on creeks, small rivers, shallow ponds, and marshes where you can use hip boots or chest waders when you rig decoys.

Variations in rigging decoys are limitless. I have experimented with many arrangements and have settled on one small-water set. I prefer a calm pool on a river 35 to 70 yards wide from bank to bank. I use three dozen decoys, which can be set out in about 30 minutes.

Most of my decoys—two dozen—are mallards. In the eastern U.S., black-duck decoys can be substituted for or mixed with the mallards. About a dozen decoys are scattered randomly across the river at the head of the set, with the farthest decoys 50 or 60 yards from the blind and the nearest 25 yards from the blind. The rest of the mallards are staggered along the far bank and downstream past the blind, leaving a semicircle of open water with a 25-or-30-yard radius in front of the blind.

At the tail of the set I scatter a half-dozen pintail decoys. In the absence of pintail decoys, mallard decoys can be used. I use the pintails because the drakes have a good bit of white in the heads, making them easy to spot, especially in the morning or on overcast days.

Two Canada goose decoys are set out front at the head of the set, about a third or halfway across the river. The geese are large decoys, easy to spot from a high altitude, so they serve as attractors. Second, since geese are cautious waterfowl, their decoys are a "confidence set."

Along the near shore, close to the blind, I set out tip-up-type

decoys that imitate feeding puddle ducks. They not only signal a good feeding area, but their placement near the blind makes them confidence decoys. The bright white of "duck butts" is easy to spot from above.

Some ducks (which I suspect of being dull-witted and unobservant) insist upon landing above or below the set, but the smart majority set their wings and slip right into that semicircle of open water in front of the blind. Everything is arranged to encourage them to do it. At the head and tail of the set, decoys are scattered from bank to bank. The best feeding area, as indicated by the tip-ups, is the shallow water in front of the blind, and the pintails appear to be moving toward that little patch of open water. If you were a duck, where would you land?

A couple of years ago, my brother Phil and I put out an identical rig on the Boise River. We were standing in front of our blind in the first glimmer of dawn, trying to see how the spread looked. "It doesn't look right, Kenn," Phil complained.

"What's wrong with it?" I asked.

"Well, I don't know. From upstream it looks OK, but from here it looks too, uh, well, regimented. Too planned. The hole in front of the blind just looks too obvious to me. I think we need a few decoys right there," he said as he stretched out his arm and pointed a finger to the open water about 30 feet in front of the blind.

The whisper of wings followed by a flurry of splashes caused us to freeze instinctively. Phil's arm was still outstretched. His finger, though it hadn't moved, was no longer pointing to open water, but to a flock of chattering mallards.

I grinned at Phil. He shook his head and said, "I'm not going to say another damned word."

We climbed into our blind and got ready for what proved to be an active morning of calling and decoying.

Waterfowl photography can be incidental to waterfowl hunting, which confines activity to fall and early winter. The pure waterfowl photographer is not bound by regulated seasons, and has other advantages over the hunter. Most important, he can concentrate his efforts on late winter and spring decoying. The waterfowl are less wary then, and they will be decked out in their handsome winter plumage. The colorful drakes especially are ideal subjects for color photography.

Also there is little competition from other waterfowl photographers. More than likely your decoys will be the only ones on the river, pond, or marsh, and you'll get plenty of action.

In the spring diver ducks are more inclined to enter the smaller streams and ponds, perhaps because they don't need the refuge of more open waters. So a small-water set is more apt to draw a greater variety of waterfowl in the spring than in the fall.

For flock shots over decoys, lenses ranging from slightly wide-

conflicts between man and beast, but for every story of a bear mauling a man, I have dozens of memories of people doing stupid things to bears. I have seen photographers traipse across open tundra to snap a picture of a sow with cubs. I remember a pair of Frenchmen I met in McKinley Park who waded across a river to a small gravel bar occupied by a huge, chocolate-brown grizzly sow and her cub—to get a picture. And the day the rangers caught them in another silly act and rescinded their photographers' passes, I saw them stop on their way out of the park to walk up on a cow moose and its twin calves.

Recently a woman in Wyoming was gored seriously by a bison, and I was reminded of a time on a South Dakota prairie when I stopped along a roadside to photograph a few bison off in the distance. There were several cows (one with a calf) and one very large bull in the small herd. They were slowly working their way toward me, so I waited for 45 minutes until they got within range of my telephoto lens. Other passersby were not as patient. Several grabbed up their pocket instant cameras and hiked across the open range right up to the buffaloes, as if they were photographing family pets.

I suppose what bothers me most about such displays of ignorance is that when people get away with a foolish approach to a dangerous animal, they'll do it again and again, and each time their fear is reduced a little more. Others who witness the stupidity also assume it is safe to get near these animals. Then it's only a matter of time before someone gets seriously injured or killed, and the animal, or several likely suspects, will almost certainly be executed in a misguided effort to prevent similar attacks in the future. What a senseless waste of wildlife!

Avoiding danger is a matter of using your common sense. If a situation can be made safe, do so. If you decide you stand a chance of being injured or possibly killed by an animal, ask yourself if a picture is worth that much to you.

LANDSCAPES AND WATERSCAPES

Many landscape photographs contain some watery elements, and most waterscapes rely upon land formations to give them depth and perspective. Landscape and waterscape photography are closely related and share the same principles. For simplicity, I will use "landscapes" to include waterscapes, unless it is important to make distinctions.

Landscape photography is the easiest kind of picture taking in some ways; in other ways, it is the most demanding and difficult. It doesn't make great physical demands on the photographer and it doesn't require sophisticated equipment, so most photographers shoot some landscapes, whether they are experts or not. Some excellent landscape photographs have been taken with simple, fixed-lens viewfinder or TLR cameras, even by beginners.

When a photographer decides to seriously go into landscape photography he learns how much there is to it. It calls for much thought and painstaking devotion to composition. The landscape photographer must spend time with his subjects, studying them and analyzing them, looking for the best possible camera angles and points of view. He must be a stickler for meticulous arrangement of details, searching always for that elusive element—visual impact. I consider the picturing of landscapes to be the most challenging and personally gratifying kind of photography.

Pick Apart a Panorama

The beginner tends to confine his interpretations of landscapes to the broad, all-encompassing, panoramic view. Panoramas are important, and when properly executed are often stunning portrayals of scenic vistas. But within a single panorama there may be dozens—even hundreds—of suitable landscape subjects. So don't be satisfied to snap the big picture and leave. Study every part of the scene, section by section, to seek out the details that can be subjects.

Look for the landscape within a landscape. Binoculars, a spotting scope, or a long telephoto lens will help you locate subjects. Search for interesting land contours, cliffs and bluffs, unusual rock formations, canyons or draws, meandering brooks,

The inexperienced photographer might pass over this area. At first glance, it is a dull-looking piece of real estate, but it does have a few things going for it. There's a creek meandering through the countryside. There's no wind to ripple the surface—a good chance to exploit reflections. And over by that tree on the left is an old fence, angling down to the creek. Could be worth investigating.

meadows, fields of wildflowers, waterfalls, an interesting tree or small grove of several trees.

Often in making a detailed search you will find a better point of view for the original panorama. If the panorama is an alpine scene with one tall, snowcapped peak dominating the composition, you may have recorded a pleasing image from your first vantage point. A short hike over the next hill may provide you with a different view, and several detailed subjects as well: a chrome-smooth pond which, placed in the foreground of the alpine scene, will mirror the magnificence of the mountain; or a patch of colorful flowers, a peaceful meadow, a winding stream, an old trapper's cabin or wooden fence.

Use a Tripod for Landscapes

Use a tripod for landscape photography whenever possible, and that is most of the time. Your subjects aren't going to be darting about, so using a tripod is no problem; it can improve composition and image clarity.

A tripod stabilizes your camera, thus minimizing camera motion. This is important in landscape photography, where you

And wasn't the short walk worth it? By focusing attention on the scene within the scene—searching for the elusive subject—the photographer was able to record this stunning image in an otherwise dull setting.

A wide range of lenses can be employed in landscape photography. Your choice of focal length should depend on your intention and your planned interpretation of the scene. In the accompanying series of landscapes, the same pastoral scene was recorded with lenses of various popular focal lengths. Notice how the character of the scene changes as the focal length is increased. Some details not apparent in the wider-angle shots become clear in the photos made with longer lenses. The barn, which is merely a subordinate detail in the wide-angle shots, becomes the subject in the photos taken with the longer telephoto lenses.

28mm lens.

35mm lens.

105mm lens.

135mm lens.

usually shoot at small aperture settings requiring very slow shutter speeds, especially with low-ASA film.

A tripod also makes you slow down physically. It takes time to set up a camera on a tripod and to find a good position. Moving a tripod takes time, as does the fine-tuning of camera and tripod. You have to look, study, think, and become intimate with your surroundings.

You become conscious not only of the broad view, but of all the subtleties of the landscape. You think, discover, and create. You find that every subject has a right point of view, a correct angle, a precise interpretation.

50mm lens.

85mm lens.

200mm lens.

Lenses for Landscapes

The most useful lenses for landscape photography are from 28mm to 200mm. Since good depth of field is called for, the wide-angle lenses are favored; but some effects can only be accomplished with telephoto lenses. The normal lenses are useful too, especially at the smaller apertures.

Wide-Angle Lenses for Landscapes

The primary use of a wide-angle lens is not sweeping panoramas. Photographers accustomed to normal lenses can be disappointed with wide-angle lenses if they concentrate on dis-

tant vistas, so that a range of mountain peaks or the craggy cliffs along a rocky shoreline, so awesome and impressive to the eye, are diminished to minuscule bumps and dents in the wide-angle photograph.

Camera position and angle of view pose problems for the beginning wide-angle photographer. Placing subjects or the horizon in dead center is even worse with this lens. Eye-level, straight-on shots reduce the natural contours of a landscape and flatten them out into a dimensionless rendering.

What is impressive about well-executed wide-angle landscape photographs is that they seem to surround your sensibilities and force you into the picture's point of interest. Everything is in acceptable focus; there are no out-of-focus distractions. You can clearly see what was immediately underfoot when the photographer snapped the shutter. And you are drawn into the distance by this sharpness of detail.

A normal lens only tolerates a minimum amount of tilting before you cut off the top of a mountain, tree, or windmill. With a wide-angle lens, however, you can tilt the camera quite a bit, bringing foreground details into the viewfinder while leaving distant objects intact.

From ground level you can create an imposing, dominating view. From an elevated position with your camera pointing down onto the subject you can display the intricate depths of a landscape, giving the viewer a detached sense of place, as if he were riding the thermal currents on eagle wings.

The wider the lens angle, the more the image is distorted. This is why lenses wider than 21mm are seldom useful for landscape photography. I recommend beginning with a 28mm lens; its distortion is minimal, yet its depth of field and field of view are considerably greater than those of a normal 50mm lens. For serious work, invest later in one or more wide-angle lenses at 21mm, 24mm, and 35mm.

Telephoto Lenses for Landscapes

When telephoto lenses bring distant objects nearer they have the opposite effect of a wide-angle lens, reducing or even eliminating perspective, and flattening the subject.

Telephoto lenses are most useful in mountainous or hilly country, where distant peaks can be pulled into the scene to loom over the objects in the foreground. Using a telephoto, the photographer can fill a frame with one mountain, or can stack vast expanses of rolling foothills atop one another in layers of varying shades and hues.

Sunrises and sunsets can often be greatly improved with a telephoto lens, especially when the sun is in the picture. Where a normal lens will render the sun as a tiny, unexciting dot, a tele-

photo can transform it into an imposing point of interest that dominates the scene. The same is true of night photography under a bright moon.

The most useful telephoto lenses are 90mm, 105mm, 135mm, and 200mm, or zoom lenses that incorporate these focal lengths. Lenses as long as 400mm are good for sun and moon shots.

A telephoto lens has shallow depth of field, so don't include foreground or peripheral details that will appear out of focus, and shoot at the smallest possible aperture to get all the depth of field the lens is capable of.

Landscape Lighting

The principles of lighting covered in chapter 6 apply to landscapes and waterscapes, but there are some special points.

Some qualities of light are easier to work with than others. We tend to think of our favorite lighting conditions as good lighting, and others as bad lighting.

I like the colors and strongly directional aspect of morning and afternoon sunlight, and I prefer to shoot under a haze-free blue sky with puffy cumulus clouds. My tendency to think of this lighting as good for landscapes is natural, but faulty. My favorite kind of lighting can be disastrous for some pictures.

The bright sunlight of a clear morning or afternoon that illuminates a sweeping landscape and creates the distinct shadows and highlights necessary to give the picture depth and dimension can wreak havoc on a forest scene. The photographer working in the woods under such light will find his subject areas a mishmash of harsh, bright highlights and deep black shadow areas. Under swaying branches and rustling leaves, random splotches of light chase one another over the forest floor, whimsically changing places with shadows and adding to the confusion. With bright, contrasty, directional light, photography in the forest will be problematical at best.

"Woodscapes," broad views of the wooded landscape, are out of the question in these conditions. Even a single tree will look too contrasty. Instead, concentrate on smaller sections of the woods that can be lighted by a single beam of sunlight poking through the forest's mantle: say, a solitary leafy plant or small patch of ferns, if cropped closely and exposed carefully.

The overcast sky so often bemoaned by landscape photographers is perfect for open woodscapes, where the purpose is to create an awareness of place in the viewer. In the forest on an overcast day, nondirectional lighting opens up the shadows and adds detail to them. Highlights are softened and more evenly distributed. Textures become apparent.

In open country under overcast, the first rule of landscape photography is to crop out the dull gray sky. Look for hillsides

Here's a typically thoughtless snapshot. Obviously the subject is a lake. Or is it trees? Or perhaps drab and ugly sky? Who knows? The photo has equal parts of all three elements. All we can ascertain is that it was shot from eye level and probably from the edge of the lake.

where you can make photographic studies of land contours. With color film you can photograph colorful fields of wildflowers or you can make comparison studies of the shades of green exhibited by trees, shrubs, and grasses. The diffused light of a hazy or foggy day can transform vivid colors into gentle pastels that are perfect for creating a mood of pastoral tranquility or peaceful solitude.

Cliffs, canyons, bluffs, and rock outcrops should not be photographed under the nondirectional lighting of an overcast day or under the midday summer sun. Such subjects gain depth and character when they are sidelighted by a sun that is bright enough to create distinct shadows in the cracks and crevices. Without shadows, the subjects are flat and uninteresting.

You must match your subjects to the existing light and prevailing atmospheric conditions. As *Popular Photography* editorial director Arthur Goldsmith has observed: "In the world of nature, there is no such thing as bad lighting; there is only lighting which is badly used."

Film for Landscapes

Your subject and the immediate circumstances should dictate your choice of film for landscape photography. Medium- and high-speed film is most useful for average conditions.

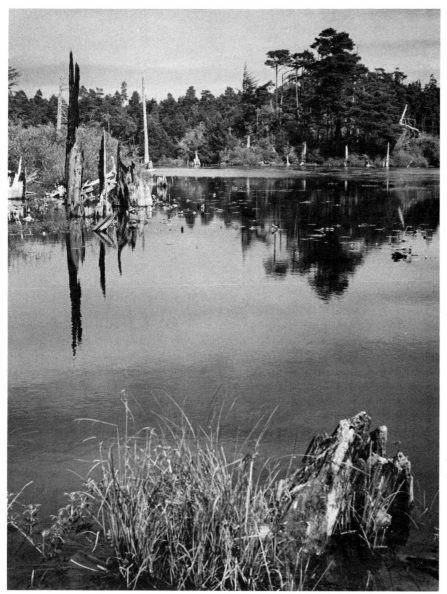

With a bit of thought the photographer found a vertical tension he could exploit. A few steps back from the water's edge and a few steps to the left enabled him to put an old weathered stump and shoreline grasses in the foreground. The low camera angle allowed him to crop out some ugly sky, and old stumps and their reflections helped balance overall composition.

My recommendation may be contrary to what you have heard or read, because many landscape photographers insist on using the slowest film in order to get the finest grain in their prints and transparencies. But there is more to picture clarity and sharpness than fine grain, and I suspect that many landscape failures result from using film that is too slow.

However, if your camera is mounted on a sturdy tripod, chances of excessive camera vibration are reduced. If your composition does not require near foreground or peripheral objects, you can use a wider aperture and faster shutter speed, which will also minimize camera motion. If it is a dead-calm day with no breeze to give you problems, you can use a small aperture and slow shutter speed with no trouble. In these instances, film such

as Kodachrome 25 and Panatomic-X are excellent choices if you insist on finest grain.

I rarely use slow, extremely fine-grain film, because I prefer to be prepared for average conditions; consequently, I like the extra speed of Kodachrome 64. There are times when that film isn't fast enough, and I use Ektachrome 200 for landscapes. For black and white I use Plus-X rated at EI 250 most of the time and Tri-X rated at EI 800 when I need extra speed.

I prefer to use a small aperture for maximum depth of field, shooting at f/16 with a normal or wide-angle lens. Sometimes I can get by with f/11 or even f/8, but rarely anything wider. This means I must set slower shutter speeds to compensate.

If I am using a hand-held camera, I am restricted to a minimum shutter speed of about 1/60 second, although I like a faster shutter better. If I am photographing a landscape in bright sunlight, I can use Kodachrome 64 at 1/60 second and f/16, or 1/125 second and f/11. Kodachrome 25—according to the formula I gave you earlier—calls for a shutter speed of 1/30 second at f/16. To shoot at 1/125 I would have to open up to f/8—and this is in bright sunlight. Overcast, cloudy skies, or shade will call for even wider apertures or slower shutter speeds.

That's one reason I use a tripod for nearly all of my landscape photography. But a tripod is not a complete solution of the shutter/aperture problem. Consider wind: a light breeze will not cause excessive vibration in a camera mounted on a sturdy tripod, but it can create movement in the subject area. Grasses, leaves, flowers, and tree branches sway in the breeze and will blur if you are using a slow shutter speed.

To effectively stop the motion of foliage in the lightest breeze requires a shutter speed of at least 1/125 second. A brisker breeze calls for 1/250 second, and a stout wind, such as is experienced regularly along the coast or in the mountains, calls for 1/500 or 1/1000 second, not only to stop the rustling of plants, but to negate the effects of excessive camera vibration.

So, even if you use a tripod you may need fast shutter speeds. And if you need the depth of field that can only be accomplished with a small aperture, the only way you can record the image is with a medium or fast film. If you live in a windy area you will learn to rely on faster film for much of your landscape work.

Most filters used for landscape photography require additional exposure to compensate for the light loss they cause. In color, a polarizer reduces the amount of light reaching the film. In black and white, a polarizer, and yellow, green, orange, and red filters commonly used in landscape photography reduce the speed of your film.

Recently a friend wrote me about some baffling results he got on a trip when he used Plus-X and Tri-X rated at ASA exposure

indexes of 125 and 400. "I know this sounds crazy," he said, "but the prints I made from the Tri-X negatives are far better than those made from Plus-X. They're crisper. How can that be?"

He was expecting an argument from me, but he got none. Rather, I explained that since so many factors affect image clarity, it is possible to get clearer pictures with coarse-grain films than with fine- or extremely fine-grain films. I created a hypothetical landscape to illustrate my point:

Assume that you are photographing a landscape with two tripod-mounted cameras—one loaded with Plus-X, the other with Tri-X. There are some interesting plants in the foreground that you want to keep in sharp focus. The sky is lightly overcast—rather dull and uninteresting—so you crop a lot of it out, and to conceal some of the flat gray of the remaining sky and add depth to the picture you use some overhanging leafy tree branches to frame the scene. In the field of view are several trees and some tall grasses, flowers, and other plants. A slight breeze is blowing—just enough to stir the foliage.

Depth of field is critically important for this picture, and you want to shoot at f/16. If you convert the speed of Plus-X to the nearest shutter speed, you know that you can shoot at 1/125 second in bright sunlight. But the light overcast means you will have to shoot at 1/60 second.

Now you put a #8 Yellow filter on the lens, which cuts the light in half and dictates a shutter speed of 1/30 second if you are to maintain the f/16 aperture. If you crank up to the minimum recommended shutter speed of 1/125 second to stop the motion of the foliage, you will have to open the aperture to f/8, which will throw the near foreground and framing slightly out of focus. Either way, overall image sharpness is going to suffer.

With Tri-X the yellow filter reduces the exposure index to 200, which means you can set the camera for 1/250 second at f/16 in bright sunlight. Under light overcast, you will have to slow the shutter to 1/125 second, which should be adequate to still the rustling foliage. If the breeze picks up a bit, you can shoot at 1/250 second by opening to f/11, which is probably a small enough aperture to keep nearby objects in reasonably good focus.

The result is a sharper picture with Tri-X than with Plus-X.

Seasonal Landscapes

If you live in a part of the country with distinct seasonal changes (and that includes much of the U.S.), be watchful for landscapes that lend themselves to seasonal studies. The scene you photograph in summer—under blue skies and dramatic cloud formations, fields laced with wildflowers, trees and shrubs laden with greenery—is starkly different in the winter, except for familiar landmarks. Spring and autumn will also be dissimilar.

You can include identifying elements that call the viewer's attention to the season.

Deciduous trees and shrubs which shed their leaves annually are important. They bud and blossom in spring, are fully leafed in summer, are ablaze with color in fall, and pose starkly denuded with skeletal branches outstretched in winter.

The mood of a mountain changes dramatically from season to season, so alpine settings are good seasonal studies, as is a meadow brook or mountain stream. In spring, the stream runs roily and bank-full, and may flood low-lying areas. In fall, the stream is lower and as clear as vodka. It will keep changing during the winter: capture its moods during frequent trips to the locale.

If you want to show the viewer the changing seasons through one scene, your camera should be placed in exactly the same spot for each picture. Orient yourself with landmarks, and take notes. If possible, measure exact distances from nearby stationary objects: a tree, a fence, a boulder, a hedgerow. Use the same lens for each picture too.

A seasonal study calls for four pictures, but two pictures—a summer and a winter shot—can be effective too.

Photographing Lakes and Streams

Many waterscapes suffer from the eye-level syndrome—the same straight-on, heads-up shooting position that ruins so many wide-angle landscapes. The cure is simple: look for high vantages for waterscapes, or shoot your picture at water level with a wide-angle lens.

Eye-level shots of lakes and streams lack depth. The foreground of empty water exhibits no contours or interesting detail; the surface of the water becomes an intruding horizontal line that divides the picture in half.

From an elevated position you can include shoreline contours that will add visual appeal to the photograph. By aiming downward you crop out unnecessary sky and render a more dominant, imposing view. Include foreground and framing elements to increase the depth of the picture and improve overall composition.

When you shoot from water level, preferably with a wide-angle lens, and certainly with the smallest possible aperture, you need an impressive foreground that will be kept in sharp focus with maximum depth of field: shoreline lily pads on some lakes and ponds or rocks beneath the surface in shallow foreground water on clear lakes and streams—here you may need a polarizer to eliminate surface reflections.

If you can't get to high ground, and if you can't find interesting foreground details, don't make the common mistake of shooting from the water's edge. Back up just enough to include a portion of

the bank or foliage underfoot. This will tighten up overall composition and draw the viewer into the waterscape.

Small streams are good subjects for waterscapes and are good subordinate details in landscapes. Try to have the stream run into the picture from the bottom of the frame, rather than running out of the frame. The picture should contain the stream. Winding streams that allow you to incorporate sweeping S curves in the composition enhance visual appeal.

Riffles, Rapids, and Waterfalls

In the late 19th and early 20th century, some of the best images recorded by outdoor photographers were cascades and rushing streams. The slow emulsions of that era required lengthy exposures that resulted in pictures that captured the fluid movement of the water.

Although we now have film with fast emulsions and cameras that can expose film for 1/1000 second or less, the most effective photos of riffles, rapids, and waterfalls are still made at slow shutter speeds that allow the moving water to blur in the direction of the flow for a convincing depiction of motion. Some vertical waterfalls and rushing rapids can be shot with shutter speeds as fast as 1/30 second. Average fast-water scenes are shot at 1/15 to 1/4 second (I always bracket the exposures widely), while a tame brook may call for a 1/2-second exposure.

Maximum depth of field is essential: I try to use aperture settings of f/11 or smaller. As I vary shutter speeds to assure the proper effect of motion, I rely heavily on neutral density filters.

Match the film to the existing light; slow and medium speed is best. In bright sunlight you need the slowest film—Panatomic-X for black and white, Kodachrome 25 for color. The streams and waterfalls in shaded woodlands can be well photographed with medium-speed Plus-X and Kodachrome 64. Only in the dimmest light in deep shadows do you need a faster film.

Let's assume I have found an attractive stretch of stream tumbling over rocks in open shade. The water is bubbly and turbulent enough to create the effect I want, and I estimate an exposure of 1/8 second. I not only want to assure proper exposure by bracketing as usual with overexposures and underexposures, but I want to vary the shutter speeds from 1/4 to 1/15 second while using the smallest possible aperture for maximum depth of field. The only way to accomplish double bracketing is to use the proper film and neutral density filters.

For color I use Kodachrome 64. For black and white I use Plus-X rated at ASA 125, which, when exposed through a #8 Yellow filter, has the same exposure value as the Kodachrome 64. These films in bright sunlight would call for an exposure of 1/60 second

Left: *A shutter speed of 1/60 second was only slow enough to slightly blur these twin falls.* Right: *A setting of 1/15 second was slow enough to depict water motion. Film was Plus-X rated at EI 250 and photo was recorded with #8 Yellow and 4X neutral density filters.*

at f/16. The subject in the open shade requires 1/15 second at f/16, and that is my first exposure. I would overexpose the next frame by opening the aperture to f/11. To complete the exposure bracketing and underexpose the third frame, I would stop down to f/16, and would then also attach a 2X neutral density filter to the lens.

For the next series I shoot at 1/8 second, with exposure at f/16 with the 2X neutral density filter. To overexpose one frame, I remove the filter. To underexpose the next frame, I use the same shutter and aperture, but with a 4X filter.

The last series is shot at 1/4 second. First frame is at f/16 with a 4X neutral density filter. To overexpose I switch to a 2X filter, and to underexpose I use an 8X filter. If I don't have an 8X neutral density filter, I can stack the 2X and 4X filters for the same results, but this may cause vignetting with a wide-angle lens, particularly with black-and-white film which is also being exposed with a #8 Yellow filter.

This may seem like too much shooting for one subject, but I have gone to some trouble to locate the perfect spot for my camera and to set up the best possible composition. The exposure of nine frames is not a waste of film, but a matter of assuring me of one frame that will be precisely exposed and that will depict the fluidity of the tumbling stream. It's worth it.

The motion of this cascading little stream was nearly stopped with a shutter speed of 1/125 second.

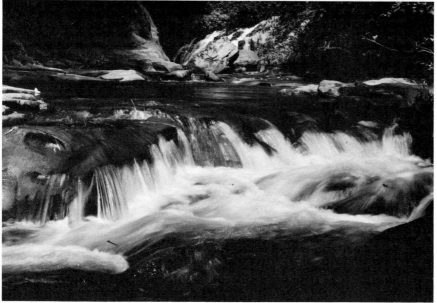

The 1/8-second setting for this frame adequately depicted the movement of the water. Film was Plus-X rated at EI 250. Filters were #8 Yellow as well as 2X and 4X neutral density.

Some Tips on Seascape Photography

The coastline of America offers the outdoor photographer an infinite array of exciting, appealing subjects, from vast expanses of sandy beaches to towering dunes, craggy cliffs, raging surf, quiet lagoons, estuaries, tide pools, lighthouses, and breakwaters—and the list goes on.

Again, it is important to vary the camera angles and positions in shooting seascapes. And again, photographs from elevated positions or taken at water level with a wide-angle lens will have more impact than a thoughtless, eye-level shot.

Waves are important elements in many seascapes, and can be

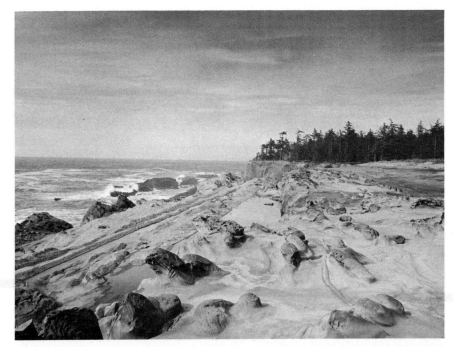

A typical thoughtless seacoast snapshot finds the horizon at dead center, which splits the photo in half and includes far too much dull, overcast sky. The capabilities of the 28mm lens were wasted here, and what a shame, with all the potential foreground elements available.

excellent subjects in their own right. For a distant seascape a shutter speed of 1/60 second is enough to stop the motion of incoming waves. To depict the fluid motion of incoming waves, use the technique above for photographing rushing streams. Correct shutter speeds depend upon the speed of the waves and their tumbling action, but generally, the higher the surf, the easier it is to depict motion. A good starting point is 1/8 second, bracketed at 1/15 and 1/4 second.

Waves crashing over reefs, jetties, seawalls, or rocks are good subjects for dramatic stop-action photography. Use the fastest shutter speed your camera is capable of. Position yourself so that the wave is strongly backlighted, and shoot from a low angle if you can. The idea is to halt the wave at the peak of its crashing action, suspending the myriad droplets of water against the strong backlight. To vary the effect, experiment with a cross screen or diffraction screen attached to your lens (see also chapter 12).

There are dangers associated with this kind of photography, ranging from you and your equipment getting drenched by a large wave to being overtaken by a wave and carried off by strong currents. A little more than a year ago a young man climbed out on a rock to photograph waves near Bandon, Oregon—just south of where I live—and was swept off the rock by a wave, carried out by a strong undertow, and drowned.

Before putting yourself in a potentially dangerous position, observe the waves and wave patterns for 15 or 20 minutes. You will notice that some waves are higher than others. Know where the highest waves are crashing, and stay out of their way.

On windy days, blowing sand and salt spray are a threat to your equipment. Keep your camera covered with a plastic bag, remov-

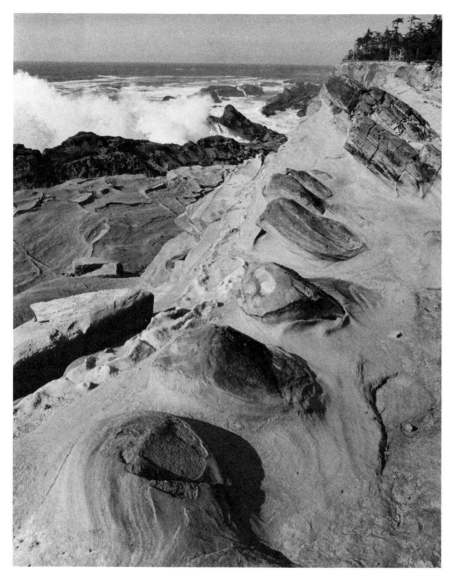

By overcoming a case of "horizontalitis" and switching to vertical format, the photographer exploited the contours of the coast. Tilting the camera downward allowed him to crop out most of the ugly sky and to include interesting rock formations in the near foreground. An aperture of f/8 and the inherent depth-of-field capabilities of the wide-angle lens kept everything in focus. Timing and a shutter speed of 1/1000 second caught the crashing surf. And the diagonally vertical tension naturally draws the viewer into the heart of the picture.

ing the bag only to take a picture. Make sure auxiliary lenses are capped at both ends, and at day's end, thoroughly clean all your equipment.

The Lure of Waterfront Photography

Many artists and photographers like waterfront scenes. A waterfront speaks of man's relationship with his environment, and of his dependence upon nature's waterways.

At first glance a busy waterfront is a blur of confusion, even for the seasoned photographer with a skilled eye for composition. Like a child in a toy store at Christmastime, the photographer finds almost too many subjects that seem to compete for his attention. Structures of all sorts—bridges, piers, docks, buildings, and boats—are tempting.

Good waterfront photography is reasonably easy if you spend

Landscapes and
Waterscapes

the time to sort out the details and isolate the subjects. Choose framing and foreground elements from pier pilings, bridge girders, dock railings, mooring cleats, and boat rigging. Work ropes, nets, crab pots, and lobster traps into the composition. There are plenty of linear elements that can be arranged to draw attention to the subject and add perspective to the picture.

My favorite time of day for waterfront photography is early morning, just after first light, when no breezes are stirring. Flat and glassy water surfaces mirror many images then, boats rest placidly in their moorings, and there are few people around to get in the way of my work. Early morning is a good time to slip a skiff into the water and explore photographic possibilities from water level.

Visits to a coastal or Great Lakes area can introduce you to waterfront photography. If you take plenty of time to plan your shots, and if you are on location by sunrise, you should be handsomely rewarded for your efforts.

TOOLS AND TECHNIQUES FOR CLOSE-UPS

11

At the beginning of Kodak's technical publication #N-12A, *Close-up Photography*, is an evocative observation: "Our entire planet offers an astronaut in space only one photographic subject." The correct implication is that we earthbound shutterbugs have an endless variety of subjects to photograph. As every outdoor photographer discovers when he ventures into the realm of close-up photography, the nearer we get to earth, the more there is to photograph.

Like other wildlife photographers I have traveled hundreds of miles and spent days observing, searching, and stalking big-game animals to get a few good pictures. I have traveled as far and devoted as much time to getting photographs of waterfalls, bridges, mountains, and seascapes. But when I have spent a day in close-up work only a few miles from home or a few steps from camp, in an area no larger than a football field, I have exposed hundreds of frames that added dozens of usable negatives and transparencies to my subject files.

Close-up photography opens up new worlds to the outdoor photographer. The wildlife photographer who finds his untamed subjects uncooperative can turn to subjects underfoot. The landscape photographer faced with gloomy days and putty-gray skies can shoot miniature landscapes at ground level. The urbanite or suburbanite who doesn't have time for a trip to the mountains, coast, or country can find exciting subjects in his backyard, neighborhood, or nearby park.

Close-up subjects are diminutive and often mundane, but the photographer's individual point of view can turn the most commonplace subjects into exciting pictures. The lowly dandelion has been the subject of more than one published or prize-winning photograph. Common insects, pebbles, spiderwebs, tree bark, and leaves have enjoyed similar recognition.

Coming to Terms

Photography sometimes seems overburdened with terminology, but accurate use of the language of photography is basic to communication. Unfortunately, in close-up photography terms with different meanings are often used interchangeably, and other terms are twisted about or misused.

Take the terms "macro" and "macrophotography." The latter should be "photomacrography," the product of which is a photomacrograph, not a macrophotograph as many photographic writers would have you believe. Photomacrography is close-up photography that produces images on film with reproduction ratios of 1:1 (life size) or larger. Enlargements of negatives or projections of transparencies are many times life size, and are magnifications. Almost all photomacrography is a specialized form of close-up photography, perhaps most useful scientifically.

The terms have crept into our everyday photographic vocabulary: photographers and writers often refer to all close-up work as "macro," and all lenses capable of close focusing as "macro lenses."

The manufacturers are not without fault in perpetuating this confusion of terms. Dozens of lenses, mostly zooms, have appeared sporting the macro label when they do not approach macro capabilities, but rather, focus somewhat closer than normal lenses do.

The confusion of terms makes it impossible for photographers to make reasonable comparisons among lenses without physically testing their capabilities. Sloppy terminology makes reading and writing about the subject laborious and susceptible to misunderstanding.

The Vivitar Corporation has drafted some realistic standards of terminology, after seeking the assistance of optical specialists, lens designers, and other photographic authorities. The following Vivitar standards for zoom lenses can also be applied to fixed-focal-length lenses.

MACRO
The term "macro" is specific. It describes a lens that will focus to a 1:1 (life-size) reproductive ratio. Furthermore, the lens must have true edge-to-edge sharpness (field flatness).

MACRO-FOCUSING
A macro-focusing zoom lens is one capable of producing a reproduction ratio in the range of 1:1.2 to 1:2.2 (that is, from slightly less than life-size to slightly less than half-life-size), with curvature-of-field characteristics comparable to fixed-focal-length lenses using extension tubes in the near-macro range.

CLOSE-FOCUSING
A close-focusing zoom is one that can achieve a reproduction ratio in the range of 1:2.3 to 1:4.4 at its closest focusing position. Curvature-of-field characteristics will be similar to those of a macro-focusing zoom lens.

NORMAL
Zoom lenses with reproduction ratios of 1:4.5 or less at their closest focus position are considered "normal" zoom lenses.

Even though the folks at Kodak distinguish among the terms "medium-close-up," "close-up," and "ultra-close-up" photography, we will just speak of close-up photography.

Equipment for Close-ups

Many of us ease into close-up photography only after having gained some experience in other aspects of photography. Photographers may be frightened off by the erroneous idea that close-ups require complicated techniques and expensive, sophisticated equipment.

There was a time when close-up photography called for exposure calculations that baffled those of us who had trouble learning how to write four and carry two in third-grade arithmetic. Equipment limitations further complicated the work. But with today's modern SLR cameras and TTL metering, automatic diaphragms that allow wide-open metering and focusing, and an array of top-quality accessories, much of the guesswork has been taken out of close-up photography.

Equipment and accessories used in close-up work include macro, macro-focusing, and close-focusing lenses; bellows; extension rings or tubes; and accessory close-up lenses which attach to the objective end of the primary lens the way a filter does.

Macro and Macro-Focusing Lenses

I recommend the macro lens to any outdoor photographer who does at least a moderate amount of close-up work. It is not only capable of 1:1 reproduction, but because of its flat field, offers edge-to-edge sharpness.

Macro lenses are often criticized for being slow and expensive. I believed these criticisms several years ago when I updated my 35mm SLR system by buying five new Nikkor lenses. I briefly considered buying a Micro-Nikkor 55mm f/3.5 macro lens, but decided instead on the faster, cheaper 50mm f/1.4 lens. I bought a set of automatic meter-coupled extension rings to handle my close-up work.

I should have chosen the macro lens. First, modern film has such fine grain and high speed that an outdoor photographer rarely needs a lens as fast as f/1.4. Second, the field curvature of a conventional lens dictates the smallest possible aperture during close-up work with bellows or extension rings. And third, I only saved $17.

The most common focal length of macro lenses is 55mm. If you already own a 50mm lens and want a macro lens too, consider one of the macro telephoto lenses, such as the Vivitar Series 1 90mm f/2.5 and the Auto-Nikkor 105mm f/4. The longer macro lenses

allow the photographer to work at more comfortable distances from his subject; this is particularly helpful when animal subjects are wary or belligerent.

If you would rather use one zoom lens than several fixed-focal-length lenses, check into the macro-focusing zoom lenses that allow reproduction ratios up to 1:1.2, or slightly less than half life-size without close-up accessories. On adding extension rings or accessory close-up lenses, the zoom lenses focus closer and will suit any outdoor photographer's close-up needs.

Bellows and Extension Rings

Bellows units attach between the lens and camera body; as the lens-to-film distance is increased, the minimum focusing distance is decreased. There are special flat-field bellows lenses that will give satisfactory results at wider apertures, but most photographers use conventional curved-field lenses and need to use the smallest possible aperture setting in order to attain maximum image sharpness.

The advantage of the bellows is that it can be adjusted for a variety of applications. But it is a nuisance, a bulky item that is often more bother to tote along than it's worth.

Extension rings also attach between the lens and camera body. They are not adjustable, but come in sets of different lengths and can be stacked to increase close-up capability. They are lighter and smaller than bellows units, and less expensive. If you combine a conventional lens with rings or bellows, try to shoot at apertures of f/11 or smaller.

Bellows and extension rings reduce the amount of light reaching the film. Before the days of TTL metering, proper exposure called for elaborate mathematical calculations. If you own a modern SLR you can use the built-in meter, but less light plus shooting with a small aperture may force you to use some mighty slow shutter speeds. You will have to use a tripod, and may often be forced to use a strobe.

Be sure that bellows or extension rings are automatic. You have enough to fool with in close-up photography without having to bother with stop-down metering.

Close-up Lenses

When I began close-up photography some years ago, I used close-up lenses, because they are cheapest.

I listened to the many critics of close-up lenses, who said for top-quality close-ups I needed a macro lens, or at least a bellows unit. I could afford the bellows unit.

I tried to learn to like the bellows, but I found I was leaving the awkward thing at home more often than not. It was more compatible with studio work than with field photography.

CLOSE-UP LENS FOCAL LENGTH LIMITATIONS

CLOSE-UP LENS (DIOPTERS)	MAX. LENS FOCAL LENGTH
+1	500mm
+2	250mm
+3 (+2 & +1)	180mm
+4	135mm
+5 (+3 & +2)	100mm
+6 (+4 & +2)	80mm
+7 (+4, +2 & +1)	75mm

The table shows Vivitar's recommended limitations on focal lengths of lenses used with a close-up set of +1, +2, and +4 lenses.

The chart (below) shows approximate magnification ratios that can be attained with the Vivitar close-up lens set used on prime lenses of various focal lengths focused on infinity. As the focusing (lens-to-subject) distance decreases, magnification increases.

MAGNIFICATION RATIOS WITH CLOSE-UP LENSES

CLOSE-UP LENS (DIOPTERS)	50MM LENS	55MM LENS	85MM LENS	100MM LENS	135MM LENS	200MM LENS
+1	1:20	1:18	1:12	1:10	1:7.5	1:5
+2	1:10	1:9	1:6	1:5	1:3.7	1:2.5
+3 (+2 & +1)	1:6.6	1:6	1:4	1:3.3	1:2.5	---
+4	1:5	1:4.5	1:3	1:2.5	1:1.9	---
+5 (+3 & +2)	1:4	1:4	1:2.4	1:2	---	---
+6 (+4 & +2)	1:3.4	1:3	---	---	---	---
+7 (+4, +2 & +1)	1:2.9	1:2.6	---	---	---	---

The extension rings I bought next were more portable, but not as easy to use as close-up lenses. Since I used conventional curved-field lenses with the bellows and extension rings, I had to stop down for best results.

Today when I leave home for a photographic session of any kind, I have close-up lenses in my pocket. The early criticism of close-up lenses may have been based on their poor-quality optics. Photographers warned that if you put an inferior piece of glass in front of the best lens in the world you would still be taking a picture through an inferior piece of glass. But good close-up lenses, available from a number of reputable manufacturers, do not affect image quality any more than good filters do.

The critics like to blow negatives up to the size of a barn wall, then make comparison prints and discuss what is acceptable and what is not. I daresay few negatives can stand up to such scrutiny. I look for acceptable 8″ x 10″, 11″ x 14″, and 16″ x 20″ prints and acceptable projections of transparencies.

Tools and Techniques for
Close-ups

If you want to photograph a honey bee on a wildflower and blow the negative up to a wall-size mural, I suggest you borrow or rent a 4″ x 5″ view camera for the job. You will find the 35mm SLR more adaptable for normal close-up work. If you don't want to buy an expensive macro lens, by all means get a set of close-up lenses. You will find them handy for shortening the minimum focusing distance of telephoto lenses too.

Close-up lenses come in sets of three, containing +1 (diopter), +2, and +3, or +1, +2, and +4 lenses. There are +10 diopter lenses available, and Spiratone offers the Macrovar, a variable close-up lens attachment.

Close-up lenses attach to the lens as a filter does, and like filters they can be stacked. Since stacking a +1 and a +2 means a +3, it makes sense to buy the +1, +2, and +4, giving you a range of +1 to +7 diopters to work with—a reproduction ratio range of 1:20 (+1 diopter) to 1:2.9 (+7 diopters) with a 50mm lens.

Close-up lenses have three advantages over bellows and extension rings: (1) they are easier to use, since you don't have to remove the camera lens to attach close-up lenses; (2) they are more compact and portable; (3) they are considerably cheaper.

Even more important, close-up lenses can be used without reducing the amount of light reaching the film. In good light with medium-speed film you can often take close-up photographs with a hand-held camera and without a strobe.

Other Close-up Accessories

Tripods are essential for some close-up work. One problem with many tripods is that they don't allow the camera to be positioned at or near ground level where most close-up subjects are. Unless you do a lot of close-up work, buying the special tripods manufactured for this purpose by Slik and other companies is difficult to justify.

Some photographers carry tiny tabletop tripods. Some ultra-compact tripods allow near-ground camera positioning with their legs folded, but they won't support much weight, so they are not recommended for elaborate setups.

A handy item for low camera positioning is a leg platform, which allows the camera to be mounted on the leg of a tripod and positioned as near to the ground as necessary. Such an accessory is available from Slik.

The closer your 35mm SLR is to the ground, the harder it will be for you to peer through the viewfinder. Spiratone has a helpful right-angle eyepiece, the Anglescope, that fits most popular 35mm SLR cameras.

The closer the camera is to a subject, the more critical and difficult focusing and composition are. A focusing stage (also known as a focusing rail or by trademark names such as Slik

The Spiratone Anglescope—a right-angle eyepiece that fits most popular 35mm SLR cameras—makes ground-level photography easier.

2-Axis Macro Adjust) takes much of the pain out of close-up work. It attaches between the camera and tripod platform and allows minute precision movement of the entire camera/lens assembly during focusing and composition.

Film for Close-ups

Select film for close-up photography by the same criteria you use for other work. But remember, fine grain is an asset in any critical study, and close-up photography is the most critical kind of study; therefore, high-speed film such as Ektachrome 400, Tri-X, and Ilford HP4 and HP5 are not the best for close-up work.

Fine detail is often extremely important in close-up photography. The best color film for the finest details is Kodachrome 25. For black and white, Kodak Panatomic-X and Ilford Pan F are best. But these are slow films that often call for slow shutter speeds and a tripod—especially at smaller apertures and in shadow or dim light. A strobe may be required too.

A medium-speed film allows the use of a hand-held camera, often without a strobe. If you are willing to sacrifice a little detail and fine grain for added speed, you can get excellent results with Kodachrome 64. Even Ektachrome 200 gives you acceptable results. For black and white, my old standby, Kodak Plus-X, is all I need for most close-up work.

Close-up Lighting

I prefer available light, but when ambient light is not sufficient for close-up work, on a cloudy or heavily overcast day, or if the subject is in deep shadow, then rather than switch to a high-

speed film and sacrifice fine grain and depiction of delicate detail, it is best to use electronic flash to light your subject.

Since the camera-to-subject distance is so short, you don't need a powerful strobe. The smallest, cheapest units work fine, and if even they are too powerful you can reduce the strobe's output by covering it with a layer of handkerchief or with a finger (see chapter 6). Remember, a layer of handkerchief or one finger over the strobe reduces output about one f/stop. The handkerchief will soften the quality of light by diffusing it; the finger is used for harsher, more contrasty light.

To determine the best exposure with a strobe shoot a couple of test rolls, bracketing widely, and recording not only aperture settings but flash-to-subject distances. After determining the best average exposures for a variety of distances, bracket one stop over and one stop under when you do the actual shooting.

The strobe also stops subject motion. A slight breeze can blur a wildflower if a small aperture dictates slow shutter speed; the high speed of electronic flash can combat blurring without creating ghost images. Make sure that the subject is well shielded from the ambient light that can cause such images.

When using a strobe, try to make the lighting natural. Light the subject from above the camera and usually from one side. When shooting an insect, small reptile, or amphibian, make sure the subject is heading toward your strobe and will be lighted head first. Elevation of the strobe will drive most of the harsh shadows down behind the subject. Remaining shadows can be toned down and made more natural-looking by aiming a reflector, positioned opposite the strobe, at the subject. A sheet of white paper or posterboard or the matte side of a sheet of aluminum foil works well as a reflector.

Reflectors can be used to fill in harsh shadows from available light, too, to reduce excessive overall contrast, or throw more light on a subject to bring out detail.

If bright sunlight causes too much contrast or too many distracting highlight areas, cast a shadow over your subject, using your own body or something held between the subject and the sun. To partly tone down solar intensity and to soften the lighting, use a piece of cheesecloth which will allow generous amounts of diffused light to reach the subject. Have someone hold the cheesecloth, or stretch a piece between the rings of a large embroidery hoop.

Look for good backlighting opportunities, especially when photographing flowers and other plants. Backlighting is always the hardest kind of lighting to analyze and interpret, so bracket widely—one and two f/stops over and under your expected best exposure.

Use a lens shade to guard against flare, and use the depth-of-field previewer to stop the lens down. This way you can detect flare spots and ghost images—which might not be visible through a wide-open lens—before you shoot.

For a backlighted subject photographed by available light, take an average meter reading and open the aperture one f/stop. If a strobe is the main light and sunlight is used for backlighting, take an average meter reading and stop the lens down two f/stops, or reduce strobe output proportionately. Bracket widely.

Separating Subject from Background

Close-up photography is a matter of depicting details; if details of the subject mingle with details of the background, the photograph will be a confusing mishmash.

Separation is easiest in color photography. A red flower will stand out against a background of green foliage; in black and white, these similar gray values would meld, calling for use of a filter (chapter 8).

Use depth of field to separate subject from background. Depth of field is shallow in close-up work—even at small apertures—because one of the determinants of depth of field is camera-to-subject distance.

Work at the smallest possible aperture most of the time to gain depth so the subject will be in acceptable focus. If the background is very near the subject, distracting background details may be focused too clearly. If possible, move the subject away from the background or vice versa.

Use lighting for separation. Backlighting outlines the subject, which separates it from the background; but strong directional lighting is good too. Watch for sharp beams of sunlight poking through branches and leaves in the early morning or late afternoon; such rays can make close-up subjects stand out dramatically against a dark or shadowed background.

When a strobe lights only the subject (because the background is sufficiently distant) the background goes black. The effect can be stunning.

Contrasting textures (smooth against rough) will separate subject from background: a rough-skinned starfish against a smooth, wet rock, or the hard, shiny shell of a crab on a background of sand. The glossy side of a leaf makes a good background for a fuzzy caterpillar, and the dull side, for a beetle's hard, smooth back.

When these techniques of separation fail, try a portable background of cloth, paper, or posterboard in natural colors: green, blue, brown, black, and white. Cloth is best because it can be stacked, rolled around a dowel rod, and carried in a small con-

tainer such as a case for a fishing-pack rod. Don't use felt and other nappy materials that will easily pick up debris, but satin, taffeta, or ripstop nylon.

Be careful not to let unnatural textures, wrinkles, or folds from an artificial background show up in the photograph. Place the background back far enough to be out of focus.

Composing and Working with Close-up Subjects

Close-up subjects, especially if they fill the frame, need not necessarily be placed off center by the rule of thirds. A single flower may be most pleasing to the eye when centered. For two or three flowers, off-center placement is usually preferable.

Compose according to not only vertical and horizontal tension of the subject, but diagonal tension. A classic pose of an insect, lizard, or snake on a branch has the branch entering from or near a lower corner of the picture and reaching to the opposite upper corner. The natural profile of a sitting frog or toad is diagonal too: with the hind end of the creature near a lower corner of the picture, the nose will naturally reach toward the opposite upper corner, with the amphibian's back in a diagonal line.

Some purists say you should never modify the subject area. We should disturb subjects and their habitat as little as possible, but to refrain from minor changes that clarify our intentions and interpretations is inhibiting and a bit ridiculous. If you want to picture the natural habitat of a creature, or to show how well it is camouflaged in its natural surroundings, separation of subject from background is unnecessary, since the whole picture is the subject. But you should follow the picture up with a full-frame exposure of the insect or animal. Then, without disrupting nature, get rid of distracting details. This can mean tidying up the subject area by removing twigs, dead leaves, and other objects, or it can mean moving a salamander onto a bed of moss rather than leaving it wallowing in the mud beneath a rock where you found the creature.

Be gentle with animals, and if you must move them, put them back when you are finished.

In photographing unprotected wildflowers, weeds, or berries, you will find that wilted blossoms, dead leaves, and insect-damaged berries and foliage add nothing to the natural quality of your photographs. Remove them.

If you are photographing protected plants and wish to isolate some blossoms or leaves, crop the others out with the camera if you can. If they still impose, use background cloths to cover them or have someone hold them out of the field of view while you take the picture.

You can create your own dew on such close-up subjects as plants, flowers, and spider webs by misting them with an atomizer.

Raindrops and droplets of dew add a refreshing aspect to pictures of flowers, plants, leaf buds, and spiderwebs after a storm or early in the morning before the dew has evaporated. If nature has not cooperated, you can make your own dew by spraying the subject with an atomizer. Carry a small plant atomizer, or make one from a discarded spray deodorant bottle.

For a close-up of feeding butterflies, bees, and hummingbirds, isolate one or two flowers or blossoms by covering nearby ones with cheesecloth. The insects or birds may pick the isolated blossoms with no coaxing, but you can cheat a bit with a drop or two of nectar in the center of the isolated bloom. Carry a small medicine bottle full of nectar (one part sugar in two parts warm water) and an eyedropper.

Close-ups demand even more patience than other photographs, especially when you are trying to keep an active subject within a tiny field of view. Your patience will pay off with exciting additions to your photographic files.

SPECIAL EFFECTS AND MOOD PHOTOGRAPHY

We often exploit natural effects—time of day, time of year, clouds, haze, fog, mist, and rain—to record not only nature's moods but ours. Since photographers often use special-effects equipment to create or enhance moods, the areas of special effects and mood photography can be considered mutually dependent, which is why I discuss them together.

The Moods of Nature

Pictures are taken for reasons of communication, information, education, and entertainment. Mood photographs can embody any of these intentions; the message is a very personal one where the photographer imposes his emotions and feelings on a subject and creates a subjective image. A picture may evoke the same or a similar mood to the one nature evoked in the photographer—or one that is quite different. And what the picture makes the photographer feel may not be what the objective viewer experiences. It seems to me that the primary intention of mood photography is to satisfy the photographer; whether it satisfies other viewers in the same way is of no consequence. When it comes to mood photography, I tend to agree with the art critics who tell us it is not the intention of the artist that matters, but the intention of the art.

Nature is moodiest during times of change—early morning, late afternoon or early evening, before and after storms, spring, autumn. Sunrises and sunsets are moody—for nature and for most of us too. My favorite time of day for mood photography is probably early morning from just before sunrise to eight or nine o'clock; my favorite season is autumn, especially when the leaves begin to turn and wispy fog rises from lakes and streams in the early hours. But there's a lot to be said for an April shower or a late afternoon summer thunderstorm.

In the early morning hours lakes and ponds are often flat and glassy, and you can take advantage of the mirror images they offer. These reflections emphasize the subject, improve composition possibilities, and suggest a tranquil mood.

Mood subjects can be simple or awesome, meek or mighty.

Special Effects and the Greek Virtue

Everyday equipment can be used to create special effects. Use of a telephoto instead of a normal lens can create a desired illusion in landscape photography. We can distort reality with a wide-angle lens, or intentionally over- or underexpose a subject for effect. Also there is an ever-growing array of special-effects accessories and lens attachments with which we can emphasize, tone down, change about, and create moods.

Using special effects is like cooking with garlic. Inexperienced photographers tend to overdo it, and the results can be mighty distasteful. The idea is not to overwhelm the subject, but to shape it carefully and delicately to your personal taste.

The secrets of effective mood and special-effects photography are discretion, selectivity, personal sensitivity, and that ancient Greek virtue—moderation.

A slide show or photographic sequence can be improved with a

few special effects, but a collection of nothing but special effects overburdens the viewer. Overuse of one particular accessory or technique results in pictorial redundancy and pictures that are boring clichés.

Photographers tend to overuse new, exciting gadgets and techniques. Remember a few years ago when everybody discovered the fisheye lens? For months every picture I looked at appeared to have been taken through a crystal ball or glass paperweight.

Not long ago the TV folks discovered the cross screen, and for months we were bombarded by starbursts of light on every television special and most of the dramatic productions as well. Then came the diffusion screen that for a while seemed to wrap every TV program and commercial, movie, and magazine picture in a gauzelike fog that made me rub my eyes and squint to search for one spot of sharp detail.

Exposure for Special Effects and Mood

Spend time with your "moody" subjects. Study, see, and feel. Analyze your mood and interpret the scene according to it. But when a rare, exciting lighting situation occurs for a fleeting moment, you must think quickly and shoot. A tripod gets in the way: the time it takes to set up a tripod shot can keep you from capturing the moment. For this part of your special-effects and mood photography, the medium-speed and fast film is more suitable than slow film.

Early morning, evening, and foggy or stormy weather call for faster film, too, as do dense filters used to create certain effects.

Bracketing is important, as always. Shoot plenty of film, bracket widely, and take notes of your shutter and aperture settings until you have a sense for the peculiar lighting you need for effect. Even after you have become experienced, continue bracketing: the underexposure (often) and the overexposure (on occasion) give pleasantly startling results.

Sunrises and Sunsets

Few subjects are more evocative than a colorful sunrise or sunset, yet many photographers fail to capture their moods, because of poor composition or improper exposure.

Dramatic and colorful clouds and sky are not adequate subject matter in themselves, so don't be so captivated by their beauty as to forget the principles of composition. Include important foreground and framing elements; silhouette a person, animal, or tree against the sky; include foreground water—lake, stream, or ocean—to improve sunrise and sunset shots, especially when it is calm enough for good reflections.

A few exposure guidelines: When the sun is just below the horizon, take a meter reading at the horizon, then elevate the meter

Opposite: *Mood photography is one of the most personal kinds of expression. This photograph is one of the author's favorites, but others have about equally liked it, disliked it, or shrugged their indifference to it. Campfires are multimood subjects, but are most often considered "friendly." The intention of the photographer was to express a restful contemplative mood. Medium depth of field was deliberate, so as not to totally blur the background, but to keep the facial details of the reclining camper from being so sharp as to distract the viewer. A ground-level camera position allowed the campfire to dominate, and a slow (1/15 second) shutter speed recorded flames as they licked at the sides of pots.*

to a 45° angle and take a second reading. The average of the readings is the correct starting exposure. If the first reading is f/16 and the second f/4, you set the aperture at f/8, and bracket.

When the sun is just above the horizon, point the meter straight up, take a reading, then open up two f/stops for the correct starting exposure, and bracket.

There is time to use a tripod for sunrise and sunset photography, and there is plenty of light, so you can use slower, fine-grain film. Kodachrome gives the most pleasing results for color shooting.

Silhouettes

If you silhouette a subject against a sunrise or sunset, use the starting exposures just given. If it is against a bright sky later in the morning or in the late afternoon when the sun is still fairly high, take the reading of the bright sky and bracket one stop over and one stop under. If it is against a cloudless light blue sky and you are using black-and-white panchromatic film, don't use a yellow, orange, or red filter as you might for normal landscapes or waterscapes. Such filters absorb blue, thereby darkening the sky and reducing contrast between subject and background. Use a blue filter that will lighten the sky. A #47 Dark Blue filter will turn the sky white.

Infrared Film for Special Effects

Infrared film, which is widely used for scientific and military purposes, can be considered special-effects film by the outdoor photographer because it does not render colors as we see them.

The beginner should not experiment with infrared film—it is too fussy, fickle, and unpredictable for him. Even the experienced photographer should be prepared for hassles and disappointments; but successful infrared photographs can be exciting indeed.

Storage and Handling of Infrared Film

Kodak High Speed Infrared (black and white) and Kodak Ektachrome Infrared film are those most often used for outdoor work. They are short-lived compared to conventional film.

Unexposed High Speed Infrared is stored in a refrigerator at 55°F (13°C) or colder, sealed in the original container. In the field, keep the sealed film in plastic bags in an ice-chest tray. To store it 6 months or more, keep in a freezer at 0° to −10°F (−18° to −23°C).

Don't let cold film be damaged by atmospheric moisture. Allow refrigerated film 1 hour warm-up time at room temperature (frozen film, 1 1/2 hours) before opening the original container and loading the camera.

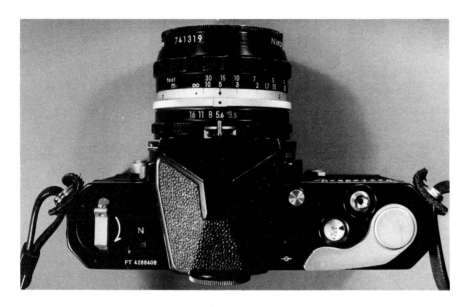

The tiny dot on the depth-of-field scale, just below the infinity mark on the distance scale, is the infrared mark on this lens.

Unexposed Ektachrome Infrared must be stored at even lower temperatures (0° to −10°F) to prevent shifts in color balance. Warm-up time: 1 1/2 hours.

Process infrared films as soon as possible after exposure. Kodak recommends that exposed infrared film that must be held for more than a day before processing be refrigerated at a temperature below 40°F (4°C).

Ektachrome Infrared film can be camera-loaded in subdued light (shade); High Speed Infrared must be handled in the dark. Keep the latter film sealed until loading in a closet, bathroom, or other small room that is completely lighttight. Seal windows and cracks around doors or windows with heavy-duty aluminum foil taped, Kodak recommends, with Scotch Photographic Tape #235. A darkroom is fine if it is lighttight against infrared as well as visible light.

The simplest way to load cameras with High Speed Infrared is to use a changing bag; before buying one, make sure it is suitable for use with infrared film.

Keep your camera out of bright sunlight when it is loaded with infrared film. When you're not using the camera keep it in a carrying case, backpack, or other darkened container.

Filters for Infrared Film

Filters must be used with infrared film; the best filter for the outdoor photographer is the #25 Red. The denser #29 Deep Red is also useful, but focusing through the lens will be easier with the #25.

Ektachrome Infrared film should be used with a #12 Yellow filter. Since this is a special-effects film, for our purposes filters of other colors can be used to get other effects. Experiment with yellow, orange, and red filters for bizarre color renditions.

Polarizing screens can be used with infrared film in color or black and white.

Kodak High Speed Infrared film can turn an ordinary landscape or seascape into an exciting scene.

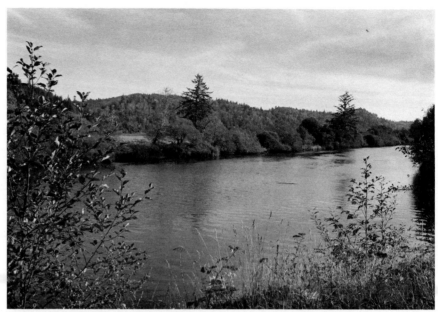

Shot with panchromatic film.

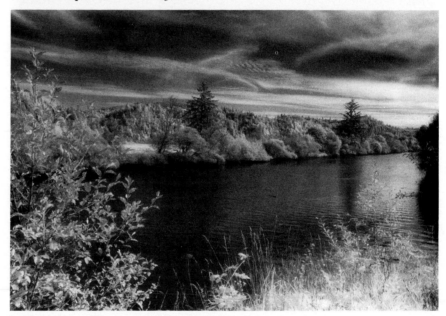

Infrared rendition of the same scene.

Exposure with Infrared Film

Infrared radiation is invisible, it varies in the atmosphere by time of day and year, and it cannot be measured by conventional light meters. Determining proper exposure takes some guesswork.

Kodak's guidelines for exposure should be considered rough starting points. Bracket your exposures, and take detailed notes. You will always have to bracket.

For the average scene shot in bright sunlight with High Speed

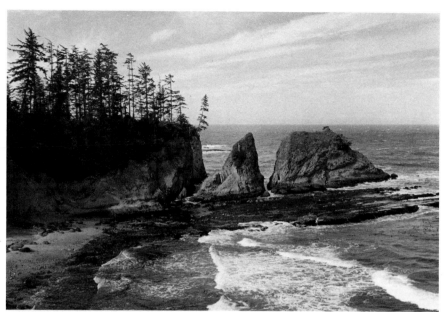

The panchromatic version.

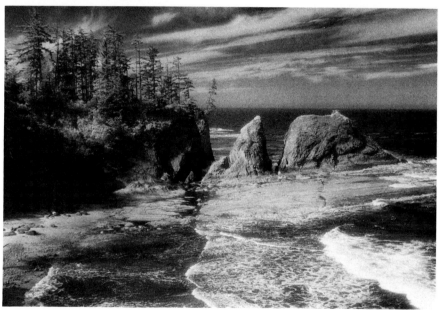

The way infrared sees it.

Infrared through a #25 filter, set your camera for 1/125 second at f/16. In hazy sunlight, try 1/60 second at f/16. In light overcast, slow the shutter to 1/30 second.

Close subjects like a single tree, a lighthouse, or bridge that fill the frame require more exposure than distant landscapes. Use 1/30 second at f/16 for starters in bright sunlight.

Kodak recommends a starting-point setting of 1/125 second at f/16 in direct sunlight for Ektachrome Infrared with a #12 Yellow filter.

Bracket infrared exposures, but adjust shutter speed rather than aperture, trying to maintain aperture settings of f/11 or smaller. At first, bracket one and two shutter settings below and above the starting-point setting.

Focusing with Infrared Film

Conventional camera lenses do not focus infrared and visible radiation in the same plane, which is why most modern lenses have infrared marks etched in the lens barrel with the depth-of-field scale. Usually it is a red dot or small *R*. To focus with such a lens, bring the subject into focus. Check the distance on the distance scale of the lens and turn the focusing ring until the distance setting aligns with the infrared mark.

If there is no infrared mark, focus on the near side of critical focus until the subject is slightly out of focus.

The best way to assure sharp pictures is to use aperture settings of f/11 or smaller. At f/11 the minor focus shift is compensated by increased depth of field. And that's why you should maintain a small aperture and adjust shutter speed when you are bracketing.

What to Expect from Infrared Film

I haven't liked much of the color infrared photography I've seen: the results are a bit bizarre for my taste. But that's just my opinion. Mood photography and special effects are personal; self-gratification is the primary motivant. If you like the effects of color infrared, use it.

Ektachrome Infrared used with the recommended #12 Yellow filter produces fairly normal-looking blue skies, but green foliage appears red. Other subjects that do not reflect infrared reproduce abnormally, green turning into blue and red into yellow. Other filters will bring about other color changes.

I consider black-and-white High Speed Infrared to be more versatile and useful. It can turn a mundane landscape into an exciting, sometimes eerie or otherworldly scene. Blue skies look almost black, making white clouds stand out dramatically. Water is darkened, and shadow details are more evident. Foliage turns cotton bright, and haze is virtually eliminated.

A scene shot with High Speed Infrared through a #25 Red filter and a polarizing screen, then printed slightly darker than normal, will pass for a night shot. Sunlight appears as moonlight, spilling over the landscape and sparkling on leaves and grasses.

Infrared film has a high inconvenience factor, but is worth experimenting with. I recommend two booklets from Kodak: *Kodak Infrared Films* (publication #N-17) and *Applied Infrared Photography* (#M-28).

A shaft of late afternoon sunlight broke through trees to illuminate these delicate plants and mosses on the remnants of a rotting, derelict pier. The bright beam isolated the subject from the background of dark water. Photographer used a #11 Yellow-Green filter to brighten the light green foliage, then exposed for the highlights to turn the background black.

Filters, Screens, and Lens Attachments

Filters are used in mood photography for the usual reasons, and also to emphasize or strengthen a special effect. Suppose you are photographing a delicate plant in strong, directional morning light with black-and-white film. You can use a #11 Yellow-Green or #58 Dark Green filter to brighten the plant, then expose for the highlights, which will underexpose the background and turn shadows black. Or try a yellow flower with a #8 Yellow filter, or a red flower and a #25 Red.

To emphasize haze, fog, or mist in black-and-white landscapes and waterscapes, use a #47 Dark Blue filter.

Colored Filters with Color Film

When you use colored filters with color film for special effects, remember that the film tends to take on the color of the filter. Consequently, not all colored filters are suitable to all subjects. I have found the #21 Orange, #25 Red, #47 Dark Blue, and #85 Amber most useful for special effects in color: sunsets, strongly backlighted subjects, and marine subjects.

An ordinary sunset can be made a dramatically colorful event with a #21 Orange or #25 Red. Slight underexposure gives the best results and reduces distracting ghost images and flare spots. Pick a geographical area that is fairly flat: ocean, desert, or prairie. Try to silhouette something against the bright sky: along the coast, a tree, passing boat, or person; in the desert, a saguaro cactus or Joshua tree; in prairie country or flat farmland, a windmill or solitary tree.

Such a photograph will show only three discernible colors, with

A photograph of a plane, silhouetted against the setting sun, was improved by using a variable cross screen and placing the sun behind a wing. Note the smaller star effect created where the sun reflected off the fuselage.

Opposite: *Late afternoon sunlight illuminated ferns and mosses on the floor of this forest scene. Visual impact was heightened by placing the sun partly behind a tree and photographing it through a cross screen.*

several hues of the filter color. The silhouetted object will be black, the sun will be yellow, and the rest of the scene will be shades of orange or red, depending on the filter used.

Rocky coastlines with crashing surf, lakes and bays with surfaces gently rippled by the wind, and panoramic waterscapes—all backlighted or strongly crosslighted—are excellent subjects for the #85 Amber filter, which, unlike orange, red, and blue filters, allows some vivid colors to be reproduced in the transparency (although they will be altered somewhat). The whole scene will be bathed in gold. You can use intentional underexposure to increase the amber and tone down or eliminate other colors.

A #47 Dark Blue filter can be used in color to create nighttime effects in daylight. Underexposure by one to two f/stops will sufficiently darken trees, buildings, and white clouds and will turn the sky navy blue and make sunlight look like moonlight. Bracket to assure suitable exposure.

Cross Screens

When photographing a scene containing one or more point sources of light, you can turn each source into a long-pointed star by placing screening in front of the lens. Cross screens, sandwiched in glass and mounted in filter rims, are available in series or thread mounts. You can make your own by cutting a 3-inch square of screen and using it in a gelatin filter holder, or you can cut a circular piece of screen to fit inside series-type filter adapter rings.

The cross screen, one of my favorite special-effects lens attachments, can make the ordinary exciting and the exciting spectacular; but don't overuse it.

Cross screens can be used in night scenes (a pier, bridge, or boat dock illuminated by a few lamps), backlighted scenes with a low sun in the frame, and waterscapes where a rippled surface of a lake or stream creates a myriad of tiny point sources of light. But a scene crowded with many bright lights—a multilighted waterfront or a busy, well-lighted city at night—becomes an overwhelming confusion of star points when a cross screen is used.

In the scene backlighted by a low sun, allow only a small part of the sun to peek around an edge, silhouetting the subject against the sun and bright sky; the star beam focuses the viewer's attention on the subject.

You can stack two cross screens to create eight-pointed stars, and you can combine cross screens with other filters for added effects. Tiffen manufactures the Vara-Cross screen, featuring a rotating front ring that permits the user to choose the effect he wants. Cross screens come in 1mm, 2mm, and 3mm grids.

Diffraction Screens

More and more diffraction screens are available today; thanks to laser technology, the field of light diffraction for special effects will continue to expand.

Diffraction is the breaking down of visible light into the color spectrum, resulting in a rainbow effect. It is accomplished by sending a beam of light through a prism or—for photographic purposes—by using a transmission diffraction grating or a holographic grating.

I was introduced to diffraction gratings in a college astronomy course. The professor showed us the expensive glass gratings used in a spectroscope and demonstrated how the finely etched parallel lines in the optically flat plate break down light as it passes through the grating. For our student experiments, we got inexpensive sheets of plastic diffraction gratings.

These plastic grating sheets, which can be used in outdoor photography, are available from Edmund Scientific Company. From an 8 1/2" x 11" sheet you can cut 3-inch squares to fit a gelatin filter holder, or you can use larger pieces with larger lenses.

Diffraction gratings and holographic gratings set in series-type or thread-mount filter rims are available from Hollo Corporation, Porter's Camera Store, Spiratone, and Tiffen.

For best effect you need a fairly concentrated light source, as in sunrises, sunsets, and other low-sun subjects. Sunlight reflected off water is effective, as are outdoor lights.

For a full rainbow effect, shoot against a dark background, or if that is not possible, underexposures of one or two f/stops are advised. As always, bracket.

Traditional diffraction gratings create rainbows in straight lines. Other diffraction screens create circular rainbow patterns or—like Spiratone's Stellar and Tiffen's Vari-Burst—light bursts of rainbows radiating from the light source.

Diffusion Attachments

Diffusion scatters light to create a soft-focus, misty effect. There are two kinds of diffusion attachments: the diffusion disk and the random diffuser.

The diffusion disk is a circular glass lens attachment in which concentric ridges emanate from a central clear area. It allows you to control the amount of diffusion with the lens diaphragm: maximum diffusion occurs when the diaphragm is opened to its widest aperture.

The random diffuser creates an overall soft-focus effect, regardless of aperture setting, by scattering light randomly through a glass attachment with a rippled surface.

Center-sharp diffusers allow the central portion of a photograph to remain crisp and clear while the edges are softened by diffusion. I find these more useful than total diffusion attachments for outdoor photography. The effect is reduced when you stop the lens down to smaller apertures. To allow for wide apertures you will have to use slow film or neutral density filters in bright light.

Diffusion attachments are best suited to outdoor portraits of women and children and close-ups of flowers. Only occasionally is a picture of general wildlife, a landscape, or a waterscape improved by creating a misty effect (preferably backlighted).

To make your own diffuser, coat a clear glass, skylight, or ultraviolet filter with a layer of petroleum jelly. The thicker the coating, the greater the diffusion. For a center-sharp diffuser, dip a finger in petroleum jelly and run it around the outer edge of the filter glass, leaving the center clean and clear. Coat only the inside (lens-facing) side of the filter, so that the jelly will not pick up dust and debris in the field. The jelly can be removed from the filter with warm soapy water.

Other Special-Effects Attachments

Too many special-effects gadgets and gizmos are proliferating for me to mention them all. Of course, what seems like nothing more than a costly gimmick to me may strike you as an exciting adjunct, and vice versa.

I am bored by the innumerable special-effects attachments that create multiple images. After seeing two or three shots, they all begin to look alike to me. One exception for me was the Spiratone repeater, which produces a normal image in half of the film and up to five repeated images on the other half, depending on aperture setting. I had in mind several photographs I wanted to make and consequently was able to justify its purchase.

Left: *A split-field attachment allowed close focusing of the shell in the foreground while retaining total clarity to infinity for super depth of field.* Right: *The same shot without the split-field attachment renders the shell an out-of-focus distraction.*

I have also found a number of uses for a split-field attachment. This is a filter rim, half of which is filled with a close-up lens, and the other half left empty. With the attachment you can place a subject closer to the lens than minimum focusing distance allows, while leaving the background in focus. The effect is super depth of field. There is an out-of-focus line between the close-up subject and the background, but careful placement of this line in an unimportant part of the picture can make it barely noticeable. Shoot at small apertures. Tiffen Split/Field and the Spiratone Proxifar attachments are available in series-type and thread-mount rims in several sizes.

To learn about other special-effects attachments, send for catalogs and descriptive literature to the companies mentioned in this chapter. (For addresses, see the Directory at the back of the book.)

PHOTOGRAPHY IN POPULATED AREAS

It's easy to browse through magazines like *National Wildlife* and *International Wildlife* and think, "If only I had the time and money to travel to Wyoming, Alaska, Africa, the Galapagos Islands—by gosh, then I could really do some exciting work . . ." It's easy to despair of being city-bound—tied to a desk or drill press, a nine-to-five job, freeway traffic . . . It's easy to fret over tasks that seem to eat up our free time—home maintenance, dental appointments, PTA meetings . . . It's easiest of all to write off the time we waste bemoaning our plight.

But most of the fine photographs we see in magazines and books or at photographic exhibits are taken by people like you and me. They live in Boston, New York, Cincinnati, Miami, St. Louis, Dallas, Tucson, Los Angeles, Seattle, Dagsboro, Lovington, Walkerville, Heuvelton, Nesquehoning, and Lobeco. The vast majority are amateur photographers who have found ways to work photography into their busy schedules and fast-paced life-styles. Those who do the best work have discovered that there are photographic subjects everywhere, even amid the people-packed cities and sprawling suburbs.

Zoos and Public Aquariums

There are zoological gardens and public aquariums in many U.S. metropolitan areas; they offer the urban photographer the opportunity to compile extensive files of photographs of animals, birds, and fish—both domestic and exotic.

Some, usually inexperienced, photographers have contempt for those who dare to snap a shutter at a captive animal, but most of the experts recommend zoo photography not only as an alternative to photography in the wild but as a creative, demanding endeavor in its own right.

We can learn much from the practice we get in zoos and aquariums. They are good places to try out new equipment, experiment with film, and to try new techniques.

Zoos are the only chance most of us will ever have to photograph exotic animals from all over the world. Some rare, endangered, or elusive creatures can only be photographed in zoos.

Equipment for Zoo Photography

Macro lenses are valuable in zoo photography, where the tight confines of a cage, terrarium, or aquarium may place your subject close to the lens. When the subjects are in open areas where longer lenses are required to fill a frame, a macro-focusing zoom lens is handy. At least pack a set of top-quality auxiliary close-up lenses that will shorten the minimum focusing distances of your lenses.

Telephoto lenses are useful for full-frame photographs as well as stunning head shots and detail studies. A wide-angle lens will prove its worth when you photograph reptiles, amphibians, and other animals confined to tight quarters.

My zoo pack includes two 35mm SLR camera bodies, 35mm lens, 50mm lens, 200mm lens, 2X teleconverter, close-up lenses, assorted filters, tripod, strobe, cable release, lens brush, lens tissues, a few odds and ends, and plenty of film.

Some photographers like to carry all the equipment they can lift. I prefer my gear to be truly portable, not only to fight fatigue, but to keep my equipment at hand where I can watch it. If conditions are crowded, I don't want people tripping over my gear, and I certainly don't want to invite thievery. Some photographers who carry a lot of bulky gear rent baby strollers and use them as equipment carts.

Film for Zoo Photography

Take all the film you can carry. Nowhere in the wilds will you find such a concentration of subjects, and you are likely to use plenty of film.

If the animals are outdoors or if confined animals are illuminated by skylights, you can use daylight film.

Aquariums, reptile houses, and other indoor habitats are usually artificially lighted. Check with the zoo or aquarium staff about the type of lighting, and try to match it with appropriate color film. Experiment with several types of indoor film, perhaps adding some filters, until you find the right combination. Under fluorescent lighting use daylight and Type B indoor film with fluorescent light filters, such as the Tiffen FL-D (for daylight film) and FL-B (for Type B indoor film). The excessive greenish tint of some aquarium shots may be corrected by color compensating filters; try a CC10R or CC20R. If the artificial light is not very strong, you can probably use daylight film and a strobe to get true colors.

Begin with black-and-white film for zoo and aquarium photography under artificial light. Once you have mastered it, go on to color.

Timing for Best Results

Crowds can be a problem in the zoo or aquarium. You have to

keep watch on your equipment, and you have to compete with other visitors for position. Some animals seem to be turned off by crowds and retreat to the most obscure corner of their domain.

Summer, weekends, and holidays are crowd times, so go on a weekday in the fall, winter, or spring. If you must go on a crowded day, be the first in line when the zoo or aquarium opens in the morning. Usually you will have a couple of hours of trouble-free shooting before the crowds arrive. When they do you can spend time studying the animals, analyzing lighting conditions, and taking notes for future reference.

Go on a rainy day, or during snow or cold weather. Not only are there no crowds, but in clear cold weather you will find excellent outdoor opportunities, and a recent snowfall will disguise many of the obvious signs of confinement, making natural-looking shots easier.

Some zoos and aquariums post feeding times, or the staff can tell you them. Feeding times can work for or against you. Lethargic animals become alert and photogenic just before mealtime, but the big cats pace so nervously that they can be impossible to photograph. After eating, however, the felines groom themselves and find a comfortable spot for a snooze. Consult your feeding schedule; set up while the cats eat, and be ready for some serious photography afterward.

Feeding time for fish can be frenzied. They may feed frantically until the food is gone, then calm down gradually. The elusive species that spend most of their time hiding in nooks and crannies will come out to eat, and it may be your only chance to photograph them.

Some Tips on Shooting in Zoos and Aquariums

The zoo or aquarium photographer tries to picture his subjects naturally, giving no clue to their confinement. Even in open areas there are manmade backgrounds to avoid. Caged animals must be photographed through fences or screens. Fish, most reptiles, and some other animals must be photographed through glass, which can throw reflections on the lens.

Many zoos now have natural-looking settings for the animals, so that the photographer can easily eliminate signs of man's intervention. Many animals are quartered in large open areas bordered by moats; the animals are easy to photograph if you have a good telephoto lens. A 200mm lens is enough to get full-frame shots of larger animals, and a 400mm lens can often pull the subject in close enough for stunning head shots. Although telephoto lenses have shallow depth of field, you should shoot at a large enough aperture to obscure any unnatural background. Use the depth-of-field previewer to check the background before shooting.

Shallow depth of field is also important when you shoot through wire fences and screens. Put your lens right up against the screen (if it is safe to do so) and use the lens's widest aperture. This will throw the screen completely out of focus. A wide-mesh screen, such as a cyclone fence, will not change the level or quality of illumination by much, but a fine-mesh screen can reduce the amount of light reaching the film by as much as one f/stop, and can slightly diffuse the light and soften the image.

If you shoot through a fine-mesh screen and your subject is in dim light or shadow, use a strobe. If the screen cuts your light in half, you have to compensate by two f/stops, as the strobe light will be reduced by one f/stop going through the screen and another as it is reflected back through it to the camera.

Glass-front reflection problems can be dealt with. Eliminate some reflections by dressing in dark clothing. You need not go to the length as some do, of dressing in black—including gloves—and using black draperies to eliminate reflections.

There is a photographic "window" with no reflections, and the nearer you are to the glass, the larger the window is. If you put your lens against the glass, the window is the entire frame, and there will be no reflections. To back away from the glass safely, cut a circular hole in the center of a piece of black cardboard or chipboard (such as the stiffeners packaged with Kodak photographic paper) and poke the lens through the hole. Back away until the point just before reflections appear in your viewfinder.

Shooting at a 45° angle to the surface of the glass will prevent reflections from entering your lens. A polarizer will help eliminate reflections.

You can back up with a strobe as long as it is pressed against the glass. If you have to move the strobe away from the glass, be sure the lens is against the glass.

Plan your trips to your nearest zoo or public aquarium. Learn the layout thoroughly; schedule your visits for best lighting conditions. Study your pictures carefully and learn from your failures. And don't try to get all your photos in one trip. The animals will be there when you return.

Drive-Through Zoos and Game Ranches

In open zoos and game ranches, which are getting popular in the U.S., large tracts of land are fenced off peripherally, and compatible species are allowed to intermingle. Visitors travel through the impoundments in their own cars or in buses or monorails, so that the animals are free to roam and the visitors are encaged. The animals remain wilder and act more naturally, often displaying territorial and mating rites.

Unless the subject is near a road or fence that you want to leave out of the photo, treat it as you would a wild animal.

Before you take a picture, stop your vehicle and turn off the engine to eliminate vibrations. If you are in a bus, monorail, or cable car, use the fastest shutter speed possible and do not rest your camera against any part of the conveyance.

Parks

Our country is full of parks—neighborhood parks, city parks, county, state, and national parks—which contain countless subjects for the outdoor photographer. Even if you don't live near Yellowstone, the Great Smokies, Craters of the Moon, or Katmai, you can seek out local parks and find plenty to photograph.

Although the smaller parks accommodate the local populace with picnic areas, baseball diamonds, and tennis courts, they also have woodlands, creeks, and hillsides where local flora and fauna can be found and photographed. They may have nature trails or tours guided by naturalists. Their proximity allows us to use a spare hour or two to hike and photograph in the outdoors.

Your Neighborhood

I don't mean to sound cute or corny, or to overstate the obvious, when I say the realm of outdoor photography begins just beyond your doorstep. But the things that are most familiar to us are often the least obvious. You will find local discoveries as exciting and rewarding as those that cost you dearly in time, money, and distance traveled.

My wife and I settled in Coos Bay, Oregon, by choice. If I cataloged the photographic opportunities available to me here, you would think I chose a photographer's paradise. But I have lived in the Midwest, the South, New England, and Alaska, and spent at least a month or more at a stretch in the Southwest, the inter-mountain West, and in Canada; everywhere I have been had many opportunities for the outdoor photographer.

In chapter 9 I told you about how I entice birdlife near our house. I can also look over my typewriter and see several dozen varieties of trees, shrubs, weeds, and (in season) wildflowers and berries—all suitable subjects for the camera. This cover contains photogenic insects (spiders galore), raccoons, squirrels, chipmunks, field mice—and birds.

When my in-laws came to visit two summers ago, they hadn't been here an hour when my teenage nephew came in the door with three or four lizards and a couple of handsome garter snakes he had found under rocks and logs along the edge of the parking lot. He found tiny tree frogs along a drainage ditch behind the property, and salamanders nearby. These fine subjects were within a few steps of our front door, yet I hadn't bothered to look.

At the end of the parking lot just next to our town house is a tall fir that was already dead and denuded when we moved here—its

skeletal branches devoid of needles, its bark peeling and falling off. I have ignored its ugliness for more than three years.

But this very morning, only minutes before I sat down to work on this chapter, I saw that hulk of dead timber in a different light (pardon the pun). I had gone out to feed the birds just after sunrise, and as I was walking back to our front door a crow, perched in the top branches of the old fir tree, squawked what I like to think was a note of gratitude, but was more likely a call to his comrades announcing chow time.

I glanced up at him and was immediately struck by a strange and exciting beauty—a new life in the dead tree. The low sun had burned off most of the early morning fog and was strongly backlighting the tree, whose branches were intricately connected with hundreds of sparkling, dew-laden spiderwebs. It was a virtual spider condominium that I had never noticed before. This morning's lighting and heavy dew finally made it obvious to me that the old tree is an excellent subject for a highly unusual photograph.

Other Nearby Places

That little patch of woods at the end of the street where the neighborhood kids play nearly every day must be full of good subjects. And there's that big grove of trees just off the freeway that you pass every day on the way home from work. Remember the flaming colors of the leaves last autumn?

How many bridges do you cross daily? Are there creeks under any of them? Have you hiked up those creek beds to see what you might find there to photograph?

University campuses are well cared for and are beautifully landscaped with fine old trees, shrubs, and flowers. They are natural havens for birds and small mammals—particularly squirrels, chipmunks, and rabbits. Many contain woods and ponds.

No matter where you live, you will not lack some nearby place to enjoy outdoor photography.

TRAVELING WITH CAMERAS

14

We are concerned here with the physical, logistical, even emotional problems of traveling with photographic equipment.

I can honestly tell you that in the many thousands of miles I have traveled with my cameras during the past 15 years I can't recall facing a single major problem; yet I've seen mishaps happen to others all around me, because they had no idea what to expect.

If you know what to do, for example, you will never be detained while clearing customs. But if you don't, you might have all your luggage searched and reduced to disarray.

Pre-Trip Preparations

Before setting out, check that you have with you all the equipment you need. Even if you keep your gadget bag or carrying case packed and ready to go, check it. Such items as cable releases, extension rings, and PC cords have a way of not being where they should be.

Clean your lenses, filters, and other optics. Make sure you have a good supply of lens-cleaning tissues and lens fluid, and a cleaning brush.

Be sure your batteries are fresh. Check your light meters, and if it's an important trip, replace the batteries if they are more than six months old.

If you have a strobe that uses alkaline batteries, take some spares. If it uses ni-cad batteries, be sure they are fully charged.

Your equipment should be covered by your homeowner's or renter's policy, on and off your property. Check with your insurance agent and be sure you have proper coverage.

Luggable Luggage

Oberrecht's first law of outdoor photography: on any photographic expedition (from a day hike to an extended trip) the item most needed is the one left at home. That may be why so many of us head into the boondocks overburdened with paraphernalia, some of which never gets used.

My friend and colleague Sam Fadala has a law too: for every advantage there is an equal and opposite disadvantage. Remember if you have excess equipment, the burden of it can inter-

fere with creativity, not to mention shoulder, back, and neck muscles. Too much weight will sap your energy if you are hiking or backpacking.

The one-camera, one-lens photographer has few problems. But if you own many cameras, lenses, and accessories, consider each item before you decide to take it. That means considering what you *will* use based on experience—not what you *might* possibly use. Be ruthless. If an item is useful 10% of the time, that means it is useless 90% of the time. Leave it home.

Be especially weight-conscious about your equipment if you are traveling by air or are going afield or afloat.

I know that I do half of my outdoor photography with 35mm and 200mm lenses, so I always take them. I use my 50mm and 135mm lenses least, so I cull them first.

If I am traveling to photograph birds, waterfowl, and other animals, I will pack a long lens. But if long-range telephoto work will take up one-fourth or less of my time, I leave the big guns behind and rely upon the more compact, easy-to-use 200mm. A top-quality Nikon teleconverter that takes up very little space and weighs only a few ounces gives me 400mm capabilities with my 200mm lens.

I always have a tripod in my car or pickup truck. But when I venture away from the vehicle, the tripod stays behind, and I rely on faster film that will allow faster shutter speeds—and I'm careful to keep the camera steady. It's easier to carry a small camera clamp that can be affixed to a tree branch to hold the camera steady for telephoto and close-up work. If I must take a tripod by air, I don't carry my sturdy, heavy-duty model, but take a feather-weight Slik Model 500G.

Some say that the secret of photographic flexibility is owning a vast array of equipment, but a cumbersome collection of gear can keep you from getting the best shots. If your pack is light you'll hike a little farther or climb higher to get the great photographs. When the action is fast, rely on one camera instead of fumbling with several.

Although I rarely go anywhere without two cameras—a color and a black-and-white—I don't often take a third into the wilds. And if the going is rough, the second camera will usually be a compact 35mm viewfinder that fits in a jacket pocket.

I enjoy close-up work as much as any other aspect of outdoor photography. Consequently, I have to use this same kind of ruthless judgment when considering what sort of close-up gear to carry on any given trip.

Among close-up accessories, the bellows unit can often be left behind and a compact, lightweight set of extension rings or close-up lenses taken instead.

I tend to carry too many filters and special-effects lens attach-

ments, rationalizing that they are light and don't take up much space. The bare-bones necessities are a #8 Yellow, a #1A Skylight, and a polarizer. Well, maybe a #25 Red or a #11 Yellow-Green, and I might need a cross screen or a diffuser . . .

Don't skimp on film. It is better to carry too much film than not enough. I would leave a favorite lens or extra camera behind to make room for film if I had to. But to lighten up, carry 36-exposure rolls and leave the 20-exposure rolls home. (The cassettes are about the same size and weight.) Remove film from the box and carry it in the protective canisters. If you take more than one kind of film, use small pressure-sensitive labels on the canister caps for identification. When you return an exposed roll to the canister, peel the label off or mark an X through it.

Tips on Traveling by Car

My favorite way to travel is by car or pickup truck; having traversed most of the contiguous states, much of Canada, and Alaska by car, I have learned a few things that may be worth passing on to other outdoor photographers.

Avoid expressways and interstate highways whenever possible. In long-distance travel you can make good enough time on the less traveled highways. Indeed, you can often make better time at a more relaxed pace.

When you travel the smaller highways and back roads you can find places to pull off the road and take pictures; stopping along the side of a superhighway is permitted for emergency purposes only. On the back roads you are more likely to encounter the wildlife that tends to avoid noisy, busy expressways.

Keep your camera ready at all times when traveling by auto, because the picture of a lifetime might be just around the bend or over the next hill. But don't leave a camera on the dashboard or on the rear window shelf where excessive heat from the sun can ruin your film. For the same reason, don't leave film or loaded cameras inside a closed vehicle or car trunk during warm weather. If you leave your vehicle, take your photo gear with you. If you must leave it behind, the best protection against theft is to lock it in your car trunk, but insulate it from excessive heat with an ice chest or cooler; first seal your gear inside a plastic trash bag to protect it from moisture inside the cooler. If you have no cooler you can insulate the gear by wrapping it in a sleeping bag; for stops of a couple of hours, layers of clothing or blankets will do much to insulate gear.

Tips on Traveling by Airplane

Luggable luggage is most important when you travel by air; restrict bulk and weight as much as you can.

On commercial airlines I always pack my photo gear as carry-on

baggage. Luggage that is checked in is handled too roughly for my peace of mind. If any of your equipment is in suitcases that will be handled by the baggage manglers, be sure it is packed securely. Wrap it snugly in sheets of 1-inch high-density foam (available from upholstery shops), and pack it so it will not move about inside the suitcase. Pack clothes tightly around it, and keep your fingers crossed.

Your carry-on baggage has to be small enough to fit under a seat, unless you are on a large, wide-bodied jet where there are overhead compartments for gear. The more compactly you can assemble your equipment, the easier it will be to handle. Fitted luggage-type cases (such as Halliburtons) are best. They don't advertise the contents like conventional photographic gadget bags that almost invite theft.

Traveling economy class on international flights, you are allowed 44 pounds of baggage; in first class, 66 pounds. Weigh your equipment beforehand to assure you won't have to pay excess baggage charges, which can be mighty high.

The equipment I take in a car—a carrying case loaded with three bodies, five lenses, strobe, filters, and other accessories—weighs 18 pounds. A 600mm lens and its case adds 5 pounds, and my heavy-duty tripod is 5 pounds more. If I took it all on a plane, I could only take 16 pounds (economy) or 38 pounds (first class) of personal effects. Note that sometimes it is cheaper to travel first class than to pay excess baggage charges.

That's the bad news. The good news is that carry-on baggage is seldom weighed. So if you want to take a chance, take as much photo gear as you can carry onto the plane. Don't be too upset if a ticket clerk requests you to put your photo gear on the scale. It has happened to me only once, and luckily I was traveling light enough to be under the limit.

We can thank the goons, freaks, and weirdos who hijack airplanes for the most troublesome hassle associated with air travel—the security check. We probably always will have to put up with this ordeal.

Now that airports using X rays are as common as carp, the authorities assure us that the dosages of radiation are so low as not to harm photographic film. One time through the machine probably won't hurt unprocessed film; but X rays are cumulative, and the more your film is exposed to radiation the more likely it will be fogged. On all but the simplest nonstop trip your film can get zapped many times.

The best way is to request (demand, if necessary) visual inspection of your photographic equipment. Even if the inspector tries to assure you that X rays won't harm the film, say that you prefer a visual inspection. Most inspectors will oblige, as they are supposed to. I have had to deal with a few surly ones, however. I

usually inform them that I am spending a good bit of money to take the trip I'm on and to get the photographs I'm after and if they wish to sign a statement accepting responsibility for any damage done to my film by X ray, I would be glad to put the film through their little machine. The same inspector who has such undying faith in the harmlessness of X rays is never willing to sign such a statement. I always get the visual inspection I requested.

To simplify the process, check in early before the inspection lanes get crowded. Pack film separately and be sure your cameras are empty.

An alternative is to pack your film in protective, X rayproof bags available at photo shops or through mail-order suppliers. The inspector may ask you to remove such packages for visual inspection, so keep them packed near the top of your equipment carrier.

X rays are used more and more to examine checked-in luggage, so don't pack film in your suitcases. Also, if you are traveling abroad and mail film to the U.S. for processing, be sure to label the package "Unexposed Film—Do Not X-Ray."

Foreign Travel Tips

The secret of enjoyable foreign travel with cameras is fore-knowledge of the rules, regulations, and restrictions in the countries you plan to visit—not to mention the regulations imposed by the U.S. government.

Before heading for Mexico you should know that you can take only one camera and 12 rolls of film. In the Bahamas there is no limit on film, and you can take two cameras, but you will have to register them on entry. Canada has no set limits, although I have read a few isolated reports that heavily equipped professional photographers have had problems on crossing into Canada.

In some countries, such as Algeria, New Zealand, and Tahiti, you can be limited to 5 rolls of film—another good reason for going with 35mm and 36-exposure rolls.

In some countries certain subjects—bridges, railroads, cemeteries, or royal palaces—are off limits to photographers. In Mexico you cannot photograph archaeological sites. In Jamaica and the Dominican Republic, photographing beggars is forbidden. In West Germany nothing is *verboten*, but you need a permit for some subjects.

Travel Photography, a volume in the Life Library of Photography, lists regulations and restrictions abroad. The nearest foreign consulate of the country you plan to visit can also give you information. Travel agents can help you.

When you return to the U.S., foreign-made items are subject to import duties unless you can prove to customs that you owned them before leaving the U.S. So before leaving, stop by a local customs office and have your cameras, lenses, and serial-

POPULAR PHOTOGRAPHIC TRADEMARKS REGISTERED WITH THE U.S. DEPT. OF THE TREASURY

TRADEMARK	RESTRICTION
Ansco Argus Contaflex Contarex Fujica Minolta Miranda Olympus Ricoh Topcon Topcor Vivitar	No restriction on any importation of trademarked merchandise
Gossen Mamiya Minox	One article of each named trademark may be imported if in the owner's possession upon entering the U.S., and if for personal use and not for sale.
Bronica*	One camera (including attached lens) and two interchangeable lenses of each named trademark may be imported if in the owner's possession upon entering the U.S., and if for personal use and not for sale.
Konica Mecablitz Mecatwin Metz	Two articles of each named trademark may be imported if in the owner's possession upon entering the U.S., and if for personal use and not for sale.
Asahi Pentax* Pentax*	One camera (including attached lens), one projector, and one each of any accessory of each named trademark may be imported if in the owner's possession upon entering the U.S., and if for personal use and not for sale.
Nikkor Nikkormat Nikon Nikonos	Three still cameras (including attached lenses), three movie cameras, three binoculars, six interchangeable lenses, and three other optical instruments or accessories of each named trademark may be imported if in the owner's possession upon entering the U.S.
Leica* Leicaflex* Leicina* Leitz*	One camera (including attached lens), and one camera carrying case, of each named trademark, may be imported if in the owner's possession upon entering the U.S., and if for personal use and not for sale.
Komura* Takumar*	Two lenses of different focal lengths of each named trademark may be imported if in the owner's possession upon entering the U.S., and if for personal use and not for sale.
Novoflex Prinz In Design Tel X tender Tiffen	Importation prohibited without written specific consent of the trademark owner.

* Additional restrictions are imposed on these trademarks for officers and crew members
 of any ship, aircraft, or any other type of carrier. Consult U.S. Customs Service for
 further information.

numbered accessories registered on Customs Form 4457, "Certificate of Registration for Personal Effects Taken Abroad." In the absence of a Form 4457, a bona fide bill of sale, insurance policy, or receipt for purchase or repair is considered reasonable proof of prior possession by the U.S. Customs Service. Be sure to have proof of purchase of smaller photographic accessories such as filters and cable releases. If you don't have proof, take a list and the items to your local customs office for inspection before departure. The customs agent will probably agree to attest to having inspected the items and will sign the list, but this is no guarantee that the accessories will be exempt from duty on your reentry into the U.S., when the decision will be up to the agent at port of entry. The list will probably suffice with most agents: it has worked satisfactorily for me.

Photographic equipment purchased abroad is subject to import duties of 6% to 12% of purchase price. There are restrictions on importing some products whose trademarks have been registered with the Treasury Department. Some trademark owners have consented to limited importation of their products by a traveler who brings them to the U.S. personally and not for the purpose of resale.

To import an item with a restricted trademark you must have written permission from the trademark owner, or the trademark must be physically removed from the item before it can pass customs.

The Customs Service has paraphrased the old adage "Look before you leap" in the title of their booklet of hints, "Know Before You Go," available free from the U.S. Customs Service, Treasury Department, Washington, DC 20229. Ask for another helpful booklet, "U.S. Customs Service Trademark Information for Travelers."

EFFECTS OF CLIMATE AND WEATHER

15

The same outdoorsman who shrugs off or even hopes for what others would consider bad weather may leave his camera at home when the weather is poor. The waterfowler curses those "bluebird days" and revels in the blustery gloom that keeps ducks moving. A bass fisherman will take heavy overcast over sunny blue skies anytime. Skiers, snowmobilers, and ice fishermen look forward to the mercury dropping.

The outdoor photographer can learn to use fog, overcast, storms, rain, and snow; he can explore an exciting world full of new, stimulating subjects. He must know the capacities of his film and equipment—and of himself.

Dealing with Haze and Overcast

Haze and overcast are enemies of the landscape or scenic photographer. On such days I focus my attention on other kinds of photography. If I do photograph landscapes I try to keep the sky out of the pictures and I avoid shooting distant scenes which can be adversely affected by atmospheric haze.

Haze and light overcast wash out the sky. Light becomes more nondirectional, which makes shadows open up considerably. This is a good time for outdoor portraiture and for close-up work.

If you're shooting in color, especially with a cool-color film, use a #1A Skylight filter to absorb some of the excessive bluishness reflected by subjects photographed under overcast skies. The trusty #8 Yellow filter gives pleasing results in black and white, although the #11 Yellow-Green will render better flesh tones. Try to warm up your photographs by including subjects that are brightly colored, especially in reds, oranges, and yellows.

Flowers, mushrooms, and insects are good subjects for close-up work on hazy days. Heavy overcast usually flattens the light too much, resulting in dismal photographs with little contrast and poor color saturation—use a strobe to spark up your subjects.

Be especially careful with light-meter readings, and bracket your exposures. The sunlight is scattered but is often as bright as on sunny days. As the overcast increases, so should your bracketing—from one to three f/stops over and under metered exposure for important subjects.

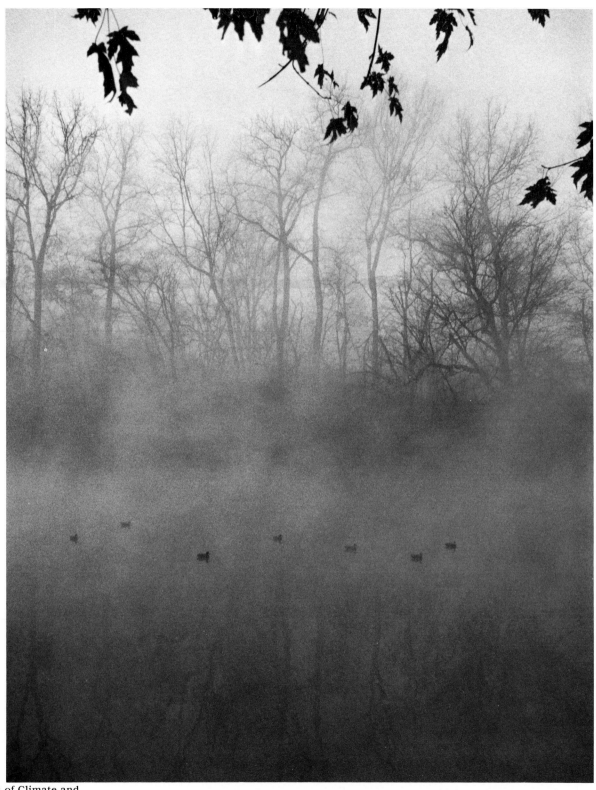

Effects of Climate and
Weather
220

Taking Foggy Pictures

Foggy days are rare during the summer and winter. Therefore, to take advantage of the moods created by fog, plan on spring and fall photography.

To exploit fog, be out early in the morning. I like to be on location before or at sunrise. I rarely take pictures that early—the light is usually insufficient and the fog is often too dense—but I am able to watch the changing conditions and grasp picture-taking opportunities that are often fleeting.

I check the weather forecast the evening before fog photography: the best kind of forecast is "early morning fog, especially in low-lying areas, but with a promise of clear sunny skies." On such days, as the sun climbs it burns the fog away. As fog density decreases, subjects are illuminated by a diffused, often eerie and otherworldly light. Remaining puffs and wisps of fog are in valleys, draws, and along the courses of streams and in lowland meadows, swamps, marshes, and ponds. In woodlands, sun rays break through branches and shafts of light illuminate the forest floor, with opportunities for some spectacular photography.

In black and white, to accentuate the fog use a #47 Dark Blue filter. In color or black and white, emphasize the fog by shooting with telephoto lenses ranging from 80mm to 200mm.

Residual fog in low-lying areas can add appeal and impact to landscapes, especially in mountain or coastal areas. In a distant scene shot with a normal or wide-angle lens the fog may be scarcely noticeable; a telephoto lens, on the other hand, will compress the scene and emphasize the fog. Photographs of bright blue sky and crisp, clear detail sharply contrasted with areas where fog diminishes detail or hides it altogether are real attention getters.

Wet-Weather Photography

I have spent a fair amount of my adult life tramping around rainy country. I did a 15-month stint in the Aleutian Islands in the army, and I have made several trips to coastal Alaska—my favorite part of the state. These areas get as much rainfall as any part of North America. My wife and I live in coastal Oregon, a region with a reputation for rainfall. So if I let the threat of rain keep me and my cameras indoors, we wouldn't get out much.

I don't have webbed feet or gills, and I don't enjoy being in a torrential downpour. I have sat shivering in a duck blind when temperatures were just high enough to keep the pouring rain from freezing. I have trolled for striped bass through a pitch-black February night during rain that dampened body and spirit. I have been waterlogged for days in camps all over North America. Once, after weeks of desert survival training, I arrived in the Mojave Desert one May morning to be greeted by an unexpected 54°

temperature and three solid days of desert storms—gully washers that seemed to dissolve the sandy terrain, making it impossible to keep a tent up.

So I'm not one to go bounding into monsoons or hurricanes looking for a picture; but there is much to be said for the photographic potential of spring showers, summer storms, intermittent rain, and misty drizzle. The lesser rains seem to freshen the outdoors, leaving foliage and flowers glistening with delicate droplets. Tree bark and weathered wood take on richer textures when wet, offering excellent opportunities for close-up work. Raindrops striking the surface of a pond can add life and action to otherwise static photographs. Fishermen, boaters, hikers, and backpackers in brightly colored rain suits or slickers add zip to a photograph.

Since light levels are reduced by rain clouds, I usually use fast film, as I often need a fast shutter speed, a small aperture, or both to record the effect I want. But there are times when a slow film in a tripod-mounted camera is right. When sharp detail is a primary concern, the fine grain of the slower film is important. In a misty drizzle that acts as a giant diffusion screen, the otherwise bright and contrasty colors of Kodachrome are transformed into gentle pastels that give scenes an appearance of pastoral serenity.

The wet-weather photographer must keep his equipment dry. Nikonos underwater cameras are great for carefree photography in the worst weather. There are underwater housings available for many 35mm cameras. Spiratone offers several inexpensive waterproof housings for 35mm SLR cameras, and a clear plastic "raincoat" of sorts that covers the camera and the photographer's head and shoulders. You can improvise your own rainproof camera cover with a plastic bag and a roll of plastic electrician's tape. Make holes in the bag for the front of the lens and for viewing; if you have a strap on your camera, you will need holes for it too. Use the plastic tape to secure the bag to the camera. The open top of the bag becomes the bottom of your camera cover and allows you to slip a hand inside to advance film, cock the shutter, and make other needed adjustments.

Keep checking the front element of your lens to make sure it hasn't been splattered by raindrops. Carry a good supply of lens tissues and use a lens shade to deflect rain.

Often you can shoot from inside a vehicle or from under the protective canopy or cabin of a boat. In camp, you can shoot through an open tent flap. You can improvise a rainproof "camera tent" out of a large sheet of polyethylene or from a waterproof ground cloth or rain poncho.

The Calm Before (and After) the Storm

Summer storms offer great, if short-lived, opportunities for

exciting pictures. When the sunny blue sky is interrupted by rolling black storm clouds, it's time to grab your camera—unless it's an electric storm, in which case you should head for shelter.

Lighting is often extraordinary before a summer rain squall; storm clouds add drama to the scene. When the storm has passed and the sky begins breaking up, look for unusual lighting and keep an eye out for rainbows. Puddles, wet pavement, and standing water in lowland areas offer chances to exploit reflections. Get plenty of shots of wet foliage and flowers before the raindrops evaporate.

Cold-Weather Photography

Winter photography is as different from warm-weather photography as skiing is from waterskiing.

First, film is a fair-weather friend. Film characteristics that we take for granted in normal weather can be severely affected by low temperatures. Film emulsions slow down as they are cooled, effectively reducing the exposure index. You may have to allow one to three f/stops additional exposure in winter. Bracketing is essential, since when we are afield we can only guess how much the film is affected.

Faster film is better for cold-weather photography. Film with a good exposure latitude is more forgiving of errors than narrow-latitude film. I use a lot of Ektachrome during cold weather, and I have found my old standby, Plus-X, to be an excellent choice for black and white in winter, although I normally carry a supply of Tri-X for low-light or fast-action photography.

As the temperature sinks below freezing, film becomes brittle and tends to crack and break. The advancing sprocket inside a 35mm camera may tear through the perforations in the film, preventing it from advancing. The photographer usually discovers this after making many exposures on the same frame.

To check that the film is advancing properly, keep an eye on the rewind knob to see that it turns as you cock and advance the lever. Always advance the film and rewind the exposed roll slowly and evenly. If you detect resistance, it is a warning that the film may be frozen and ready to break. This means you have to stop.

The "freeze-dried" atmosphere of winter is full of static electricity. Static sparks, touched off by too rapid advancing and rewinding of film, show up as unsightly lightning streaks.

The light meter or electronic exposure system is apt to give you problems in cold weather too, since mercury batteries become less reliable. The Minolta Corporation warns that battery-powered light meters are undependable below freezing, but I have experienced no problems in the 20° to 32°F range. But I bracket my exposures, so I might fail to notice minor problems.

As temperatures sink toward or below 0°F, battery-powered

light meters and exposure systems will become unreliable or will cease to function. Nikon warns that below freezing, mercury batteries will function only 3 minutes, after which they must be warmed to again operate properly.

Some photographers carry their cameras inside their parkas or coats to keep batteries and film warm. Unfortunately, when the camera comes out from inside the clothing the sudden cooling will usually fog or frost the lens and eyepiece. Also, some photographers (yours truly included) find cameras inside one's clothes to be confining and uncomfortable.

Cold-weather photographers have dreamed up some inventive (though dubious) ways to keep their cameras warm. They may tape hand warmers to the backs of their cameras. In severe cold I wonder if the gadgets really help, and in moderate cold I fear the camera might get too warm. There is no way to accurately determine the temperature inside the camera, much less to control it.

When the built-in light meters in my cameras become unreliable, I carry a small light meter on a lanyard inside my parka. I take readings quickly and return the meter at once to the warmth of my clothing and body heat. The meter is small and causes no discomfort.

Keep lens caps on your lenses in cold weather whenever you're not taking pictures. The cap protects the lens and helps combat lens fogging.

In chapter 8 I mentioned how photographers like to keep a skylight or ultraviolet filter on their lenses all the time to protect the expensive optics. Taking this precaution in cold weather reduces the chance of frosting a lens. I assume that, in principle, the function of the filter is similar to that of a dual-pane window, providing an effective thermal barrier between the lens and the frigid outdoors.

Another reason to keep a skylight or ultraviolet filter on your lens in cold weather is that ultraviolet radiation is at peak intensities at high altitudes and in northern latitudes during the first six months of the year. The filters will absorb that radiation.

First-time cold-weather photographers learn in a hurry not to exhale as they lift their cameras to their eyes. One warm breath may frost the eyepiece for five minutes. The frosting problem is not confined to optics. As you enter a warm cabin or vehicle, moisture will collect on the exterior of your equipment. The solution is to seal your cameras and lenses in an airtight plastic bag before bringing them inside.

The automatic diaphragms found on many lenses can get sluggish and may even cease to function in severe cold. If you suspect a problem, remove the film from your camera and look through the film port as you open the shutter, with shutter set on B and the diaphragm set at its smallest aperture. When the shutter is

tripped, the diaphragm should close down completely. If it is stuck wide open, and if you must continue to use the lens, go to higher shutter speeds, use slower film, employ neutral density filters, or combine all three.

Should you get your cameras and lenses winterized? It could be a good idea if (1) you are going on an expensive, extended arctic or antarctic expedition and must be absolutely sure that your cameras will function properly, since *National Geographic* is going to lavish great wealth upon you when you return with outstanding photographs; (2) you have more cameras, lenses, and money than you know what to do with. But it will cost you $50 to $100 per camera and $25 to $50 per lens (or more) to have your equipment winterized, and it will take six weeks or more. Come spring, your cameras and lenses will have to be "dewinterized," at the same cost in time and money. Your equipment will be tied up for months every year.

During the four years I lived in Fairbanks, Alaska, my writing and photography took me into remote villages during the harshest winter weather the mainland of this continent has to offer. Only once did my camera freeze up so I couldn't use it. I was a couple of miles out of Barrow on the Bering Sea ice pack, photographing the aurora borealis. It was −40°F and a 25-mph wind brought the chill factor down to −104°F. Even then I was able to set my camera on a tripod and expose seven frames before everything froze up.

In Alaska I got to know several of the best photographers in the state. None of them ever had their equipment winterized.

Snow Scenes

The beginner thinks snow is one of the greatest photographic problems. There is a good deal of misinformation circulating on the subject. Recently I read a piece on winter photography which stated that on a bright sunny day the light reflected off snow-covered ground can require stopping the lens down by an extra three f/stops. If true, this would mean that the light level is eight times as bright if there is snow on the ground. Hogwash!

Meters can be fooled by snow by three f/stops, perhaps even more. If you believe your meter you will get underexposures.

I have only rarely had to compensate for light reflected from snow onto a subject and then by no more than one f/stop. Jimmy Bedford, head of the journalism department at the University of Alaska—a man who has been in charge of the photography courses there since 1965—told me to ignore the snow and expose for the detail in the subject. He was right.

On a snow day, a spot meter gives accurate readings. You can get a reliable reading without a spot meter by moving in close to the subject or taking a reading off a nearby subject that is simi-

Winter is an exciting time of year that too many outdoor photographers overlook. It's the only time scenes like this can be recorded.

larly lighted. Use a gray card instead, or the palm of your hand—or use any of the methods discussed in chapter 6.

In shadow areas, snow reflects a lot of blue light. With color film, use a #1A Skylight filter. With black and white, the #8 Yellow will absorb the blue light that often destroys the texture of shadows in snow. On bright sunny days with snow, a polarizer will help both kinds of film.

Step into the World of Winter Photography

Winter is a good time to photograph wildlife. Many animals are easier to approach, and the snow-covered ground is quiet and allows for easy stalking.

After reading about cold-weather photography problems, some of you are probably wondering, "Why bother?" Primarily for the same reason that people find enjoyment in cross-country skiing and snowshoeing. Winter has its own character and moods. It is

an ever-changing world. It can be warm and friendly, or harsh, awesome, and dangerous, but it is rarely boring and it offers an endless variety of photographic subjects.

The Basic Don'ts of Photography at 50° Below

When I was outdoor editor of a weekly sports tabloid in Alaska, our news editor, Norm Gibbons, would drop by my office to share insights he had on subjects I was covering.

One day, after he had read through my draft of "Some Tips on Winter Photography," he told me I had neglected to inform my readers of the two most important basic don'ts of photography at 50° below.

"And what might those be?" I asked.

"Well, number one is, don't wear tennis shoes."

After a deliberately long pause, I asked, "And number two?"

"Ah! Yes! Number two quite simply is," he said, leaning back in his chair and squinting pensively, "just don't."

SHOPPING FOR EQUIPMENT AND ACCESSORIES

Innovations in equipment and accessories are flooding the marketplace—gadgets that make a process more foolproof, others that make impossible tasks commonplace, improvements in design and function of old standby cameras and lenses, and surely a certain amount of useless junk and doodads.

It wasn't so long ago that the only compact, full-frame 35mm SLR system camera on the market was the Olympus OM-1, but now all the major camera manufacturers offer similar cameras. Canon and Nikon introduced the first small, relatively inexpensive motor-drive units (autowinders) and were soon imitated widely. Other relatively recent innovations include close-focusing zoom lenses, electronic exposure (with your choice of aperture or shutter preference or both), and automatic electronic flash (more than a hundred models currently available).

As a critic, my preferences for brand names and models may be as subjective as those of a theater critic. He can be honest, but he cannot be totally objective. After you compare his reviews with your experiences at the theater, you can tell if his subjective preferences are in phase with yours. The same is true of photographic writers like myself.

If a writer for a major photographic magazine has spoken out repeatedly against electronic exposure, I would expect his subjectivity to interfere with his judgment about that feature in a particular brand of camera. If he has clearly stated the pros and cons of electronic exposure and has reported to his readers on EE systems that excel, it is more meaningful when he tells me that the EE system in a new model is junk.

You are safer if you read the opinions of several experts before buying a lens or camera for an amount that might pay your rent or groceries for a couple of months.

Shop Before You Buy

You should read at least one of the major photographic magazines regularly. Study the new product sections and equipment test reports; also read the ads, keeping in mind that advertising is promotional in nature. In *Popular Photography* you can turn regularly to the "Help" and "Just Out" sections.

Popular Photography and *Modern Photography* conduct ex-

tensive equipment tests; it's a good idea to clip reports on products you might buy and file them for use in later decisions. Many of *Popular Photography*'s test reports are available as reprints for $1 or $1.50. Write for a list to Popular Photography Reprints, Dept. P58, P.O. Box 278, Pratt Sta., Brooklyn, NY 11205.

The first step to gathering a lot of literature is to read the "Ask for It" department in *Modern Photography* and the "Aids to Better Photography" section in *Popular Photography*. Product information from manufacturers (which you can get by writing them) is understandably promotional, but will provide you with facts and specifications that will aid you.

First do your homework so that you can discuss the product intelligently, then visit camera shops to physically examine any equipment you are considering. The dealer's first interest is to sell you something; try to separate the facts from the sales pitch. Many knowledgeable dealers are sources of sound information. They may even point out the faults of a product and show you something that better suits your needs.

Handle the equipment to see how it feels to you. Check all the features and controls to make sure they are comfortable and conveniently located.

If you have friends who are knowledgeable about photography, discuss your plans to purchase new equipment with them and ask for their recommendations. Members of local photo clubs are good sources of information and opinions. If a nearby college offers photography courses, chances are instructors there will be willing to offer advice.

If no one can answer your questions, by all means write the manufacturer. It has been my experience to get honest, helpful, and complete answers to all such inquiries. You can also write Readers' Service Editor, *Modern Photography*, 130 E. 59th St., New York, NY 10022. Enclose a self-addressed stamped business-size (#10) envelope.

Where to Buy

You can buy photographic equipment from a local camera shop, a discount department store, or a mail-order supplier.

The small photographic equipment dealer has a hard time competing with discount department stores and mail-order suppliers on prices. He may have to pay more for some equipment and materials than what you pay for the same items purchased retail from high-volume outlets. Consequently, he must compete in other ways, offering personal service and attention in lieu of savings.

If you live in or near Los Angeles, Chicago, or especially New York—or any other major metropolitan area in the country—you will find many camera shops competing for your business. Dealers in large cities offer personal service and attention, are willing

to give advice and answer your questions, and try to put reasonable prices on their merchandise. (However, beware of the occasional "clip joint." Comparison shopping will keep you from being victimized.)

In a community with one or two shops, the competition isn't effective in keeping prices down. As for service, you may meet an independent take-it-or-leave-it attitude, or you may find gracious and helpful service.

A couple of summers ago I was in the small Cascade Mountain town of Bend, Oregon, to teach outdoor writing and photography courses at the community college. Before my courses began, I stopped by the two camera shops in town to talk with the dealers, and found them most cooperative. They offered discounts for my students and said they would try to get overnight delivery on any items they did not carry in stock.

Discount department stores are not without fault either. The problem is not so much of attitude as of ignorance. The photographic department managers and some of the clerks in these megalomarkets are knowledgeable about the products, but other clerks are complete dolts.

Take advantage of the consistently lower prices at discount department stores, but make sure you know what you want beforehand, and visit all the discount outlets you can. Learn to avoid the photographic department that carries only a minimum of equipment and some film to cater to customers who shoot an occasional snapshot; seek out the stores that vie with the largest photographic shops and are staffed by experts.

The discount stores have excellent sales. Items are marked down drastically to bring shoppers into the store. The large chains buy in huge lots and sell at a minimum markup; on some sale items they may even take a loss. Not long ago, a discount store near me put Kodachrome, Ektachrome, and Kodak prepaid process mailers on sale at the best price I've seen anywhere. The idea, of course, was to get customers to stop by, pick up a few rolls of film and a few mailers, and go on to buy more higher-priced items. When the store neglected to put a limit on the number of sale items a customer could purchase, I took advantage of the situation and bought 50 rolls of film and 50 mailers.

Batteries are another frequent sale item. I watch for ads in the newspapers. Sales pop up unexpectedly, so I like to keep some extra money in my photo "kitty" so I can take advantage of them. I would guess I save a couple of hundred dollars a year on sales.

Some people have fears about mail-order buying. Mail-order rip-offs were a significant problem some years ago, and still can be occasionally, but you can get the outstanding savings from mail-ordering from a reputable supplier, without excessive risk. New laws protect the mail-order consumer better, and the Postal Service comes down hard on fraudulent companies.

Since 1972 I have been buying 90% of my equipment and supplies by mail, and I have had no major problems. Of all the orders I have placed, I recall having to return one item, a filter that was loose in its rim. It was replaced immediately.

Mail-order service has improved markedly in recent years. Many companies offer same-day processing of orders. Most will accept major credit cards and some have toll-free numbers so you can phone in your order and cut delivery time by several days.

Because of space limitations and the cost of producing catalogs, descriptions of products in mail-order catalogs are often minimal. Study the products elsewhere, as discussed above. If you have specific questions, don't hesitate to write or phone the supplier.

Some suppliers state that they carry only the items in their catalogs, so don't bother them with questions about other products. If a supplier makes no such statement, you can ask for a quote on an item that doesn't appear in the catalog. Even if he doesn't normally carry it in stock, he may agree to special-order it for you, or suggest another source of supply.

I recently wrote to a mail-order company about an item not in the catalog. Several days later I got a phone call from a company manager who told me that the manufacturer of the product didn't want his line discounted at cost plus 10% and that was why it was not carried in the catalog. But if I let the manager know when I decided to buy, he would make a few phone calls to some dealers he knew who might get me a good price. That is the best kind of service, and it's the sort of treatment that will keep me buying from a company.

A good place to look for reputable companies is in the "Special Mail-Order Section" of *Modern Photography*. For a company's ad to appear there, it must agree to a special limited warranty, the conditions of which are spelled out in detail in the magazine.

Go through a mail-order catalog carefully, comparing prices. Read the statements on company policies and guarantees. The company should offer hassle-free exchange or refund on defective merchandise. Ask around about the company. Recommendations of other photographers are invaluable, especially if you plan to make a major purchase.

If you can't find out much about the company, start by ordering inexpensive items a few times to determine how quickly they fill orders and what sort of service they offer.

I recommend three companies that I have dealt with during recent years: Norman Camera, Spiratone, and Porter's Camera Store. Two others I have not yet dealt with, but which have been recommended to me by other photographers, are Frank's Camera and Parkwood Camera Stores.

You can speed mail-order deliveries by paying with a personal money order, cashier's check, certified check, or approved credit card. Personal checks are accepted by most companies, but or-

ders won't be shipped until the check has cleared, and this can take up to ten days.

I recommend that you specify shipment by United Parcel Service if it serves your area. UPS handles parcels carefully and efficiently, and can deliver most orders in one to five days anywhere in the contiguous states. It also offers Blue Label air shipment to Anchorage, Alaska, and Oahu, Hawaii.

UPS is not permitted to deliver to a post-office box, so give your residence address—and it's a good idea to include your phone number too. Don't place an order for UPS delivery if you plan to be out of town for an extended period, unless you have made arrangements to have the UPS driver deliver the parcel to a neighbor. UPS makes three attempts to deliver a package before returning it to the shipper.

Importing Photographic Equipment

Some years ago it was economical to order cameras, lenses, and other expensive photographic items from Hong Kong or Japan. But since the U.S. dollar has dwindled in value in the foreign market, savings aren't nearly as great, and for my money aren't worth the hassles.

If you contemplate ordering equipment from abroad, investigate all aspects of the transaction carefully. It will probably take a minimum of six weeks for the goods to reach you. On entering the U.S., the products must clear customs. Savings begin to shrink as import duties are levied. Unless you have obtained specific written permission from the trademark owner to import his products, the trademark may have to be physically removed (see chapter 14); such defacing of the product can reduce its resale or trade-in value.

By shopping around at the domestic mail-order suppliers, I can come within a few dollars of the savings I would realize by ordering from abroad.

Buying and Selling Used Equipment

Most used equipment is bought and sold through camera shops, some mail-order companies, and private parties. I don't know of a discount department store that deals with used equipment or will allow trade-ins.

I have bought and sold a good bit of used equipment over the years, and on the whole have had relatively few problems. Some dandy buys more than offset the few clunkers I collected.

If you don't trust your own judgment in determining the condition of used equipment and can't take an expert with you, deal with camera shops and mail-order suppliers that will stand behind their used gear with some sort of warranty. If you buy a camera from a local dealer, ask him to let you put a refundable deposit on the equipment and try it out for 48 hours. You can learn a lot about a camera in two days.

I recommend that you buy new equipment the first time you buy a camera or system of cameras and lenses, if you can afford it.

It is sound practice to buy your primary camera new and find a good used camera for backup or as a second body to add to a system.

When buying a used camera from a local source, examine it throughout. Verify that all controls function smoothly and properly. Check that the aperture ring and shutter knob click crisply from one detent to the other. If there is a self-timer and mirror lockup, try them. Get inside the camera and determine that the sprocket moves when you advance the cocking lever. Set the shutter on B and with the shutter open, turn the aperture ring on the lens to see that it stops down and opens properly. In the case of automatic lenses, either hold the depth-of-field preview button down while you check the aperture or remove the lens from the camera and look through it as you turn the aperture ring.

If the lens is interchangeable, remove it from the camera, hold it firmly, and shake it. Do the same with the camera body. If things are rattling around inside the lens or camera, pass up the sale.

Make sure that an interchangeable lens mounts firmly with no play or wobble. A loose-fitting lens can mean a damaged mount that could be expensive to fix.

If the camera has a built-in light meter, examine it. Take readings of a number of subjects of varying brightness. Change shutter and aperture settings to see that the meter registers accurate readings at all settings. Then remove the battery to check for excessive corrosion of terminals. Minor corrosion is easy to remedy and should not deter you from buying the camera. Major corrosion, however, indicates that the camera has not been properly cared for.

Examine the inside of the camera for signs of rust. Don't buy a rusty camera; it may have been subjected to damaging moisture that has corroded other parts that you can't see without dismantling the camera.

Relatively uncomplicated items like tripods, extension rings, filters, and carrying cases are easy for even the novice to examine. So if you find something used that has been cared for and looks like a good buy, get it.

I don't recommend buying a used strobe unless you know and trust the seller. Strobes must be cared for and should be used regularly. If you buy a used one from a stranger, you have no way of knowing how it was treated.

There are some items I would never buy new. I won't pay the going price for a new view camera, since it would only have limited value to me in my work. But I might convince myself to invest in one of the wonderful old Speed Graphics that can be found for sale at reasonable prices.

CARE OF EQUIPMENT

There is one sure way to keep your outdoor photography gear gleaming and sparkling like new: Don't use it. And, friends, that is the *only* way. If you doubt my word, take a look at the equipment of any busy photojournalist: bare metal shows through where chrome and other finishes have worn thin, although the cameras and lenses are in top mechanical and optical condition.

Cameras, lenses, and other photographic gear are tools, and tools are to be used without being abused. Don't overprotect them. Platings and other external coatings are bound to show signs of wear after a year or so. It is pointless to worry any more about this than you would about similar indications on your fishing tackle, hunting equipment, or golf clubs.

Be extra cautious, however, in the care of photographic optics. A bit of touch-up bluing will hide a scratch in a gun barrel, and a coat of varnish can make a fishing rod look like new, but a scratch or chip in a lens can render it useless.

Camera Cases, Lens Shades, and Lens Caps

The second-best way to keep a camera looking new is to house it in a fitted case. Most of us think camera cases are needless nuisances, yet some photographers insist on enclosing their cameras and, as a result, are unprepared for those quick shots so important in outdoor photography. It makes as much sense to go afield with your camera encased as it would to keep your shotgun zipped up in fleece and vinyl until your dog goes on point, or to put your fly rod in a tube as you move from one pool to another.

The guy who makes his living with cameras probably doesn't own cases for any of his cameras, but he protects his optics. His lenses are capped at each end. There are lens shades on his cameras, not only to guard against interference from extraneous light, but to protect the lenses from tree branches and other harmful objects. On examining his gear more closely, you will probably find UV or skylight filters screwed into the end of each lens. The filters help him to record images, and also to protect his lenses.

In the field, a stiff brush will quickly remove dust and dirt from the exterior of cameras and other gear.

Mirrors in SLR cameras should be cleaned with utmost care. It's best to pick off each particle of dust individually with a small artist's spotting brush.

Cleaning Cameras, Lenses, and Filters

Dirt, dust, lint, fingerprints, and smudges on camera lenses, filters, and lens attachments diminish the quality of the image being photographed by diffusing the light, softening the focus, often distorting the subject, changing the color quality, and increasing the probability of flare spots and ghost images. Optics should be kept spotlessly clean, but they must be cleaned carefully and correctly.

The first step is to remove dust and dirt from the exterior of the instrument, using a small brush. When I'm at home I use a one-inch paintbrush, but in the field I carry a half-inch artist's brush with fairly coarse bristles. While cleaning a camera or lens exterior, leave the lens cap on to keep from brushing dirt onto the optical surface.

Dirt, dust, and chips of film collect inside a camera too, so check whenever you change film and remove any visible matter. Examine and clean your camera's interior periodically as a matter of preventive maintenance, since tiny particles of grit can scratch

A soft camel's hair brush is best for cleaning lens optics. A blower brush will remove most debris.

Lens-cleaning tissues are best for wiping fingerprints, smudges, and spots from lenses.

your film. Use an air bulb or blower brush (available at most photo shops) or an ear syringe (available at most drugstores) to blow loose particles of dust and film out of such hiding spots as film sprockets; then brush the dust out of all the little crevices inside the camera. Be very careful with the shutter, as the slightest pressure can damage it.

Check the optics often, turning them in the light so that dirt and smudges will show up. Clean them as often as necessary.

If residue has built up on the film pressure plate, clean it with a cotton swab that has been only slightly dampened (not soaked) with warm water to which mild dishwashing soap has been added. Wipe with another swab dampened in plain water, and dry with a lens-cleaning tissue.

Although dirt and dust particles on the surface of the mirror in a single-lens reflex camera will not affect your camera's mechanical and optical abilities, they can be annoying and distracting when they show up in the viewfinder, and as the mirror flops back and forth during picture taking, there's always a chance that dirt

A lens brush can be improvised from a sheet of lens tissue pinched in the center and flared at the ends.

on the mirror can find its way to other parts of the camera. I use an artist's spotting brush to pick off each particle of dust individually—and carefully, because mirror coatings are very delicate.

Although any good camel's hair brush will clean the glass surfaces of lenses, filters, and other lens attachments, I prefer the kind attached to a squeeze bulb that blows debris off the lens and out of the lens barrel threads. After the visible traces of debris have been brushed from the lens, fingerprints, smudges, and spots must go. The cardinal rule is to always moisten the lens before wiping it clean, so that tiny particles of grit still on the lens will not scratch the surface. I recommend lens-cleaning fluid, which is available in small squeeze bottles at any photographic store. In its absence, a drop of clean water or the moisture from your breath will be sufficient to lubricate the lens before you wipe it dry.

Any clean, soft cloth can be used to wipe a lens. A large gun patch will do, or you can buy a lens cloth made for the purpose. Any cloth, though, will leave lint on the lens. And since lens cloths are reusable, they eventually soil. Worse yet, tiny particles of dirt and grit can become lodged in the fibers of the cloth, and can damage the lens surface. I prefer to use lens-cleaning tissues (not eyeglass or facial tissues), which are cheap, disposable, and relatively lint-free. And if you are caught without a lens brush, you can improvise one from a sheet of lens tissue that is pinched in the center and flared at the ends.

All glass surfaces that are put between the subject and the film should be kept clean, so don't overlook the rear elements on interchangeable lenses. It's easy to get a fingerprint or smudge on the rear element and never notice it.

Batteries

Batteries are a bigger part of photography than ever before. We use cameras with built-in battery-operated light meters,

electronic-exposure cameras that depend totally on batteries, and electronic flash units that work on batteries.

If your camera, strobe, or light meter isn't going to be used for a month or more, remove the batteries before storing the equipment in order to minimize corrosion of battery terminals. If a piece of battery-operated equipment has gone unused for more than 30 days, check the batteries and examine the contacts before using the equipment.

Regardless of use, battery contacts should be checked and cleaned every few months. Use a rough cloth or pencil eraser to clean the battery terminals and contacts inside the camera, strobe, or light-meter battery compartment.

Although the small button batteries used in light meters and electronic exposure systems can give more than a year of service, change them every 12 months to reduce the chance of battery failure in the field.

The Notorious PC Cord

Most photographers who use strobes will tell you that PC stands for "pretty crummy" or "poor connection," but actually it means "pin connector." These cords used to wire strobes to cameras are notorious problem causers; until somebody comes up with something better, we will have to deal with them.

One problem is that the connectors tend to loosen up with use, which causes them to partly or fully disconnect or even to fall out of the socket—at just the wrong time. Use a small pair of needle-nose pliers to bend the pin slightly off center, which will improve internal connection in the camera. Then use the pliers to crimp the outer rim of the connector so it will fit more tightly in the camera socket.

I always carry a spare PC cord. I have quit using the spring-type PC cords; they tend to pull out of the socket when I'm using a strobe off camera.

Equipment Carriers

Whatever you carry your gear in—fitted case, gadget bag, backpack, haversack, belt pouches, photographer's vest, or coat pockets—should be kept clean. Photographers who are meticulous about cleaning their equipment can overlook dirt and debris collecting inside equipment carriers.

Empty out carriers regularly, and use a vacuum cleaner to probe crevices that hold debris that can transfer onto cameras, lenses, and other gadgets. If you carry equipment in your coat or jacket pockets, turn them inside out first and remove all lint.

Care of Tripods

The tripod is another piece of equipment that gets ignored. To

keep your tripod functioning dutifully for many years, it should be kept clean and lubricated. Obvious dirt, dust, and mud is cleaned off with a damp sponge. Then wipe down the tripod legs with a silicone gun and reel cloth.

Do not use conventional oils or other liquid lubricants on the working parts of a tripod: they tend to collect dirt. Instead, after cleaning the tripod, apply an aerosol dry lubricant such as Du Pont Slip-Spray, to all moving parts.

Salt water and salt spray are harmful to aluminum tripods, so if you use yours along the seacoast, rinse it off thoroughly with clean fresh water after each outing. Let the tripod stand, with legs fully extended, overnight or until completely dry. (You can speed up the drying process with an electric hair dryer.) Finally, apply a coat of dry lubricant.

Dry Storage

Moisture is harmful to photographic equipment, and there are few outdoor photographers who don't have to be concerned about combating it. Atmospheric moisture, dampness, high humidity, fog, mist, and rain can enter your equipment and rust delicate metal parts or damage electronic circuitry.

Obvious moisture, as from rain, should be wiped off immediately. The problem causer is residual moisture; one of the best ways to combat it is to store equipment in a cool, dry place when it's not in use.

If you live in a damp climate, you should have an airtight chest or cabinet to store your gear. An ice chest or styrofoam cooler with a lid is dandy. To take care of moisture that takes up residence in your gear while afield or afloat, keep cartridges or bags of silica gel (a chemical desiccant) with your equipment in the airtight chest. Silica gel is available at most photographic suppliers; you can often find it in 1-pound bags at military surplus stores.

Professional Cleaning

Cameras used extensively under adverse conditions may need cleaning by a trained camera repairman from time to time, but proper care and cleaning—what the army calls first-echelon maintenance—can postpone or even eliminate the need for professional cleaning. My primary system is more than four years old now, and like my wife's cameras which are five years old, have never needed a professional cleaning, although the gear has been subjected to heavy use under the most adverse conditions, from the arctic to the semitropics, in deserts, mountains, along the coast, and on fishing, hunting, and camping trips. The cameras have been transported by boat, canoe, snowmobile, dogsled, off-road vehicles, and on foot. They've had several thousand rolls of

film run through them, and I expect them to serve us well for years to come.

Our equipment holds up well under severe use because we take care of it and keep it clean. Each professional cleaning we have avoided by such care would have cost from $50 to more than $100, and kept each camera out of use for four to six weeks or longer.

Detecting Camera Problems

Things can go wrong with cameras, even if they are properly cared for; when that happens, unless you are a trained camera repairman, you should seek professional assistance. A camera is a complex tool that should only be dismantled by someone who knows what he is doing.

The camera components most likely to develop problems are built-in light meters, shutters, and lens diaphragms.

If you keep checking shutter and aperture settings against the lighting situations you encounter, light-meter problems will be immediately evident. It helps to periodically check the light meter against another light meter for correctness. This goes for new cameras too, as I learned the hard way.

Shortly after I bought the 35mm system I am now using, I spent some time at a deserted silver mine and ghost town in northern Yukon Territory, where I shot a lot of film. The black-and-white film and the small amount of Ektachrome I exposed there turned out fine, but all eight rolls of Kodachrome were disastrously overexposed. When I checked the meter in the Kodachrome body, as I should have as soon as I removed the camera from its shipping carton, I found it was reading low by 2 1/2 f/stops. Even though I bracketed all my exposures, the closest I got on any frame to correct exposure was a 1 1/2-f/stop overexposure. And with Kodachrome, a miss is as good as a mile.

Had I tested the meters of all three camera bodies as soon as I received them from the dealer, I would have detected the disparity, and could have returned the body to the dealer for immediate replacement. As it turned out, I had to have it repaired on warranty, and while it cost me nothing for the repairs I did have to pay shipping and insurance, and was without my camera for more than eight weeks.

Some shutter problems are easy to detect. For example, years ago I had an old Pentax that developed a shutter problem caused by moisture that had corroded some of the parts in the shutter mechanism. About every six or eight frames the shutter would lock open; it would only close after I advanced the film and snapped the shutter release again, which cost me two frames out of every eight or ten.

A shutter that lags or does not allow precise exposure is more difficult to detect. If you suspect this problem get the camera to a repairman for testing. If you are in the field—and isn't that where all equipment problems develop?—you can make a simple check of your shutter. First remove the film from the camera. If you have a camera with interchangeable lenses, remove the lens; otherwise, open the lens diaphragm to its widest aperture. Then open the camera back, and if possible move to a shaded area or indoors, where you can aim your camera at a light object or bright area (a white wall is ideal). Snap the shutter at all speeds, from highest to lowest, and watch how it is functioning. You will be able to see light through the film aperture in the back of the camera as the shutter functions.

The highest speeds are the ones most likely to give you problems, as opposed to speeds of 1/60 and 1/125 second. If you have problems at some speeds, you still may be able to use your camera at the middle settings. Bracket your exposures more widely than normal—two or three f/stops below and above the correct setting indicated by the meter. Have a repairman check your camera as soon as possible.

If you suspect aperture problems, remove the lens, or in the case of a noninterchangeable lens, open the camera back, and look through the rear of the lens as you turn the aperture ring from its narrowest to its widest setting. The most common problem is the automatic diaphragm that sticks in the wide-open position. Turn the aperture ring rapidly from lock to lock, several times. This may free the mechanism, but if it does not, you will have to seek a repairman. Meanwhile, if you must use the lens, remember that you can only take pictures at the wide-open aperture setting, so you will have to use faster shutter settings, and perhaps even neutral density filters to compensate for light that is too bright for proper exposures.

Pay attention to the detents or click-stops in the camera's shutter speed dial and the lens's aperture ring. You should be able to snap each setting in positively and firmly. If the shutter speed dial or aperture ring gets sloppy and tends to slip out of the detents, get the camera in for repair.

If You Drop Your Camera or Lens
First, examine the camera or lens carefully for visible damage. Check the front and rear elements of the lens for scratches or chips, then grasp the lens firmly and shake it. If something rattles, the fall may have knocked loose an internal element.

Now focus the lens at infinity, and verify that it is focused there and not beyond.* Try focusing on several objects at various

*Some wide-angle lenses are designed to focus slightly beyond infinity when set at infinity in order to improve edge sharpness. In this case, make sure the lens is focusing as designed.

distances. If the lens brings everything into focus as it should, you're lucky.

Check the camera for visible dents caused by the fall. Minor dents will probably cause no trouble, but if the back of the camera has been damaged, the film pressure plate inside the camera may have been moved out of position, which will result in out-of-focus pictures: cease shooting and get the camera in for repairs.

Check the aperture and shutter as above. Check the light meter. Examine the aperture ring, shutter speed dial, rewind knob, and other parts such as the self-timer. If everything checks out, hold the camera firmly and shake it. If something rattles—you guessed it—see your friendly camera repairman.

If You Dunk Your Camera or Lens

A camera or lens that gets dropped in water will need professional attention, but there are a few things you can do right away to minimize moisture damage.

If the water is salt water, your problems are more serious. Get to a source of clean fresh water and rinse the equipment gently but thoroughly, either under running water or preferably in a bucket, tub, or basin filled with water. Rinse for about a half hour, changing rinse water at least every five minutes.

Some say that after gently shaking excess water off the equipment, it should be placed inside a warm oven (preheated to 125°F) where it is allowed to dry completely—probably two to four hours, during which the equipment should be operated periodically. Then the camera will need to be checked and, if necessary, repaired by a professional.

The alternative, which I favor, is to get the wet camera into a freezer immediately, since freezing will retard the corrosive action of the water. Don't wrap it, so as not to retard the freezing process; the idea is to turn the destructive moisture into harmless ice as soon as possible. Leave the camera in the freezer overnight, then wrap it in several layers of newspaper, seal with tape, and return to the freezer. Phone your local camera repair facility and discuss the problem with the repairman. Have him phone you when he can clean and inspect your gear, and take it to him in a cooler that will keep it frozen.

THE OUTDOOR PHOTOGRAPHER'S LIBRARY

Most of us, whether we are hobbyists or professionals, read about photography. We study, experiment, take notes, try to solve our problems, search for new horizons, and attempt to keep abreast of rapidly advancing technology. A well-organized library helps take much of the guesswork out of photography, build self-confidence through knowledge, develop creativity and an individual style.

The Photographer's Notebook

The successful outdoor photographer takes notes on his activities and jots down ideas for photographs and photographic sequences to be developed. Notes can help you remember subjects you have observed but wish to photograph later because lighting was not perfect when you first saw them. Notes help plan outings and extended trips. Keep your notes organized and systemized by housing them in a notebook.

I like a small loose-leaf binder, in which pages can be added or removed at will, and can be grouped according to subject and organized with index tabs. At first I used a binder of 4 1/2" x 7 1/4" pages, small enough to fit inside a gadget bag or parka pocket. It turned out to be one more item to lug along, and I soon began finding excuses not to carry it; also, it didn't take long to fill it with notes.

I eventually decided that any adequate notebook would be too cumbersome for field use. I began using 3" x 5" file cards to record comments while afield or afloat. A stack of blank cards fits comfortably in a shirt pocket, and I have grown to rely on them so much that I wouldn't think of being without them.

After a typical day of photography I may have accumulated a few notes or none at all; more than likely, though, I will have a stack of cards with notes, ideas, and problems scribbled hurriedly on them. At the end of the day I review the notes and record the useful ones in the larger notebook I now use, which holds 5 1/2" x 8 1/2", three-hole loose-leaf paper, and is divided with subject index tabs and a set of alphabetical tabs.

In my notes I describe subjects that I plan to shoot in the future. My favorite subjects are those that show up most often in the

For field use, 3" x 5" file cards are ideal for taking notes. Later, important items of interest can be recorded in a loose-leaf notebook that is organized with index tabs.

notebook, and I use the notes to build my portfolios and subject files. When I find an interesting bridge, lighthouse, weather-beaten barn or other outbuilding, waterfall, distinctive land-scape, promising game trail or watering hole, or nesting site, and the like, I note it for later. Reasons for not shooting right now include poor lighting, bad weather, wrong time of day or year, and having an urgent appointment.

I have included a photo of a typical page in my notebook.

I have about a dozen other subjects in my notebook that are within a few miles of the covered bridge, so when I shoot the bridge, I will do the other pictures too. Without the notes, my shooting would be a disorderly, hit-and-miss affair.

Last fall my wife and I were returning from an Idaho duck-hunting trip when we discovered an area in eastern Oregon with an abundance of raptors. We found nearly a dozen huge nests and decided it would be an excellent place to return to in the spring when the birds were nesting.

When I told my brother, a Boise attorney, that we would proba-bly be heading over to border country in the spring to photograph raptors, he reminded me that there is a large raptor refuge south of Boise, so I noted that too. Then I remembered a pair of beautiful barn owls we had found on a ranch in the area, and I made a note to try to get some owl shots.

You see how everything starts to come together from the notes. When we make our raptor-photographing trip to border country, we will also get in some camping and great late spring fishing.

The Photographer's Log

When I was in college I had a professor who maintained that no two photographers agree on anything except that lint on nega-tives is bad. However, I recently came across a photographer who insisted that creative effects could be accomplished with careful

Use a typewriter to prepare camera-ready log sheets for the printer.

placement of lint. His personal preference, by the way, was for cat hair. Oh well.

There still may be one point of agreement among serious photographers, and that is that there is no such thing as a handy, efficient photographer's log. Most of the logs (not to be confused with notebooks) commercially available are too unwieldy to be convenient. They're OK for the photographer who never ventures outside the studio, but they are too cumbersome for the active, mobile outdoor photographer.

After experimenting with logs of my own design I have come up with one that does the job. I included space for only essential information and laid out three log pages on an 8 1/2″ x 11″ sheet of white paper, typed it out, and took the camera-ready copy to my local quick-print facility. It cost me $4.25 to have 100 copies (300 log pages) offset-printed, and the job was finished while I waited. That's only 1.4 cents per page.

After I left the print shop I stopped by an office supply store and bought a box of pressure-sensitive, self-adhesive 1/2″ x 3/4″ labels that come packaged 1000 to the box, or 42 on a page.

Back at my studio, I used a paper cutter to cut and trim the log pages to their planned 3 1/2″ x 8 1/2″ format. I cut several sheets of plain white paper (log covers) and chipboard stiffeners (log backs) to the same dimensions.

Assembling and binding the logs was simple. For each I started with a piece of chipboard backing. On top of that went a half page of the labels (21 labels), 21 log pages, and finally a plain white cover sheet. I stapled it across the bottom, and used a strip of black plastic electrician's tape to cover the staples and keep them from catching on clothing and equipment.

Left: *The finished log fits comfortably in the hand and tucks neatly in a pocket, purse, or gadget bag.* Right: *A typical completed log page and roll of film labeled with its corresponding index number.*

And that, friends, is all there is to making logs.

Any photographer can custom-design his own log to fit his own needs. You can add to or subtract from the log that I use to accommodate your kind of photography, or you may not need to make changes. You may not need as many logs as I printed. Although it doesn't take me long to shoot up 300 rolls of film, I'm not going to try to convince you that I keep a record of every roll of film I expose.

The logs are useful for keeping track of my shooting when I'm traveling. When I'm shooting on location or an assignment, I often use a log to take notes for later reference. The greatest value—for any photographer—is use of the log for recording practical tests.

When you buy a new or used camera or piece of equipment or supplies, there is no substitute for practical field testing. The manufacturers' directions are important, but they may need modification.

To be sure, some manufacturers' claims tend to be a tad optimistic. Not long ago, I was experimenting with several high-speed, fine-grain developers, and I came across one that did, as the manufacturer stated, prevent grain clumping, and effectively produced very fine-grain negatives. The problem was that the negatives were too thin and flat for my liking.

The manufacturer's data sheet said to shoot Panatomic-X at EI 200, Plus-X at 640, and Tri-X at 1200. Several test rolls later, I had settled on exposure indexes of 80, 400, and 800 and increases in development times ranging from 30 seconds to a full minute. Then I was able to get super-fine-grain negatives of good average density and contrast with the film rated considerably higher than Kodak's assigned ASA. But I had to test and I had to keep an accurate record of my experiments in a log.

My log is a record-keeping system, from field to file. When I start a roll of film I fill in the pertinent data at the top of the page and assign an index number to the roll. When the roll has been exposed, I turn to the last page of the log and write the index number on one of the pressure-sensitive labels, which I then peel off and stick to the film cassette. If I have pushed the film or have experienced any difficulties like poor lighting, I note it at the bottom or on the back of the log page, and the index number keeps everything straight.

After processing, the index number stays with the negatives or transparencies. I enter the index numbers of black-and-white negatives on the clear plastic loose-leaf negative preservers I use, and thereby print them on corresponding contact sheets. I write the index number of slides on each mount before filing.

The system works, and my log is easy to tote along everywhere. It will fit in pocket, purse, or equipment case, and it can be folded, checkbook style, to fit even snugger quarters.

The Photography Handbook You Edit Yourself

Outdoor photography is demanding as a profession or hobby. The really good amateurs pore over as much printed matter as the professionals do. They use similar equipment and are faced with similar problems.

Most photographers recognize the importance of a reference library, but few can afford an abundance of expensive books. We rely on photography magazines to keep us posted on the latest discoveries, reading the magazines regularly and clipping articles and tips of interest to us.

The problem remains of how to organize all this data. I used to house my large collection of data in a file drawer, but I found filing a dull task that I kept putting off. Frequent rooting through file drawers for a piece of information was inconvenient. What I needed was one handy reference book containing the material I used often and wanted readily at hand, in a form that could be easily updated. Since no such volume existed, the only answer was to edit a photography handbook myself.

What eventually evolved was an alphabetized, categorized loose-leaf binder. Initial investment was minimal, and I got the

There are many sources of inexpensive or free materials.

material bound in the handbook either free or inexpensively. It is easy to maintain and can be expanded by adding more binders. I have enjoyed compiling and editing the handbook.

I use an easel binder (the Viz-a-Fiche), which is handy in the darkroom, where it stands in view of whatever I'm doing.

There are many information sources. Photography magazines are excellent, as are manufacturers of equipment, chemicals, film, and paper. Use the instructions and data sheets they pack with their products; write manufacturers for more information and data sheets, and ask them to add your name and address to their mailing list for future publications.

Camera club and photographers' association newsletters provide usable materials, as can friends and fellow photographers. And don't overlook your local photography dealers, who are deluged with literature from manufacturers which they are happy to give away.

You will need an alphabetical loose-leaf index and as many subject indexes as necessary to categorize the handbook. In my handbook I have subject indexes for cameras, chemicals, darkroom procedures, developers, and film. You will also need a paper punch.

I keep a supply of ruled loose-leaf paper for recording experiments. I type up some notes on plain white paper and make them permanent parts of my handbook.

A few hints on assembling material from periodicals will save time and frustration. Tips and brief articles of less than a full page can be neatly clipped from a magazine, newspaper, or newsletter with a sharply pointed model maker's knife (such as the X-Acto)

Some cutting tools that help when clipping and trimming articles, photo tips, and technical data. Scissors are a must, but also helpful are a ruler, single-edge razor or X-Acto knife, a Clip-It, and a paper cutter.

The Clip-It's razor-sharp blade makes short work of any job of clipping items from newspapers and magazines. At less than a dollar, it is available at office supply stores.

or a clipping tool (such as the Clip-It), available at office supply stores. Then the items are pasted to a sheet of typing paper, which is punched and filed in the handbook. Several related items can be pasted on a single page.

Break the magazine down before removing full-page and longer articles. Open a magazine with saddle-stitched (center-stapled) binding to the center, lay it flat, and pop staples out with a staple

Pamphlets, booklets, and price lists can be kept in file pockets that fit inside your handbook. The pockets can be made from file folders that are cut to 8 1/2" x 11". Punch three holes near the folded edge, then cut away the top portion of the front flap only, about an inch up from the center hole. Tape the remaining front flap on the rear flap with drafting tape. Make as many of these file pockets as you will need and slip them into your handbook.

puller or pry them out with a small screwdriver. Cut and punch pages to fit your handbook.

With a magazine like *Popular Photography* which uses "perfect" binding (glued and stapled), remove the covers; then use a knife to pry up the staple tines. Turn the magazine over and pry out one end of each staple with the knife. Use pliers to pull the staples the rest of the way out. Now tear the articles from the magazine the way you tear a sheet from a tablet of paper.

To file instructions printed on the boxes in which some photographic products are packaged, cut the box apart and paste the material on a sheet of paper with rubber cement. Since this makes a bulky page, have it photocopied. Photocopy data sheets that come printed on both sides.

For paste-up jobs use rubber cement or the handy glue sticks. Place the item to be glued face down on a piece of scrap paper; then run the glue stick around the edges, and run diagonal lines of glue from corner to corner.

Then there are pamphlets, price lists, and owner's manuals that just don't seem to fit anywhere. House them in file pockets made from manila file folders, trimmed to 8 1/2" x 11". Punch three holes along the folded edge, then cut away the top part of the front flap about an inch above the center hole, and tape the front flap to the rear flap with drafting or masking tape. Now the

Some of the best outdoor photography appears in National Wildlife, National Geographic, *and* International Wildlife. *Studying back issues is one of the best ways to develop a photographic sense.*

odd-sized literature that once cluttered your library shelves or file drawers will tuck away neatly in your handbook.

Periodicals

The monthly, quarterly, and annual photographic periodicals are the literary lifeblood of our hobbies or professions. Their expert staffs can test and evaluate equipment better than we can. They compare films and processes, and they explain new and unusual techniques.

The major outdoor magazines run articles aimed at the outdoor photographer, and publish fine examples of his craft. Careful analysis of exemplary photographs can teach us much about technique and give us ideas for our own photographic activities.

While excellent outdoor photographs and photostories show up in specialized and general magazines, the best outdoor photography, in my opinion, shows up consistently in *National Geographic*, *National Wildlife*, and *International Wildlife*. I have kept every copy of these publications since I first subscribed; they form an important part of my library. Every few months, I spend some time with these magazines, just turning the pages and looking at pictures. I always see things I failed to notice before, and I jot down new ideas and potential subjects in my notebook.

Instead of using a loose-leaf binder, you may prefer to store material you clip from periodicals in a small filing cabinet. Write the name and date of the periodical on each article you clip, in case you want to write the magazine later for more information.

Or you may prefer to keep your magazines intact. A subject index on 3″ x 5″ file cards is invaluable, though time-consuming. Alphabetical index tabs are useful, and you can add plain, third-cut index tabs on which to write subject categories such as filters, lighting, strobes, and tripods.

System Handbooks

Add a system handbook like the *Nikon Nikkormat Handbook*, by Joseph D. Cooper, to your library.

There is much useful information in the Life Library of Photography.

Such books are advertised in the periodicals, can be found in some mail-order catalogs, and are available from companies specializing in photographic books. They contain a wealth of general photographic information, plus material oriented to one particular camera system, whether Canon, Minolta, Leica, Nikon, or Olympus. The best are loose-leaf and are kept up-to-date through a subscription service for which there is a nominal charge.

The Kodak Library

I recommend as a starting point for gradually building a comprehensive photographic library the Kodak Publication Department. Send a dime to Eastman Kodak, Dept. 454, 343 State St., Rochester, NY 14650, and request the *Index to Kodak Information* (publication #L-5). Read the descriptions of literature carefully, and mark those that interest you.

Prices of pamphlets, Dataguides and literature packets, books, and multivolume sets range from 10¢ to more than $20. There are free booklets and brochures too, and chances are you can assemble a stack of useful material for a few bucks.

I also recommend Kodak's two sizes of binders with index tabs for organizing their literature; much of the material they publish is already punched to fit the binders.

This useful set of booklets is available free from Braun North America.

Some years ago I started my Kodak library with a large binder, two small ones, and less than $20 worth of literature. By now I have practically everything of interest to me in the index, housed in seven large binders and eight small ones.

Some of the more popular Kodak publications are available from mail-order suppliers such as Norman Camera and Porter's Camera Store at reduced prices.

The *Life Library of Photography*

Photographers have mixed emotions about the 17-volume *Life Library of Photography*. I am quite satisfied with it, but I recommend that before you invest in this relatively expensive set, examine it at a local library.

You may prefer to buy only one or a few individual volumes such as *Photographing Nature* and *Travel Photography*. Send your inquiry to Time-Life Books, Time & Life Bldg., Chicago, IL 60611.

I think the four yearbooks I have purchased are fairly worthless, and I won't be buying any more until the editors put together more meaningful material. They do come on a ten-day trial period.

The Hasselblad Library

You don't often get something of quality for nothing, but the folks at Braun North America—the American importers of Hasselblad equipment—will send you nine booklets on photography for the asking. The most useful are on aerial photography, close-up photography, wildlife photography, and photography in poor light. Although the emphasis is on Hasselblad photography, any

photographer will find the set of booklets worth owning, regardless of what equipment he owns.

And the price is right.

Amphoto and Laurel

You can get books on just about any aspect of photography from Amphoto and Laurel. Amphoto offers "the world's most complete catalog of photographic books," while Laurel has "the world's most complete and up-to-date catalog of photography and cinematography books." Superlatives aside, the catalogs are well worth having, and each will cost you a buck.

Send your dollars and requests to Amphoto, 750 Zeckendorf Blvd., Garden City, NY 11530, and Laurel Photographic Books, 55 West 39th St., New York, NY 10018.

If you're planning to buy equipment from Spiratone, don't bother to order the Laurel catalog, as you will get one free when Spiratone passes your address on to Laurel.

SELECTED BIBLIOGRAPHY

Bauer, Erwin A. *Hunting with a Camera*. New York: Winchester Press, 1974.

Brockman, C. Frank. *Trees of North America*. New York: Golden Press, 1968.

Collins, Henry Hill, Jr. *Complete Field Guide to American Wildlife*. New York: Harper & Row, 1959.

Coykendall, Ralph. *Duck Decoys and How to Rig Them*. New York: Holt, Rinehart and Winston, 1955.

Earnest, Adele. *The Art of the Decoy: American Bird Carving*. New York: Bramhall House, 1965.

Elliot, Charles. *The Outdoor Observer*. New York: E. P. Dutton, 1969.

The Focal Encyclopedia of Photography. 2 vols. New York: McGraw-Hill, 1965.

Hanenkrat, Frank T. *Wildlife Watcher's Handbook*. New York: Winchester Press, 1977.

Hedgecoe, John. *The Photographer's Handbook*. New York: Alfred A. Knopf, 1977.

Kinne, Russ. *The Complete Book of Nature Photography*. Garden City, N.Y.: Amphoto, 1971.

Kortright, Francis H. *The Ducks, Geese and Swans of North America*. Harrisburg, Pa.: Stackpole Books, 1967.

The Larousse Encyclopedia of Animal Life. New York: McGraw-Hill, 1967.

Palmer, E. Laurence. *Palmer's Fieldbook of Mammals*. New York: E. P. Dutton, 1957.

Robbins, Chandler S., Bertel Bruun, and Herbert S. Zim. *Birds of North America*. New York: Golden Press, 1966.

Rue, Leonard Lee, III. *Sportsman's Guide to Game Animals*. New York: Harper & Row, 1968.

———. *Game Birds of North America*. New York: Harper & Row, 1973.

Smith, Robb. *The Tiffen Practical Filter Manual*. Garden City, N.Y.: Amphoto, 1975.

Snyder, Norman, ed. *The Photography Catalog*. New York: Harper & Row, 1976.

Stroebel, Leslie, and Hollis N. Todd. *Dictionary of Contemporary Photography*. Dobbs Ferry, N.Y.: Morgan & Morgan, 1974.

Sussman, Aaron. *The Amateur Photographer's Handbook*. 8th ed. New York: Thomas Y. Crowell Co., 1973.

GLOSSARY

The following terms and definitions have been taken from Kodak pamphlet AA-9, "A Glossary of Photographic Terms," and are reproduced here with Kodak's permission.

Action. The movement of the subject within the camera's field of view.

Adjustable Camera. A camera with manually adjustable distance settings, lens openings, and shutter speeds.

Adjustable-Focus Lens. A lens that has adjustable distance settings.

Angle of View. The portion of a scene that is seen by a camera lens. The width of this wedge-shaped portion is determined by the focal length of the lens. A wide-angle (short-focal-length) lens includes more of the scene, or a wider angle of view, than a normal (normal-focal-length) or telephoto (long-focal-length) lens.

Aperture. Lens opening. The opening in a lens system through which light passes. The size of the aperture may be fixed or adjustable. Lens openings are usually calibrated in f-numbers.

Automatic Camera. A camera with a built-in exposure meter that automatically adjusts the lens opening, shutter speed, or both, for proper exposure.

Background. The part of the scene that appears behind the principal subject of the picture.

Backlighting. Light shining on the subject from the direction opposite the camera; distinguished from frontlighting and sidelighting.

Balance. Placement of colors, light and dark masses, or large and small objects in a picture to create harmony and equilibrium.

Bellows. The folding portion in some cameras which connects the lens to the camera. (Also a folding, adjustable unit used for close-up photography.)

Between-the-Lens Shutter. A shutter whose blades operate between two elements of the lens.

Blowup. An enlargement; a print that is made bigger than the negative or slide.

Camera Angles. Various positions of the camera (high, medium, or low; and left, right, or straight on) with respect to the subject, each giving a different viewpoint or effect.

Candid Pictures. Unposed pictures, often taken without the subject's knowledge; these usually appear more natural and relaxed than posed pictures.

Close-up. A picture taken with the camera close to the subject.

Close-up Lens. A lens attachment placed in front of a camera lens to permit taking pictures at a closer distance than the camera lens alone will allow.

Coated Lens. A lens covered with a very thin layer of transparent material that reduces the amount of light reflected by the surface of the lens; a coated lens is faster (transmits more light) than an uncoated lens.

Color Balance. The ability of a film to reproduce the colors of a scene. Color films are balanced in manufacture for exposure to light of a certain color quality (daylight, tungsten, etc.). Color balance also refers to the reproduction of colors in color prints, which can be altered during the printing process.

Composition. The arrangement of all elements in a picture: main subject, foreground, background, and supporting subjects.

Contact Print. A print made by exposing photographic paper while it is held tightly against the negative. Images in the print will be the same size as those in the negative.

Contrast. The density range of a negative, print, or slide; the brightness range of a subject or the scene lighting.

Contrasty. Too high in contrast; the range of density in a negative or print is too great.

Cropping. Using only part of the image that is in the negative or slide.

Darkroom. A lighttight area used for processing films and for printing and processing papers; also for loading and unloading film holders and some cameras.

Definition. The impression of clarity of detail perceived by an observer viewing a photograph.

Density. The blackness of an area in a negative or print, which determines the amount of light that will pass through it or reflect from it.

Depth of Field. The distance range between the nearest and farthest objects that appear in acceptably sharp focus in a photograph. For all practical purposes, it depends on the lens opening, the focal length of the lens, and the distance from the lens to the subject.

Depth of Focus. The distance range over which the film could be shifted at the film plane inside the camera and still have the subject appear in sharp focus; often misused to mean "depth of field."

Developer. A solution used to turn the latent image into a visible image or exposed film or photographic papers.

Diaphragm. Lens opening. A perforated plate or adjustable opening mounted behind or between the elements of a lens which is used to control the amount of light that reaches the film. Openings are usually calibrated in f-numbers.

Diffusing. Softening detail in a print with a diffusion disk or other material that scatters light.

Diffusion Disk. A flat glass with a pattern of lines or concentric rings that breaks up and scatters light from an enlarger lens and softens detail in a print. (Diffusion disks and random diffusers are also used as camera lens attachments for the same purpose.)

Double Exposure. Two pictures taken on one frame of film, or two images printed on one piece of photographic paper.

Emulsion. A thin coating of light-sensitive material, usually silver halide in gelatin, in which the image is formed on film and photographic papers.

Enlargement. A print that is larger than the negative or slide; a blowup.

Exposure. The quantity of light allowed to act on a photographic material; a product of the intensity (controlled by the lens opening) and the duration (controlled by the shutter speed or enlarging time) of light striking the film or paper.

Exposure Latitude. The range of camera exposures, from underexposure to overexposure, which will produce acceptable pictures from a specific film.

Exposure Meter. An instrument with a light-sensitive cell that measures the light reflected from or falling on a subject; used as an aid to selecting the exposure setting. Same as a light meter.

Exposure Setting. The lens opening and shutter speed selected to expose the film.

Film Speed. The sensitivity of a given film to light, indicated by a number; the higher the number, the more sensitive (faster) the film.

Filter. A colored piece of glass or other transparent material used over the lens to emphasize, eliminate, or change the color or density of the entire scene or certain elements in the scene.

Fixed-Focus Lens. A lens that has been focused in a fixed position by the manufacturer. The user does not have to adjust the focus.

Flash. A brief, intense burst of light produced by a flashbulb or an electronic flash unit, usually used where the lighting on the scene is inadequate for picture taking.

Flat. Too low in contrast; the range of density in a negative or print is too short.

Flat Lighting. Lighting that produces very little contrast or modeling on the subject, and a minimum of shadows.

F-Number. A number used to indicate the size and light-passing ability of the lens opening on most

adjustable cameras. Common f-numbers are f/2.8, f/4, f/5.6, f/8, f/11, f/16, and f/22. The larger the f-number, the smaller the lens opening. In this series, f/2.8 is the largest lens opening and f/22 is the smallest lens opening. These numbers indicate a ratio of the focal length of the lens to the effective diameter of the lens opening. F-numbers help you get the right exposure.

Focal Length. The distance from the lens to a point behind the lens where light rays are focused when the distance scale is set on infinity. Focal length determines image size at a given lens-to-subject distance.

Focal-Plane Shutter. An opaque curtain containing a slit that moves directly across in front of the film in a camera, and allows image-forming light to strike the film.

Focus. Adjustment of the distance setting on a lens so that the subject is sharply defined.

Fogging. Darkening or discoloring of a negative or print or lightening or discoloring of a slide caused by (1) exposure to nonimage-forming light to which the photographic material is sensitive, (2) too much handling in air during development, (3) overdevelopment, (4) outdated film or paper, or (5) storage of film or paper in a hot, humid place.

Forced Development. Increasing the development time of a film to increase its effective speed (raising the ASA number for initial exposure) for low-light situations; push processing.

Foreground. The area between the camera and the principal subject.

Frontlighting. Light shining on the subject from the direction of the camera.

Graininess. The sandlike or granular appearance of a negative, print, or slide resulting from the clumping of silver grains during development of the film; graininess becomes more pronounced with faster films, increased density in the negative, and degree of enlargement.

High Contrast. A wide range of density in a print or negative.

Highlights. The brightness areas of a subject and the corresponding areas in a negative, print, or slide.

Latent Image. The invisible image left by the action of light on photographic film or paper. The light changes the photosensitive salts to varying degrees depending on the amount of light striking them. When processed, this latent image will become a visible image either in reversed tones (as in a negative) or in positive tones (as in a color transparency).

Lens. One or more pieces of optical glass or similar material designed to collect and focus rays of light to form a sharp image on the film, paper, or projection screen.

Lens Speed. The largest lens opening (smallest f-number) at which a lens can be set. A fast lens transmits more light and has a larger opening than a slow lens.

Lighting. The illumination falling on a subject, particularly the direction or arrangement of the illumination.

Light Meter. See "Exposure Meter."

Long Shot. A scene taken from a relatively long distance; the main subject usually appears relatively small in respect to the entire frame size. In movies, a long shot is often used to establish the location and setting (which is also a good technique to use when shooting stills for a photo story or sequence).

Medium Shot. A picture or movie scene made about halfway between a long and a close-up shot to simulate normal viewing distance.

Negative. The developed film that contains a reversed-tone image of the original scene.

Normal Lens. A lens that makes the image in a photograph appear in a perspective similar to that of the original scene. A normal lens has a shorter focal length and a wider field of view than a telephoto lens and a longer focal length and narrower field of view than a wide-angle lens.

Overexposure. A condition in which too much light reaches the film, producing a dense negative or a washed-out print or slide.

Pan (Panchromatic). Sensitization of a black-and-white film so that it records colors in tones of about the same relative brightness as the human eye sees in the original scene.

Panning. Moving the camera so that the image of a moving object remains in the same relative position in the viewfinder as you take a picture.

Panorama. A broad view, usually scenic.

Parallax. At close subject distances, the difference between the field of view seen through the viewfinder and that recorded on the film. This is due to the separation between the viewfinder and the lens. There is no parallax with single-lens reflex cameras, because when you look through the viewfinder you are viewing the subject through the picture-taking lens.

Positive. The opposite of a negative; an image with the same tonal relationships as those in the original scene—for example, a finished print or slide.

Print. A positive picture, usually on paper, and usually produced from a negative.

Range Finder. A device included on many cameras as an aid in focusing.

Reflector. Any device used to reflect light onto a subject.

Reflex Camera. A camera in which the scene to be photographed is reflected by a mirror onto a glass where it can be focused and composed; in a reflex movie camera or a single-lens reflex camera (SLR), the scene is viewed through the same lens that takes the picture, thus avoiding parallax; with a twin-lens reflex camera (TLR), the scene is viewed through the top lens, and the picture is taken through the bottom lens.

Reticulation. Cracking or distorting of the emulsion during processing, usually caused by wide temperature or chemical activity differences between the solutions.

Script. A set of written specifications for the production of a film or slide show.

Sequence. A series of shots (or scenes) that relate to each other.

Shutter. Blades, a curtain, a plate, or some other movable cover in a camera which controls the time during which light reaches the film.

Sidelighting. Light striking the subject from the side relative to the position of the camera; produces shadows and highlights to create modeling on the subject.

Simple Camera. A camera that has few or no adjustments to be made by the picture taker. Usually, simple cameras have only one size of lens opening, do not require focusing by the picture taker, and have one or two shutter speeds.

Slide. A photographic transparency, usually color, mounted for projection.

Soft Focus. Produced by use of a special lens creating soft (rather than sharp) outlines where light areas tend to encroach on dark areas.

Soft Lighting. Lighting that is low or moderate in contrast.

Telephoto Lens. A lens that makes a subject appear larger on film than does a normal lens at the same camera-to-subject distance; a telephoto lens has a longer focal length and narrower field of view than a normal lens.

Thin Negative. A negative that is underexposed or underdeveloped (or both); a thin negative appears less dense than a normal negative.

Time Exposure. A comparatively long exposure (in seconds or minutes); it is used primarily in night photography.

Tone. The degree of lightness or darkness in any given area of a print; also referred to as value. Cold tones (bluish) and warm tones (reddish) refer to the color of the image in both black-and-white and color photography.

Transparency. A positive photographic image on film, viewed or projected by transmitted light (light shining through film).

Tripod. A three-legged supporting stand used to hold the camera steady.

Underexposure. A condition in which too little light reaches the film, producing a thin negative, a dark slide, or a muddy-looking print.

Unipod. A one-legged support used to hold the camera steady.

Vignetting. Printing the central area of a picture while shading the edge areas gradually into white; also, the cutting off of frame edges by filters or other lens attachments, especially when they are stacked on wide-angle lenses.

Wide-Angle Lens. A lens that has a shorter focal length and a wider field of view (includes more subject area) than a normal lens.

Zoom Lens. A lens in which the focal length can be adjusted over a wide range, giving the photographer, in effect, lenses of many focal lengths.

DIRECTORY OF MANUFACTURERS IMPORTERS, AND MAIL-ORDER SUPPLIERS

Acufine
439 – 447 E. Illinois St.
Chicago, IL 60611

Aetna Optix
44 Alabama Ave.
Island Park, NY 11558

A.I.C. Photo
168 Glen Cove Rd.
Carle Place, NY 11514

Alco Photo Supply
131-27 Fowler Ave.
Flushing, NY 11344

Amcam International
813 N. Franklin St.
Chicago, IL 60610

Argraph
111 Asia Pl.
Carlstadt, NJ 07072

Asanuma
1639 Del Amo Blvd.
Carson, CA 90746

Eddie Bauer
P.O. Box 3700
Seattle, WA 98124

L. L. Bean
Freeport, ME 04033

Bell & Howell/Mamiya Co.
7100 McCormick Rd.
Chicago, IL 60645

Berkey Marketing Co.
25-20 Brooklyn-Queens
Expressway W.
Woodside, NY 11377

Beseler Photo Marketing Co.
8 Fernwood Rd.
Florham Park, NJ 07932

Bogen Photo
P.O. Box. 448
Englewood, NJ 07631

Braun North America
55 Cambridge Parkway
Cambridge, MA 02142

Burleigh Brooks Optics
44 Burlews Court
Hackensack, NJ 07601

Burnham Brothers
P.O. Box 78
Marble Falls, TX 78654

Calumet Photographic
1590 Toughy Ave.
Elk Grove Village, IL 60007

Canon U.S.A.
10 Nevada Dr.
Lake Success, NY 11040

Crone
P.O. Box 309
El Cerrito, CA 94530

Eastman Kodak Co.
343 State St.
Rochester, NY 14650

Edmund Scientific Co.
101 E. Gloucester Pike
Barrington, NJ 08007

Ednalite
200 N. Water St.
Peekskill, NY 10541

Edwal Scientific Products
12120 S. Peoria
Chicago, IL 60643

Ehrenreich Photo-Optical Industries
Photo Products Division
101 Crossways Park W.
Woodbury, NY 11797

Falcon Safety Products
1065 Bristol Rd.
Mountainside, NJ 07092

Frank's Highland Park Camera
5631 N. Figueroa
Los Angeles, CA 90042

Fuji Photo Film U.S.A.
350 5th Ave.
New York, NY 10001

G. & H. Decoys
P.O. Box 937
Henryetta, OK 74437

Gander Mountain, Inc.
Box 248
Wilmot, WI 53192

Gossen Division
(see Berkey Marketing Cos.)

H. & W. Co.
P.O. Box 332
St. Johnsbury, VT 05819

Hanimex U.S.A.
7020 N. Lawndale Ave.
Chicago, IL 60645

Harrison & Harrison
6363 Santa Monica Blvd.
Hollywood, CA 90038

Karl Heitz
979 3rd Ave.
New York, NY 10022

Bob Hinman Outfitters
1217 W. Glen Ave.
Peoria, IL 61614

Holex
2544 W. Main St.
Norristown, PA 19401

Hollo
17785-D Skypark Circle
Irvine, CA 92707

Ilford
70 Century Road
Paramus, NJ 07652

Kalimar
5 Goddard Ave.
Chesterfield, MO 63017

Kalt
2036 Broadway
Santa Monica, CA 90404

Ken-Lab
Old Lyme, CT 06371

Kling Photo Division
(see Berkey Marketing Co.)

Kolpin Manufacturing
P.O. Box 231
Berlin, WI 54923

Konica Camera Co.
(see Berkey Marketing Co.)

La Grange
13209 Saticoy St.
North Hollywood, CA 90038

Lion Photo Supply
500 W. Golf Rd.
Schaumburg, IL 60195

Luminos Photo
25 Wolfe
Yonkers, NY 10705

Mallardtone Game Calls
2901 16th St.
Moline, IL 61265

Meisel Photochrome
P.O. Box 6067
Dallas, TX 75281

also:
P.O. Box 4002
Atlanta, GA 30302

also:
P.O. Box 373
Bellevue, WA 98009

also:
P.O. Box 1134
Kansas City, MO 64141

Minolta
101 Williams Dr.
Ramsey, NJ 07446

Nikon
Ehrenreich Photo-Optical Industries
623 Stewart Ave.
Garden City, NY 11530

Norman Camera Co.
56 W. Michigan Mall
Battle Creek, MI 49017

P. S. Olt Co.
Game Calls
Pekin, IL 61554

Olympus Camera
Crossways Park
Woodbury, NY 11797

Omega Division
(*see* Berkey Marketing Co.)

Orvis
10 River Rd.
Manchester, VT 05254

Parkwood Camera Stores
12201 W. Pico Blvd.
Los Angeles, CA 90064

P.R.O.
Photographic Research
 Association
159 W. 53rd St.
New York, NY 10016

Porter's Camera Store
P.O. Box 628
Cedar Falls, IA 50613

Ritz Camera Centers
11710 Baltimore Ave.
Beltsville, MD 20705

Rollei of America
P.O. Box 1010
Littleton, CO 80160

Sargent-Welch Scientific Co.
7300 N. Linder Ave.
Skokie, IL 60076

Sima Products
4001 W. Devon, Suite 106
Chicago, IL 60646

Slik Division
(*see* Berkey Marketing Co.)

Smith's Game Calls
P.O. Box 236
Summerville, PA 15864

Spiratone
135-06 Northern Blvd.
Flushing, NY 11354

Sports Haven, Inc.
P.O. Box 88231
Seattle, WA 98188

Sunpak Division
(*see* Berkey Marketing Co.)

Tamron Division
(*see* Berkey Marketing Co.)

3M Co.
3M Center
St. Paul, MN 55101

Tiffen
90 Oser Ave.
Hauppauge, NY 11787

20th Century Plastics
3628 Crenshaw Blvd.
Los Angeles, CA 90016

Ultimate Experience
P.O. Box 2118
Santa Barbara, CA 93120

Uniphot/Levit
61-10 34th Ave.
Woodside, NY 11377

Vivitar
1630 Stewart St.
Santa Monica, CA 90406

Yashica
50-17 Queens Blvd.
Woodside, NY 11377

INDEX